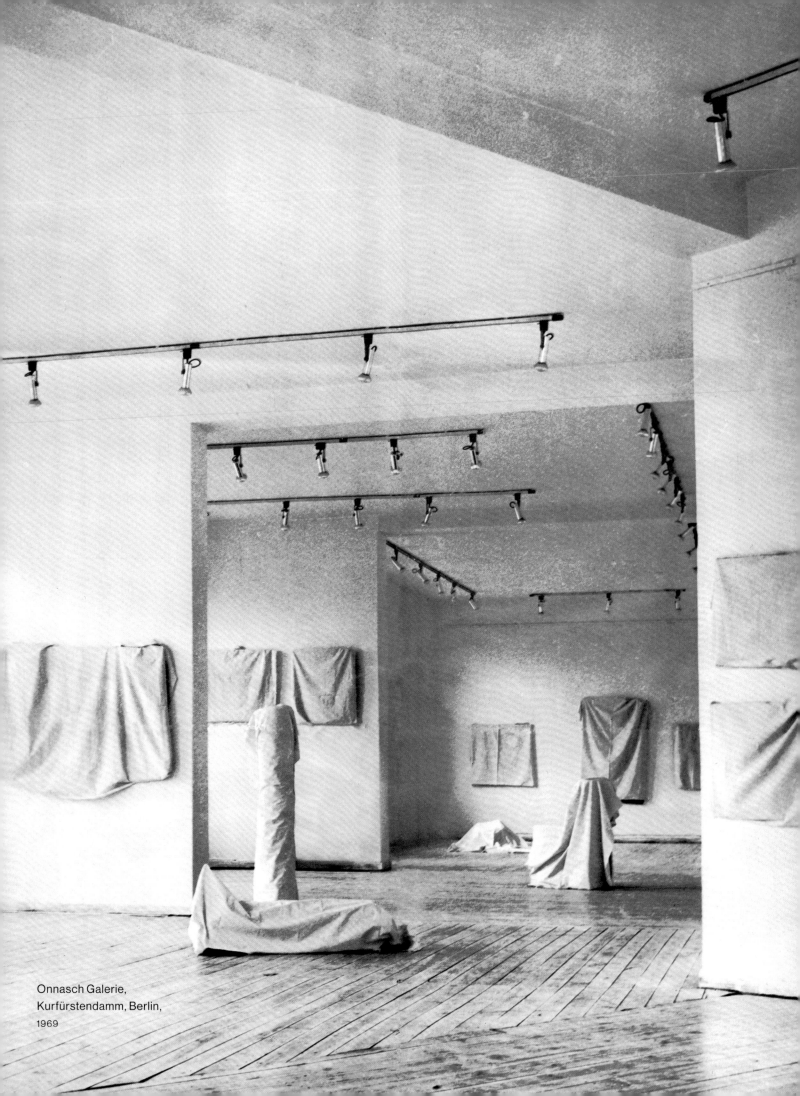

Onnasch Galerie,
Kurfürstendamm, Berlin,
1969

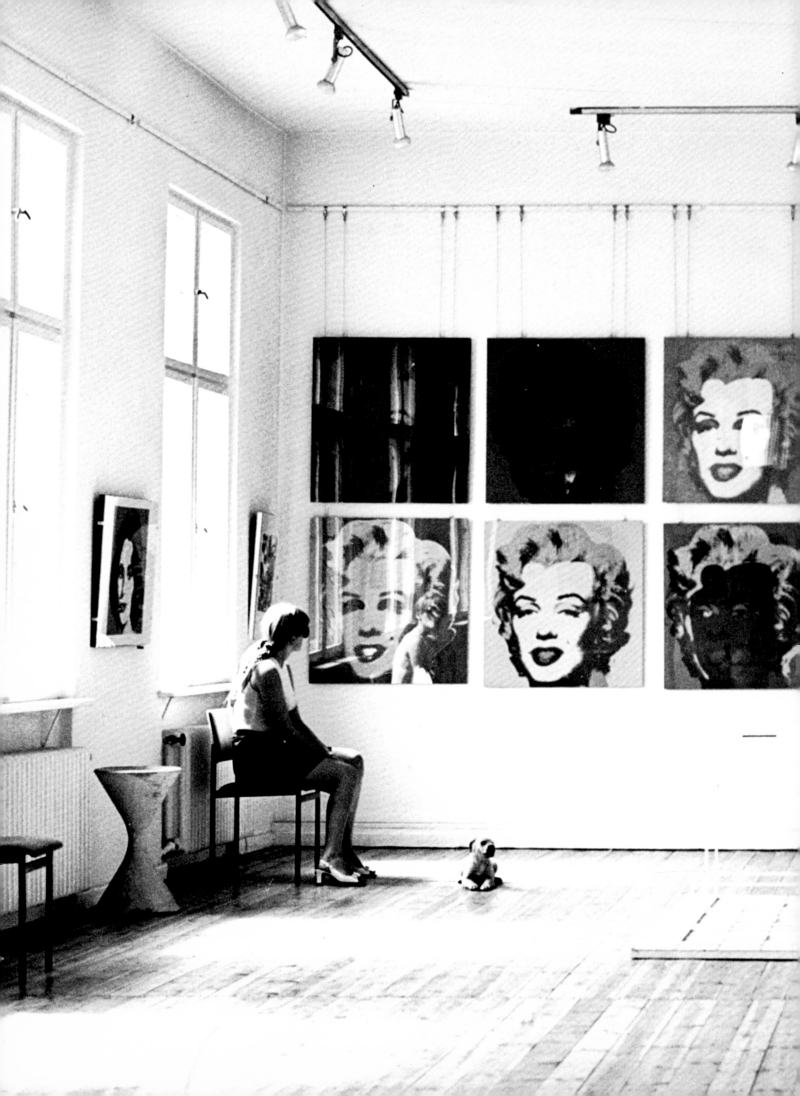

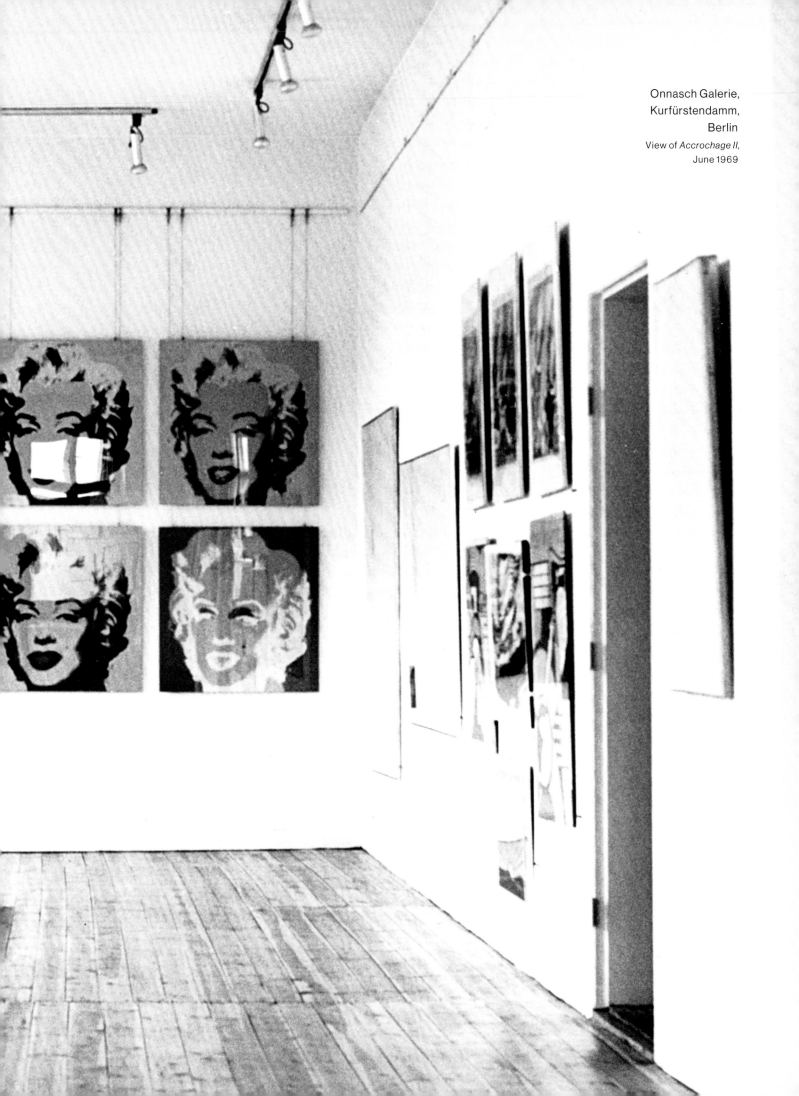

Onnasch Galerie,
Kurfürstendamm,
Berlin
View of *Accrochage II,*
June 1969

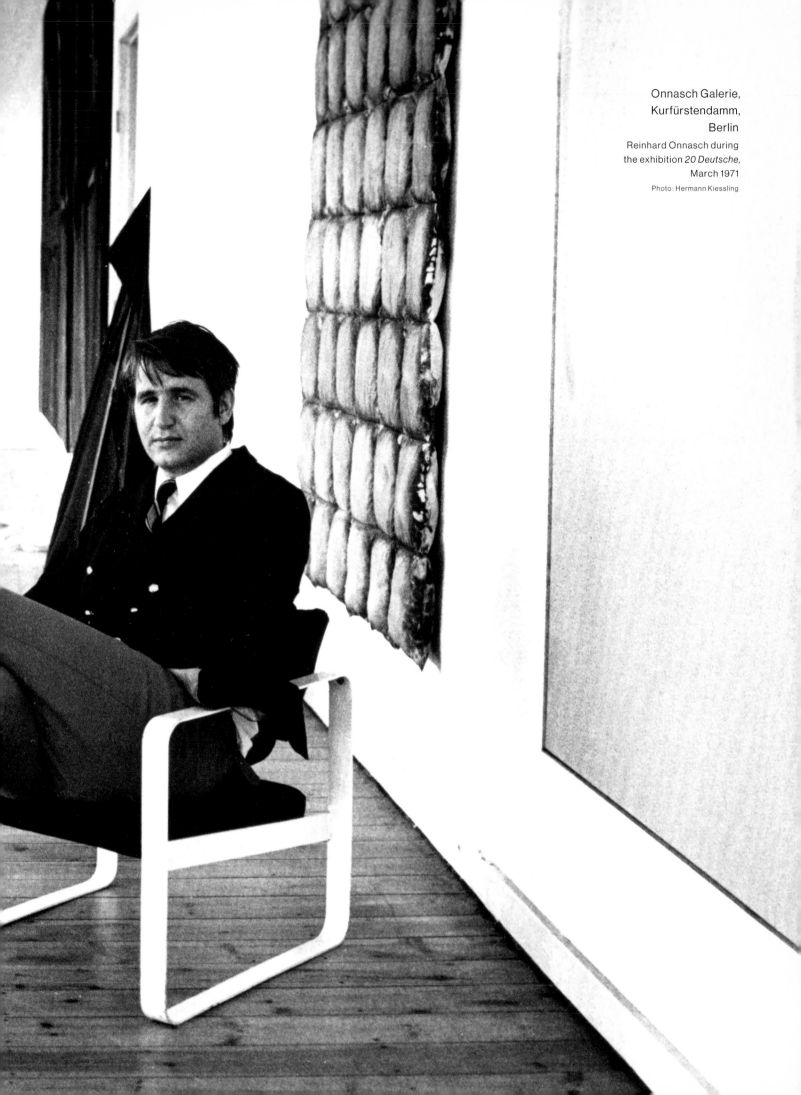

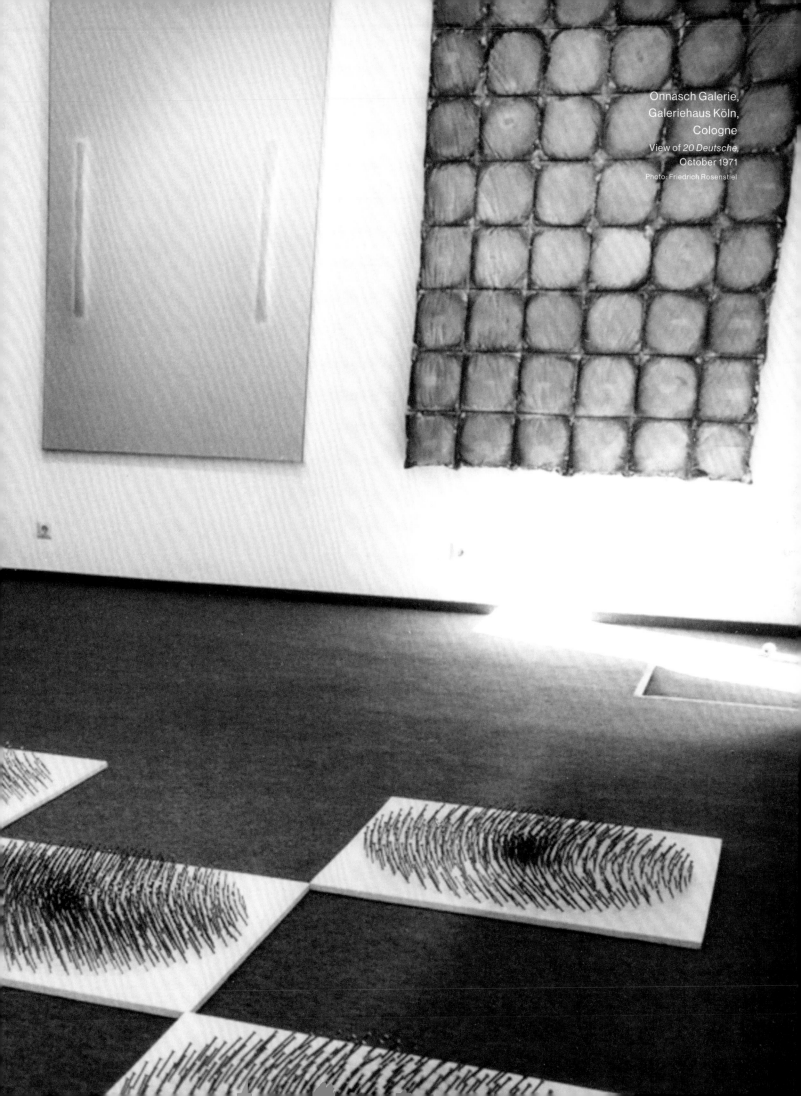

Onnasch Galerie,
Galeriehaus Köln,
Cologne
View of *20 Deutsche*,
October 1971
Photo: Friedrich Rosenstiel

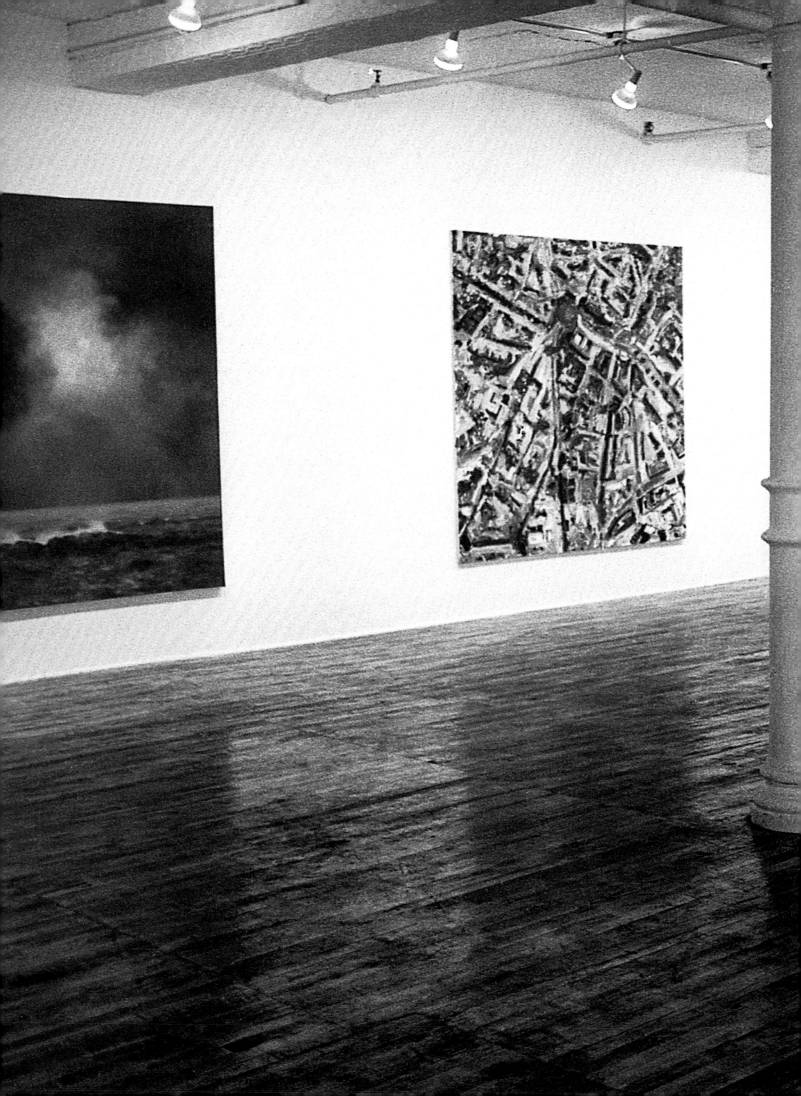

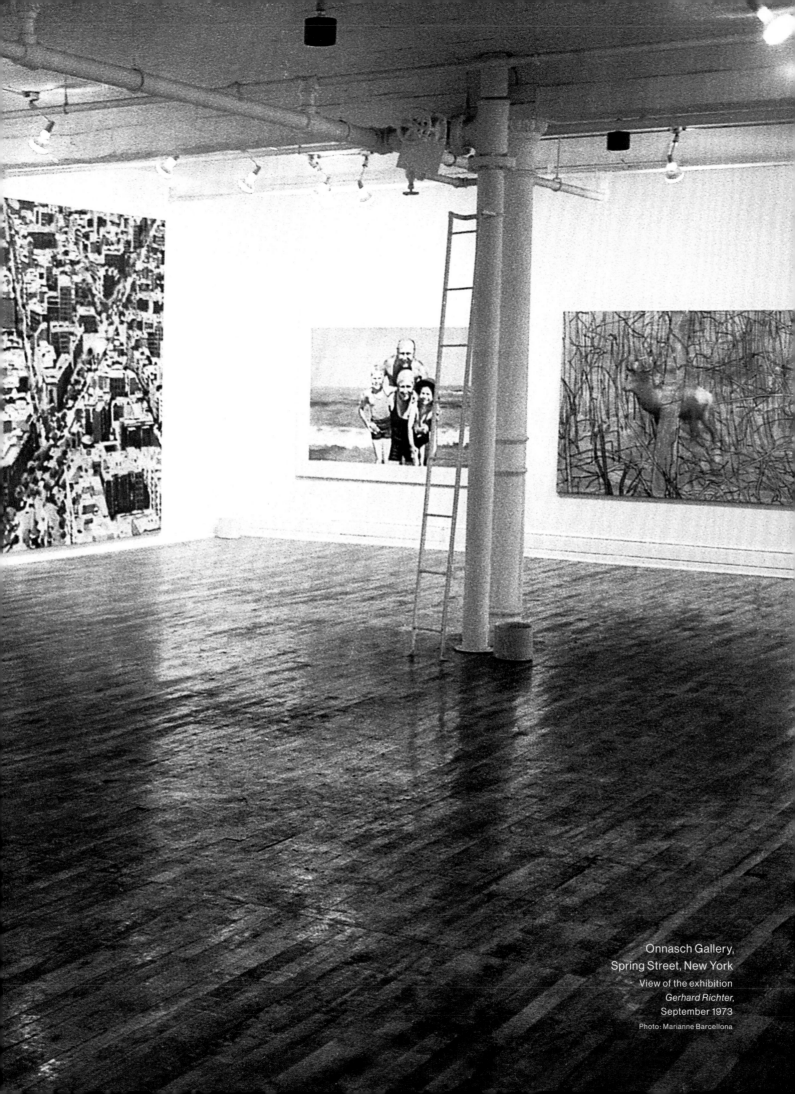

Onnasch Gallery,
Spring Street, New York
View of the exhibition
Gerhard Richter,
September 1973
Photo: Marianne Barcellona

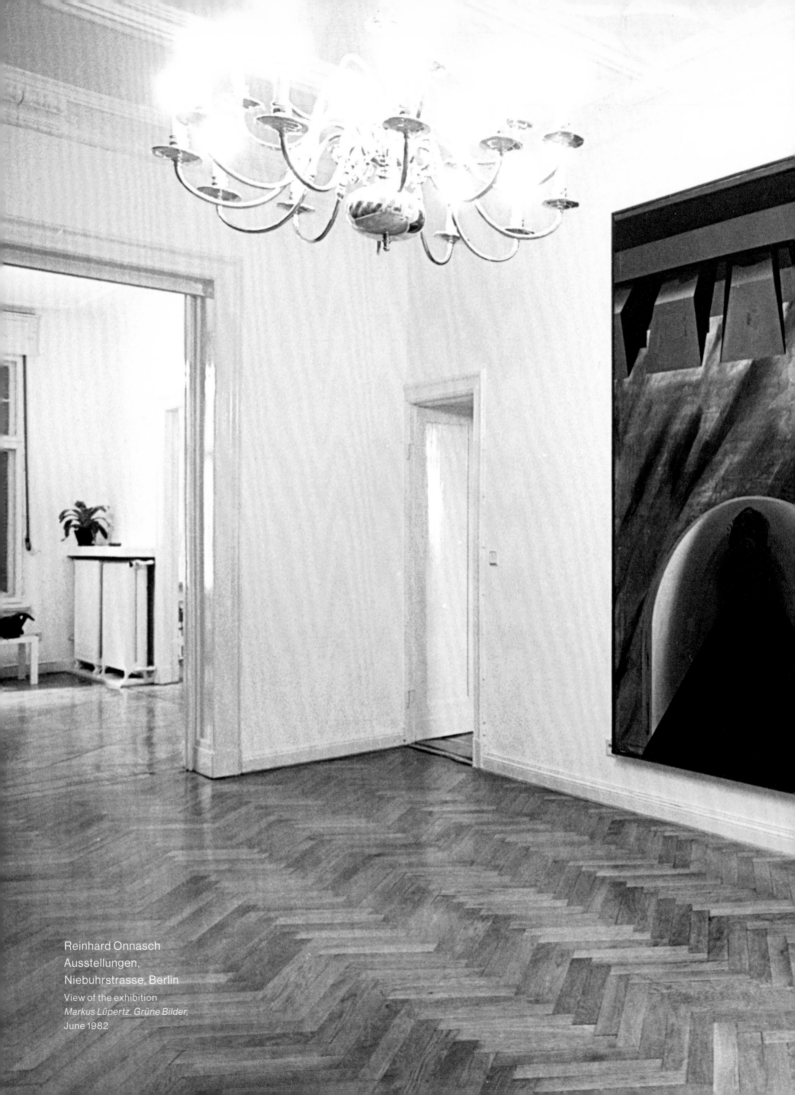

Reinhard Onnasch
Ausstellungen,
Niebuhrstrasse, Berlin

View of the exhibition
Markus Lüpertz. Grüne Bilder,
June 1982

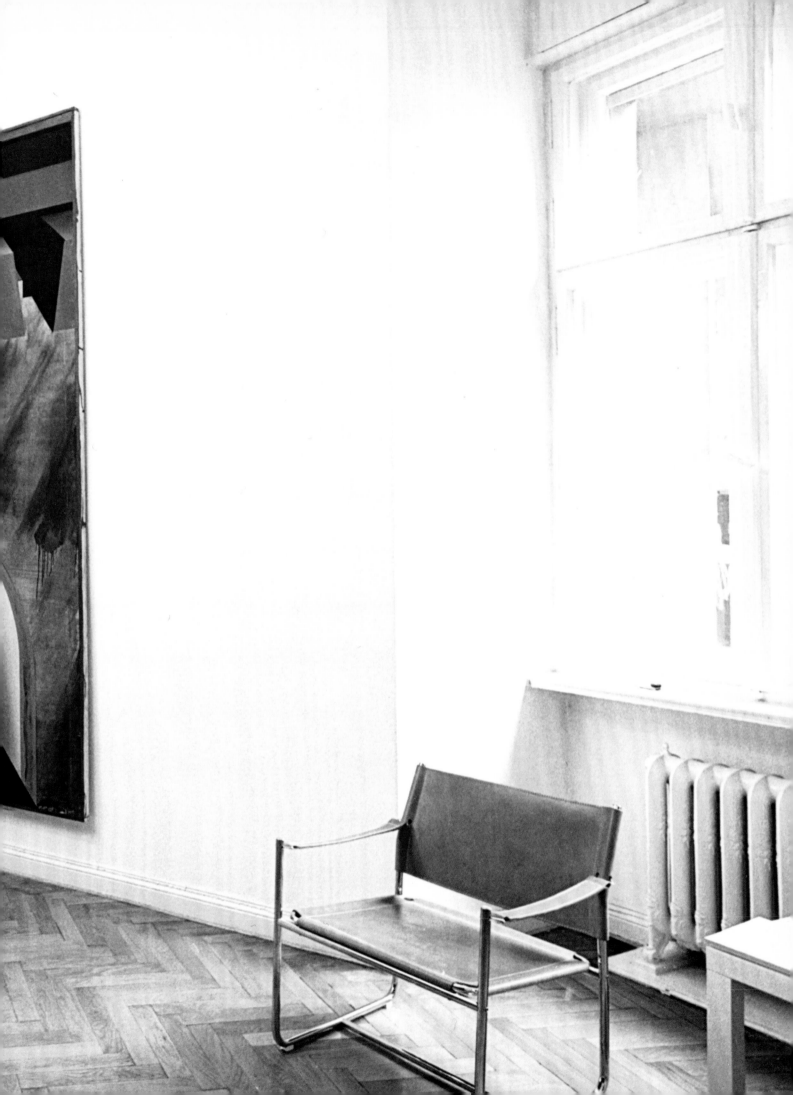

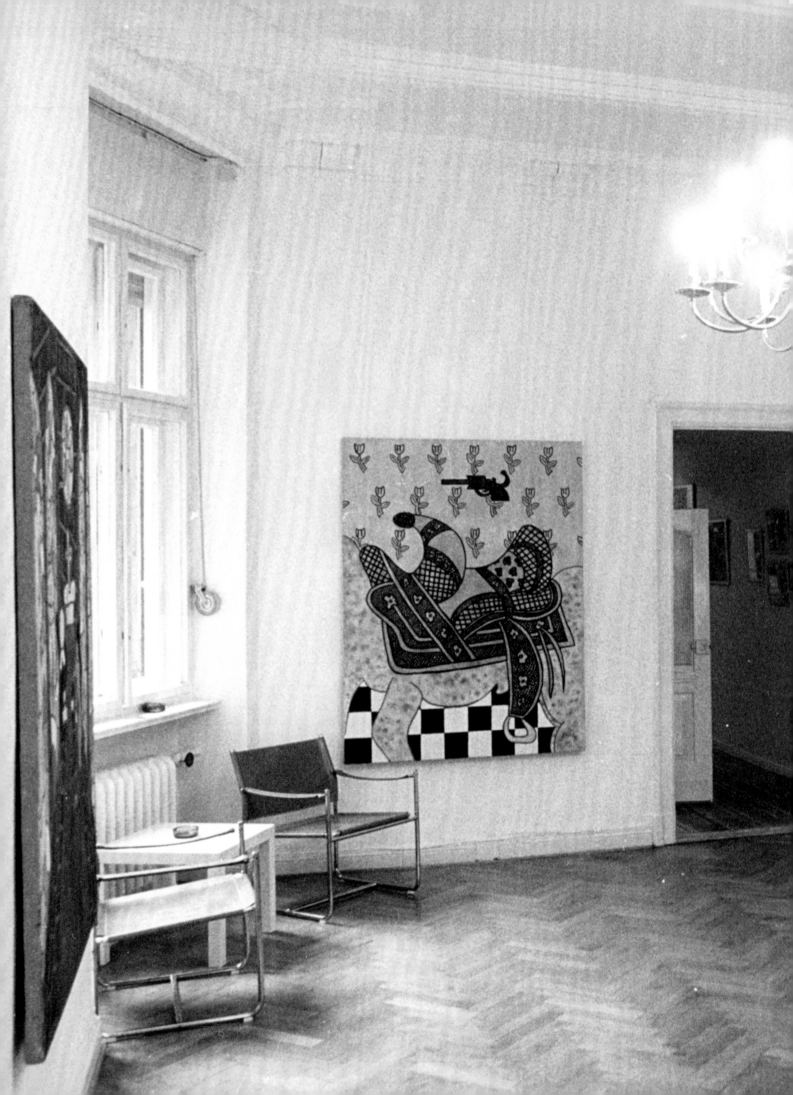

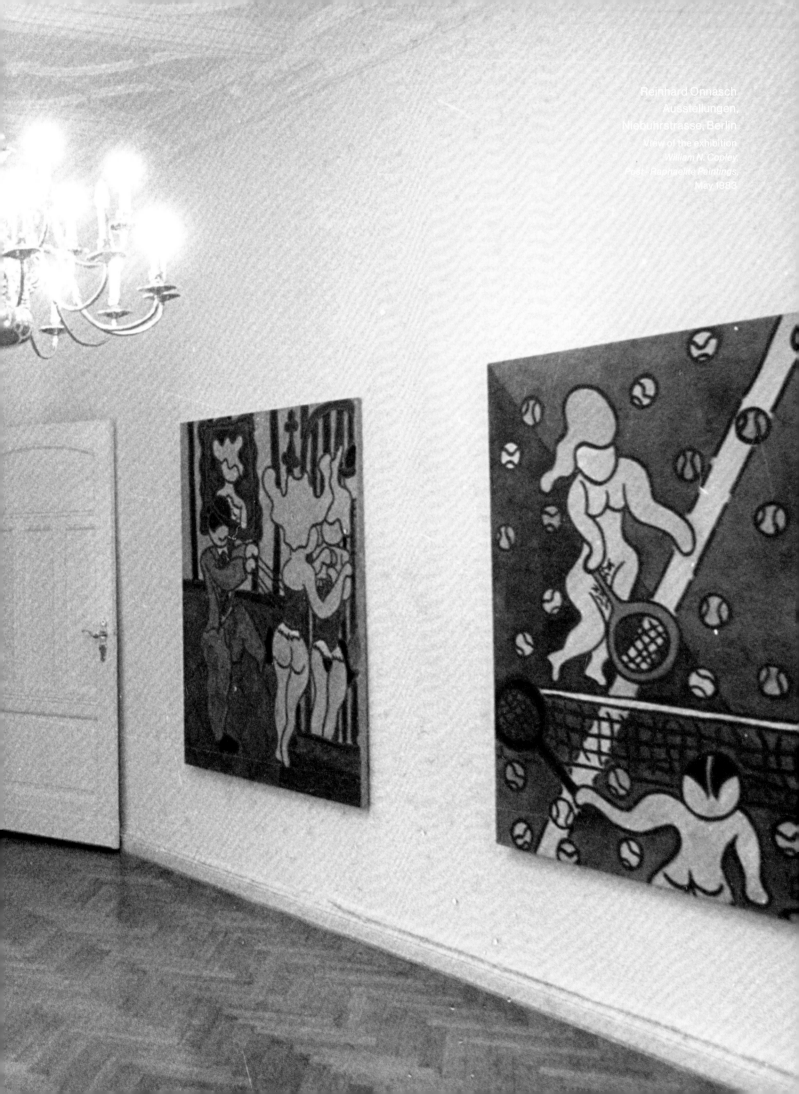

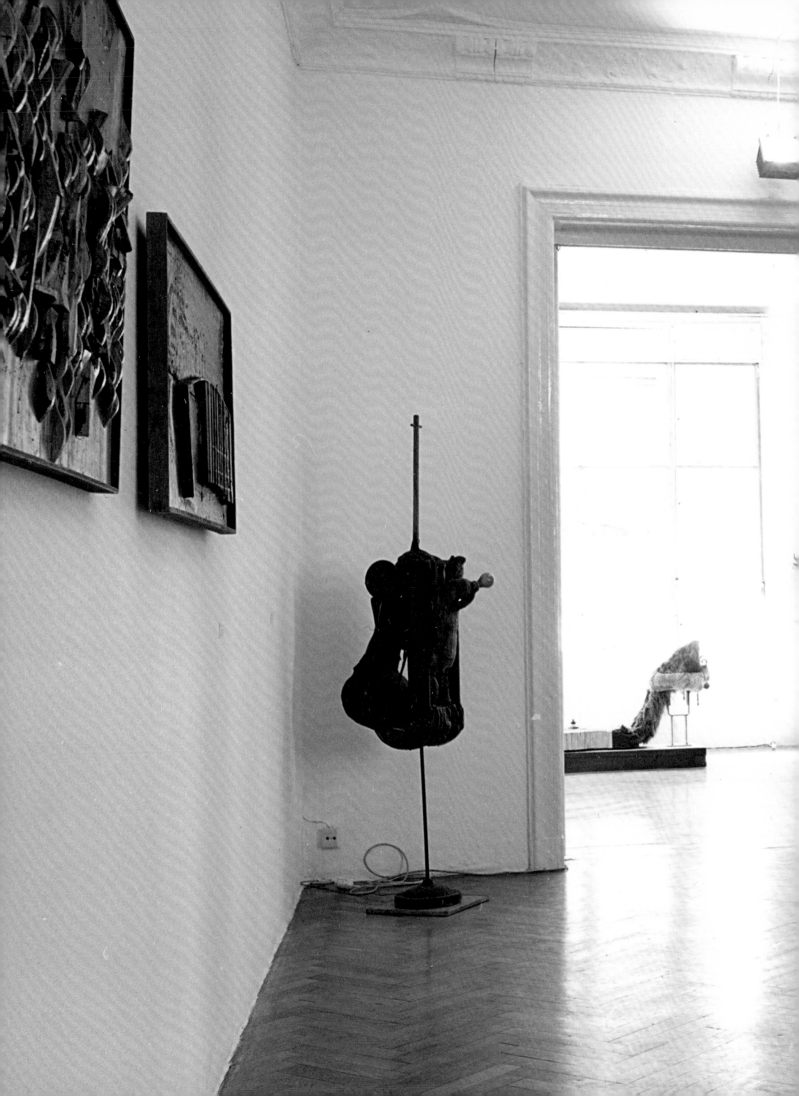

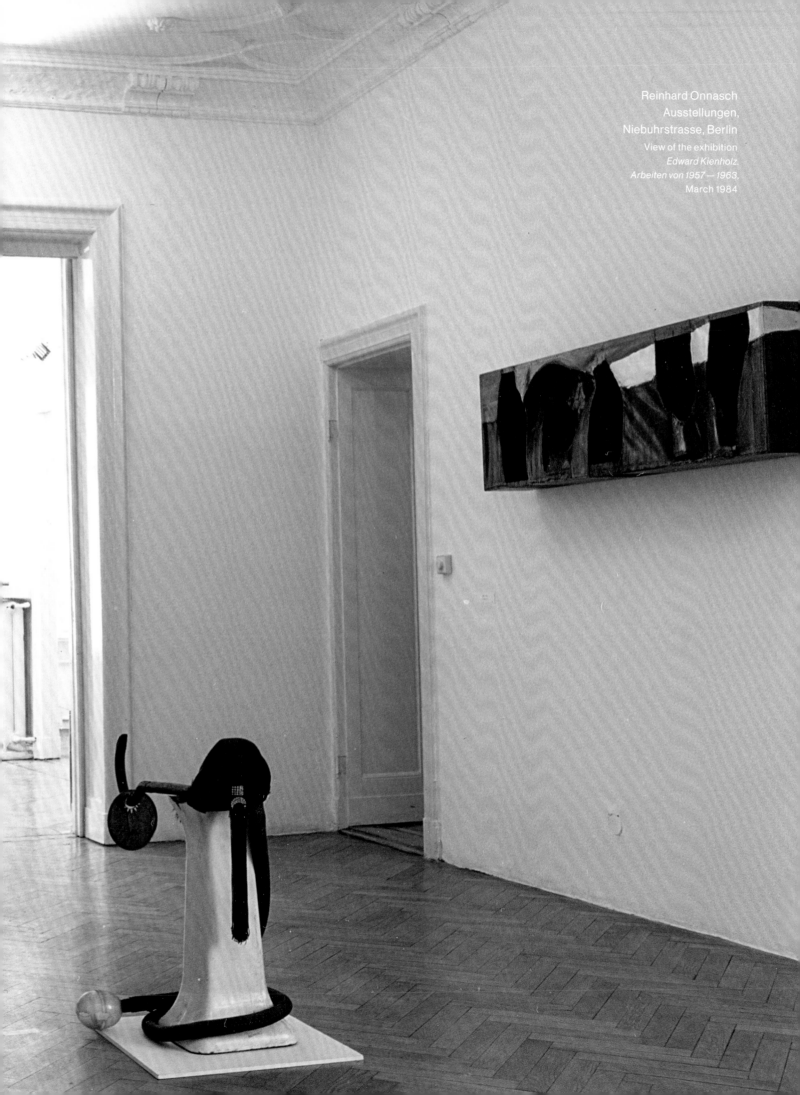

Reinhard Onnasch
Ausstellungen,
Niebuhrstrasse, Berlin
View of the exhibition
*Edward Kienholz.
Arbeiten von 1957 — 1963,*
March 1984

Re—View
Onnasch
Collection

Snoeck

This book has been published
on the occasion of the exhibition

Re—View: Onnasch Collection

Hauser & Wirth London
20 September — 14 December 2013

Curator
Paul Schimmel

Project coordination
Sara Le Turcq
Jessica Green

Production
Michael Kruger
Rowena Paget
Samantha Smith–James
Rob Eagle
Lidiane Delfanne

Hauser & Wirth New York
8 February — 12 April 2014

Project coordination
Barbara Corti
Jessica Green

Production
Michael Hall
Lauren Murphy
Jeff Bechtel
Tamar Nahmias
Maria Brassel

Re—View: Onnasch Collection

First published in 2014

Editors
Paul Schimmel
Michaela Unterdörfer

Research and editing
Michaela Unterdörfer
Gesine Tosin
Louise Buermann
Stefan Zebrowski–Rubin
Aryn L. Conway
Suzanne Gerber

Photography
Installation views of the
exhibition at Hauser & Wirth London
and documentation of the artworks:
Alex Delfanne
Names of photographers are
given where known.

Translations
Russell Stockman

Copy editing
Aryn L. Conway
Rachel Julia Engler
Hans–Jörg Huhn

Book design and typesetting
Patrick Roppel

Production
Snoeck Verlagsgesellschaft mbH, Cologne

Cover (tipped–in print)
Reinhard Onnasch during the exhibition
of works from his collection at the
Neue Nationalgalerie Berlin, February 1978
(with *Brighter than the Sun*, 1962 by James Rosenquist
and Robert Rauschenberg's *Pilgrim*, from 1960)
Photo: Benjamin Katz

If not otherwise noted source images and documents are
from the Onnasch Collection Archive. All source
images and original objects, such as invitations, posters,
books, and press clippings have been photographed
and / or scanned and are courtesy of the Onnasch Collection
unless otherwise indicated.

For certain materials reproduced herein, the editors
have been unable to trace the copyright holders and would
appreciate notification of such information for
acknowledgment in future editions of this publication.

Contents

Acknowledgments

The editors and Hauser & Wirth would
like to express gratitude to Reinhard and Ute
Onnasch for opening their collection
to us and for their blessing in the production
of this exhibition and its accompanying
publication.

Our gratitude, also, to Gesine Tosin, and
Wolfram Gabler, for their invaluable support
and knowledge.

We want to thank photographers
Friedrich Rosenstiel, Cologne;
Benjamin Katz, Cologne;
Marianne Barcellona, New York;
Stephan Janz, Berlin;
and Gunter Lepkowski, Berlin, who have
contributed so much of this catalogue's
compelling historical imagery.

Our appreciation extends to the individuals
and organizations listed below for
providing access to their archives, as well as
a wealth of archival material and historic
information: Folker Skulima, Berlin;
Nancy Reddin Kienholz and Sherry Witcraft;
Peter Goulds and Lisa Jann, L.A. Louver;
Richard Jackson and Alberta Mayo;
Prof. Dr. Herzog and Brigitte Jacobs van
Renswou, Zentralarchiv des internationalen
Kunsthandels e.V. ZADIK, Cologne;
Beate Ebelt, Zentralarchiv, Staatliche Museen
zu Berlin — Preussischer Kulturbesitz;
Jan Böttger and Norbert Ludwig, b p k, Bild-
agentur für Kunst, Kultur und Geschichte, Berlin;
Esther Siegmund–Heineke, Ulmer Museum,
Ulm; Susanne Jez, Städtisches Museum
Abteiberg; Sandra Hampe, Gesellschaft für
Aktuelle Kunst, Bremen; Thomas Deecke,
Berlin; Peter Friese and Dietrich Reusche,
Neues Museum Weserburg Bremen;
Èric Jiménez Lozano, Centre d'Estudis
i Documentació, Museu d'Art Contemporani
de Barcelona; Isabel Koehler, Biblioteca/
Library, Serralves; Ulf Küster and Tanja Narr,
Fondation Beyeler.

We are indebted to the following for reprint
permissions: Peter Hans Göpfert, Berlin;
Ernst Busche, Berlin; Kunstforum
International; Christine Breyhan, Bremen;
Rainer Höynck, Berlin; Thea Herold and
Katrin Wittneven, Berlin; and for
reproduction permissions: Konstanze Ell,
Atelier Richter; Bailey Harberg, Clyfford Still
Museum; Oldenburg van Bruggen
Studio; Ann M. Garfinkle and Renee Osburn;
Mariagiulia Numis, and Studio Gianni
Piacentino.

Preface

Although it is one of the most significant collections of artwork from the nineteen–sixties, the Onnasch Collection has, until recently, been virtually unknown outside Europe. Many of its highlights were first presented to the public at the Berlin Nationalgalerie in 1978 and, since that time, selections of work have been exhibited in museums and exhibition spaces both in Germany and neighboring countries. Now, for the first time, works from this important collection have been brought together in inaugural exhibitions in Britain and the United States.

Reinhard Onnasch was born in Germany in 1939. In 1969, he opened his first gallery in Berlin, where he still lives today, and, two years later, expanded his activities to Cologne, where he rented gallery spaces in what was, at that time, a booming center for art. In 1973, he opened a gallery in New York, and was one of the first German art dealers to do so postwar. He originally focused on introducing German artists to American audiences, but Onnasch also came to champion a large number of American artists from both the East and West Coast of the United States. He was among the first advocates of the Californian artist Edward Kienholz, for example, and many of Kienholz's most significant early works became part of the collection Onnasch began to assemble in the late sixties.

This publication presents the first in–depth historical study of Reinhard Onnasch's activities as a gallerist, art dealer, publisher, and collector. Its chronological overview presents a wealth of previously unpublished documents, archival material, and photographs and includes, for the first time in English, translations of several interviews previously published in conjunction with earlier exhibitions. These conversations reveal the passion and dynamism Onnasch exerted in his life and work, the qualities that allowed him to build his remarkable collection.

We are pleased to present this catalogue, which marks the exhibition of this collection, as *Re—View: Onnasch Collection,* presented at Hauser & Wirth London in the fall of 2013 and, the following year, at the gallery's New York space. The presentation focuses on the period between 1950 and 1970, an era that saw the emergence of some of the twentieth century's most important artistic movements: Pop Art, Fluxus, Colorfield, Assemblage, Minimalism, and the New York School's Abstract Expressionism. Bringing together works by George Brecht, Jim Dine, Claes Oldenburg, Clyfford Still, Barnett Newman, Dan Flavin, Richard Serra, and Hanne Darboven, the show exemplifies Onnasch's open–minded and exploratory approach to collecting, exhibiting the provocations, confrontations, and rapid succession of competing movements that define the sixties.

Paul Schimmel Michaela Unterdörfer

Introduction

The Onnasch Collection is a crucial link in a chain of legendary collections formed by art dealers during the twentieth century. In particular, the post–World War II era has been distinguished by a group of remarkable men and women, whose collecting activities profoundly shaped their influence and initiatives in the art world. In the United States, important collections formed by dealers such as Peggy Guggenheim, Martha Jackson, Sidney Janis, Ileana Sonnabend, Virginia Dwan, Arne Glimcher, and Larry Gagosian have enriched and, on the occasion, defined public institutions. Similarly, in Europe, such collections have enhanced some of the most respected museums. Consider, for example, the collections of Heinz Berggruen, Ernst Beyeler, and Yvon Lambert as well as the extraordinary activities of Anthony d'Offay.

To this list, one must add Reinhard Onnasch, who has assembled an exceptional collection embracing major movements of the second half of the twentieth century — a collection that is as wide-ranging geographically as it is aesthetically. Not only does this collection include exceptional trophies by individual artists, but it also possesses unparalleled depth in certain areas that rivals — and in some cases outrivals — the collections of public institutions. For Onnasch, collecting no doubt changed his life profoundly by cultivating his aesthetic vision as well as by fostering friendships that superseded ephemeral and mundane practicalities.

Onnasch's collection is more well-known today than his important, but in some ways ill-timed, activities as an art dealer. After opening a gallery in Berlin in the late 1960s, he opened another space in Cologne and then operated yet another space in New York from 1973 to 1975. His foray into New York took place during a period when the city was undergoing a severe financial collapse and when the art market, which had been exceptionally active during the 1960s, was retreating into a relatively dormant period. Yet, in this difficult context, Onnasch succeeded in presenting major exhibitions. The inaugural show was the first one-person exhibition of Gerhard Richter's work in the United States. Though this exhibition did not achieve commercial success — resulting in only a single sale — in retrospect, the difficulties Onnasch faced as an art dealer transpired to be advantageous to his position as a collector. Thus, while the gallery faced economic hardship, Onnasch's collection continued to grow. Whether this was by luck or by guile, he seemed open to chance and willing to make a passionate bet.

Among the many artists represented in the Onnasch Collection, the holdings of works by Clyfford Still and Edward Kienholz are particularly outstanding. One could argue that Still, an outsider of the New York School, was the ultimate father of Abstract Expressionism. His most significant artistic development occurred while he was living in California and Virginia in the 1940s. By the time he moved to New York in 1950, he had become one of the most advanced artists of his generation, which included Mark Rothko, Barnett Newman, Jackson Pollock, and Willem de Kooning. During his lifetime, Still sold only about one hundred paintings; Onnasch owned more than ten. The fact that Onnasch owned the largest private collection of Still's work is a remarkable testament to his tenacious belief in the artist and, perhaps, reveals the special affinity he felt with a pioneering spirit not unlike his own.

From a West Coast perspective, Kienholz's move from Los Angeles to Berlin in the early 1970s, made with great fanfare during the heated political climate of the Vietnam War era, made Onnasch legendary not just as a dealer and a collector, but as someone who was an incubator of both artists and art. Kienholz was a curator, dealer, promoter, huckster, and most importantly, an exceptional sculptor of life's tableaux. He chose to leave his beloved Los Angeles at a time when art, politics, and the economy were on a collision course in the context of the complete collapse of America's manifest destiny amidst the failure of the war. He made works that dealt uncompromisingly with this difficult historical climate — works that found a home with Onnasch. Indeed, if the Onnasch Collection has in one respect been assembled as if it were a public institution, it has also been formed as a home, a place of sanctuary, for the art and artists of Reinhard Onnasch's time.

Paul Schimmel

Editorial Note

This chronology outlines Reinhard Onnasch's exhibitions, held in his Berlin, Cologne, and New York galleries between 1969 to 1975 and, following the reopening of the gallery in Berlin, from 1982 to 1987.

The Onnasch Collection, first assembled in the nineteen–sixties, has been shown in various exhibition venues and museums in Germany and throughout Europe since the late seventies. This historical outline includes all group and solo exhibitions composed exclusively or primarily of works from the Onnasch Collection. Permanent loans from the collection to museums and exhibition venues are listed only when related to a special exhibition or publication.

A few dates in the exhibition listing remain incomplete and cannot be definitively determined, as no comprehensive archive of the gallery and collection survives. When exhibition dates are uncertain or only approximate, only the month or year is given. The gallery's participation in the various fairs in Berlin, Cologne, and Basel are not listed separately. The chronology has been compiled with the use of exhibition catalogues, newspaper clippings, and invitation cards, all of which Reinhard and Ute Onnasch have kindly placed at our disposal.

The installation views, as well as photographs of openings and other events at the various gallery and collection venues, especially those by Friedrich Rosenstiel, in Cologne, and Marianne Barcellona, in New York, have been indispensable aids in the reconstruction of the exhibition history. Most of this pictorial material is published here for the first time.

Gesine Tosin is responsible for the texts, picture selection, and exhibition list related to the Onnasch Gallery's New York incarnation. Her research on the artists, exhibitions, and events presented will be published in her forthcoming publication *139 Spring Street, NYC* by the Museo Nacional Centro de Arte Reina Sofia, Madrid. In her work, she consulted Marianne Barcellona's extensive picture archive. We are extremely grateful to Gesine Tosin for allowing us the use of her research for this catalogue.

Michaela Unterdörfer

Chronology

Berlin
1969 — 1971
Onnasch Galerie
Kurfürstendamm 62
Berlin

In early 1969, realtor and developer Reinhard Onnasch opened a gallery in Berlin. He rented a 510–square–meter space on the fifth floor of an imposing old building on the Kurfürstendamm, in what was then West Berlin.

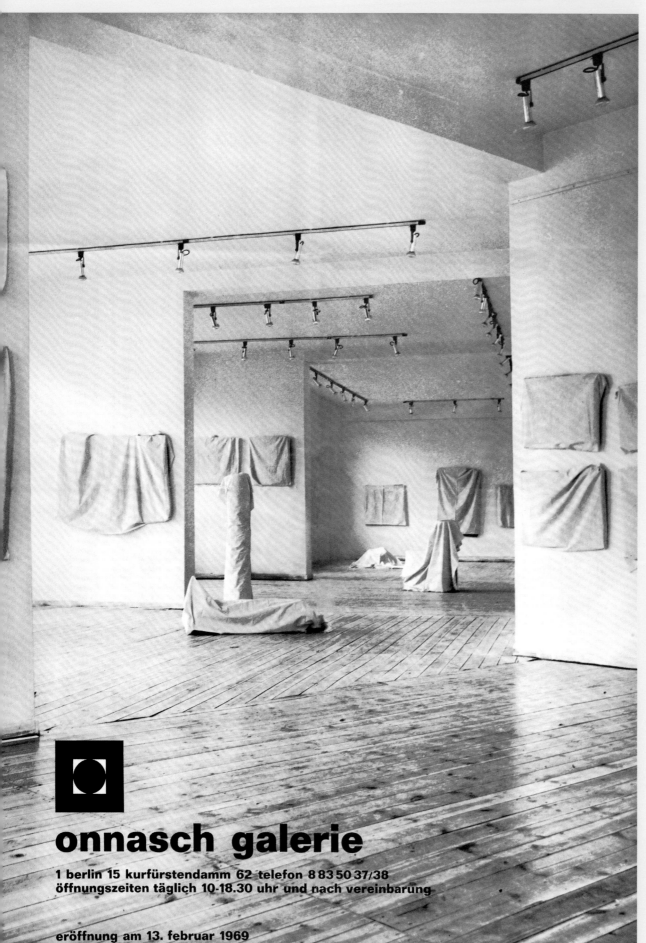

onnasch galerie

1 berlin 15 kurfürstendamm 62 telefon 8 83 50 37/38
öffnungszeiten täglich 10-18.30 uhr und nach vereinbarung

eröffnung am 13. februar 1969

Poster (recto),
1969

Archive:
Folker Skulima

onnasch
galerie

onnasch galerie
1 berlin 15
kurfürstendamm 62
telefon 8 83 50 37 / 38

eröffnet am
13. februar
mit einer
accrochage 1909/1969
(internationale
künstler in
deutschlands größter
galerieetage)

am gleichen tag
eröffnet
um 22 uhr die
onnasch nachtgalerie
in der
grolmanstraße 53
telefon 31 81 95

die nachtgalerie
bringt kunst
aller aktuellen
richtungen
in laufenden
einzelausstellungen

zur eröffnung
paintings and
kinetics
bill culbert
london

antes
arakawa
bargheer
baumeister
bea
beckmann
bellmer
berrocal
bissier
bocola
braque
bremer
brummack
campigli
lourdes castro
chagall
christo
cuixart
dali
dawson
delaunay
ernst
faber
firmans
francis
gabino
haase
heckel
heider
hockney
hundertwasser
ikewada hundertwasser
jacob
janssen
jones
kieselbach
klasen
knispel
lattanzi
lemcke
lichtenstein
lucht
macke
maether
maibaum
marini
masson
meckseper
meyer
micus
millares
miro
moore
münter
nasner
nay
oldenburg
paolozzi
pelzer
pfahler
poliakoff
quinte
man ray
raysse
reindel
ruden
schlotter
schultze
schwitters
schwoerer
segui
serpan
polk smith
tapies
teppeser
trökes
vostell
warhol
wesselmann
wintersberger
wunderlich
zimmermann

warhol 3oo dm chagall 32oo dm sonderborg 58oo dm miro 11oo dm cuixart 38oo dm maether 3oo dm pelzer 15oo dm

moore 95o dm ernst 38 ooo dm braque 6oo dm poliakoff 65oo dm wesselmann 45oo dm dali 4oo dm

macke 95oo dm schultze 6ooo dm lichtenstein 33o dm francis 16oo dm schwitters 55oo dm

millares 48oo dm pfahler 25oo dm oldenburg 215o dm man ray 48o dm münter 13 5oo dm hundertwasser 9oo dm

steinberg 3oo dm haase 25oo dm christo 58oo dm jones 4oo dm baumeister 23 ooo dm jacob 32oo dm

die abbildungen stellen einen ausschnitt aus unserem angebot dar. sie wurden nur mit namen des künstlers und verkaufspreis getextet. interessieren sie sich für nähere einzelheiten, so erklären wir sie ihnen gern bei ihrem galeriebesuch.

— Accrochage I

Onnasch Galerie, Kurfürstendamm, Berlin
February 12 — March 1969

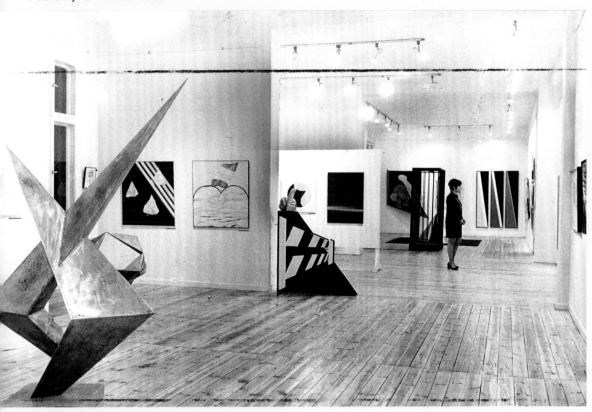

View of
Accrochage I,
February 1969
Photo:
Nina von Jaanson

The Onnasch Galerie's inaugural exhibition, *Accrochage I,* opened on February 12, 1969. The gallery presents an extensive number of paintings, sculptures, graphics, drawings, and objects by Max Ernst, Willi Baumeister, Kurt Schwitters, Ernst Heckel, Max Beckmann, Serge Poliakoff, and Joan Mirò, together with works by contemporary artists including Christo, Bernard Schultze, Horst Antes, David Hockney, Tom Wesselmann, Roy Lichten–stein, Cy Twombly, and Andy Warhol, amongst others.

In its review of the exhibition, published in the summer of 1969, the weekly *Der Stern* described the gallery's opening as that of "Germany's largest gallery space" and a "supermarket of Modern art."

In its first years, the gallery's program is multifaceted and hetero–geneous, presenting a large number of works by a variety of artists. *Accrochage I* is followed by three additional *Accrochages,* exhibitions, each featuring a broad spectrum of artists, from Ger–man Expressionism to British and American Pop Art. The list of artists presented reads like a history of art from Modernism to the present, including Max Pechstein, Max Beckmann, Max Ernst, Richard Hamilton, Allen Jones, Robert Rauschenberg, Roy Lichtenstein, Jim Dine, Shusaku Arakawa, Tom Wesselmann, Gotthard Graubner, Gerhard Richter, Cy Twombly, Christo, David Hockney, and Andy Warhol. The press describes the exhibition as an "impressive, internationally structured dis–count offering."

Reinhard Onnasch,
April 1971
Photo: Manfred Tischer

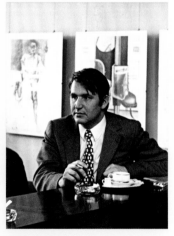

"When I first opened a gallery in Berlin, in 1968 [sic], I only had a relatively vague notion of the whole endeavor, not only about what I wanted to do in this gallery, but also about the art trade and contemporary art itself. What mattered, at the time, was doing something besides the dull business of building apartment houses, with which I had first hoped to get rich."

(Reinhard Onnasch in conversation with Dieter Honisch, from the catalogue for the exhibition *Aspekte der 60er Jahre,* Nationalgalerie Berlin, 1978, p. 7)

29

— ## Accrochage II

Onnasch Galerie, Kurfürstendamm, Berlin
June 4 — August 31, 1969

— ## Accrochage III

Onnasch Galerie, Kurfürstendamm, Berlin
September 16 — November 30, 1969

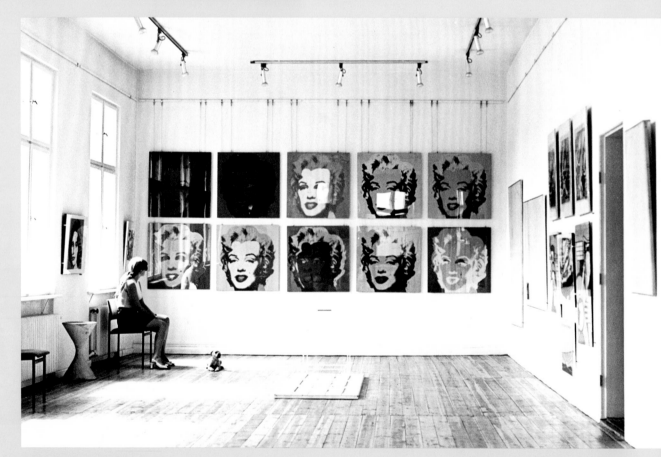

View of the opening,
with works by
Roy Lichtenstein, 1969
Photo: Ludwig Binder

View of
Accrochage II, with
silkscreen prints of
Andy Warhol's,
Marilyn Monroe,
1967; June 1969

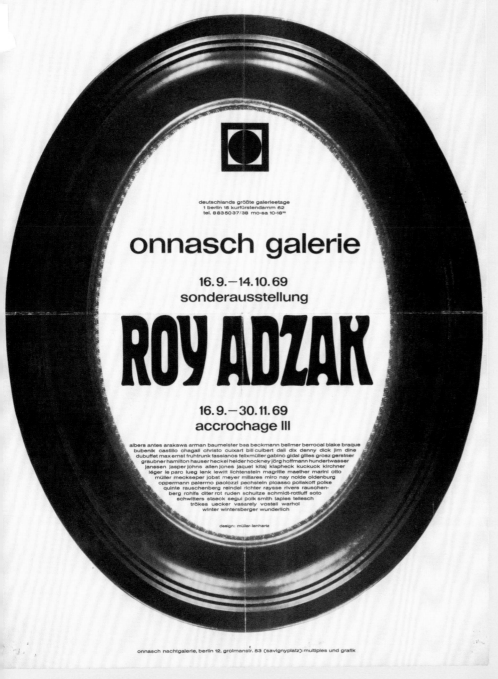

Poster,
1969

Onnasch, a partner in a real estate and development firm, clearly anticipated what was happening in West Berlin and, early on, recognized the importance of and potential for fine art in the city's development: that it might serve both as a cultural asset and an investment for private collectors. As a businessman who, from the beginning, welcomed the planned expansion of the Nationalgalerie, Onnasch was fascinated by the notion of art as a commercial article.

Today, Onnasch describes the opening of the Neue Nationalgalerie in 1968 as not only an important experience but also a decisive one; he credits the event with inspiring him to open a gallery of his own. The Neue Nationalgalerie was the last of Ludwig Mies van der Rohe's buildings to be realized during his lifetime and, with its minimalist form and steel roof, is an icon of modern architecture.

Onnasch soon secures Folker Skulima, who had previously owned a gallery in Spain, to serve as both a partner and director. Skulima advises him in the selection of works and artists, and helps acquire the works shown in the Onnasch Galerie's first *Accrochage* and in other, later exhibitions.

Reinhard Onnasch,
with gallery
director Folker Skulima
and staff, 1969

— Roy Adzak

Onnasch Galerie, Kurfürstendamm, Berlin
September 16 — October 14, 1969

In addition to the *Accrochage* series, the gallery presents its first solo exhibitions, along with a cabinet–like special room includ–ing graphics by Salvador Dalí, as well as exhibitions separately announced. In September 1969 the Roy Adzak show opens in parallel with *Accrochage III,* and, in December, works by Lucio Fontana are on display.

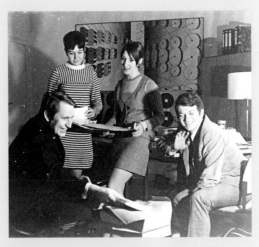

— British Movements '69

Onnasch Galerie, Kurfürstendamm, Berlin
October 10 — December 1, 1969

In October 1969, the gallery opens its first thematic group show, *British Movements,* presenting works of British Op Art in the vein of Bridget Riley. Among the seventeen young artists represented are Alan Green, Roger Dainton, Peter Sedgley, and Philip Vaughan.

Berlin's *Tagesspiegel* publishes a review of the exhibition, entitled "Art as Pure Visual Delight."

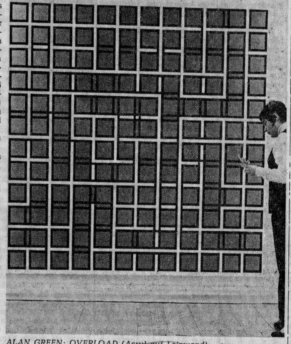

Kunst als reines Sehvergnügen
Junge englische Op-art in der Onnasch Galerie

„Op" ist die Abkürzung für „Optical Art", optische Kunst also. Nun ist im Grunde zwar alle bildende Kunst optisch, weil sie etwas zum Sehen bietet, aber tatsächlich dürfte „Op" noch ein wenig optischer sein, als was man sonst gewöhnlich zu sehen bekommt. Optik hieß ursprünglich die Lehre vom sichtbaren Licht.

Licht ist es dann auch vor allem, was in den „British Movements '69" in der Onnasch Galerie sichtbar gemacht wird, in Arbeiten von 17 jüngeren englischen Künstlern der Op-art-Richtung, die den großen Vorteil hat, daß sie den reinen Sehvorgang (wieder) zum Vergnügen zu machen versteht, und auf deren Nachteil wir noch zu sprechen kommen.

Der Sehvorgang als ein Vergnügen: man betritt den Raum, in dem Philip Vaughan (Künstler) und Roger Dainton (Elektriker) ihre elektronische Plexiglas-Plastik „Maya" aufgestellt haben. Sie besteht aus drei über drei Meter langen Neonröhren, die in Art eines spanischer Reiters angeordnet sind und die in regelmäßigen, auch regelmäßig wechselnden Intervallen einzeln oder zusammen aufleuchten. Der Raum erscheint rot, gelb oder blau, aber dann auch in Mischfarben, blitzartig aufleuchtend. Das Auge nimmt Farbe als Raum auf, und zwar als einen rasch vergänglichen und ersetzlichen.

Das gilt auch für den „Video Disc" von Peter Sedgley, eine mit Fluoreszenzfarbe be-

malte Aluminiumscheibe, die sich in ultraviolettem Licht (nach Geschwindigkeit beliebig einstellbar) dreht und dadurch die überraschendsten Farb-Dreh-Vorgänge auf die überraschte Netzhaut bannt — eine Weiterentwicklung der Rotoreliefs von Duchamp. Im gleichen Raum übrigens ein zwei Meter hoher,

fast quadratischer Rahmen, den man durchschreiten kann. Beim Durchschreiten wird eine elektronische Mechanik ausgelöst, die die Farbe der Neonröhren im Rahmen verändert, rot, blau, grün. Bill Culbert, mit dem Onnasch

ALAN GREEN: OVERLOAD (Acryl auf Leinwand) Photo: von Jaanson

vor rund einem Jahr seine Nachtgalerie eröffnete, zeigt einen Wald aus 12 vertikalen Stangen, an denen jeweils drei Lichtquellen befestigt sind, die den Raum rhythmisch der Dunkelheit entreißen, wobei die optische Reizwirkung erst im nachherein erfolgt, nämlich in dem, was man noch wahrzunehmen glaubt, wenn der Lichtblitz längst vorbei ist.

Aber „Op-art" ist nicht nur in Verbindung mit Kinetik, Bewegung also, möglich. Auf dem Umweg über Geometrie und optische Täuschung hat sie sich auch das alte Tafelbild erobert. Bridget Riley (1931 in London geboren) gilt auf diesem Sektor längst als internationale Meisterin im Verursachen von Augenflimmern. Durch ihre parallel verlaufenden Linien und Farben erzeugt sie illusionäre Bewegungsvorgänge auf der Bildfläche, die den tatsächlich-kinetischen in nichts nachstehen. Abgewandelt wird das durch Tim Armstrong in sechseckigen „Panoramagrammen", die ähnlich wie auf stereometrischen Postkarten ihre Struktur verändern, sobald man selbst eine andere Stellung einnimmt; vorgeklebtes Wellglas sorgt für die notwendige optische Überraschung. Alan Green erzeugt ähnliche Effekte wiederum durch geometrisch angeordnete Formen und Farben mit unvorhergesehenen Farbübergängen in großen Formaten, auf denen sich das Auge wie in einem Labyrinth verliert. Jeffrey Steele verzerrt derartige geometrische Vorgänge auf seinen Leinwänden, die den Eindruck hervorrufen, als ob man sie durch übergroße konvexe oder konkave Linsen betrachten würde.

Ein Außenseiter in diesen Bereichen bleibt Keith Brocklehurst, dessen bewegliche Plastik aus Folie, Motor und — wichtigster Bestandteil: — Luft („Tumulus") drei riesige verschiedenfarbige Nylonsäcke in einem Ablauf von rund 1½ Stunden aufbläst und wieder zusammenfallen läßt, was im Betrachter sowohl Assoziationen an Montgolfiere als auch an Beate Uhse erweckt. Die großzügigen Ausstellungsräume bei Onnasch sind prall voller Leben, gerade weil sie so verhältnismäßig leer bleiben und den optischen Effekten jene Ellenbogenfreiheit geben, die sie brauchen.

Eins ist freilich zuzugeben: Der Gewinn an optischem Sehvermögen wird mit einem gewissen Purismus erkauft, der notwendigerweise dies alles bestimmt. Der Kanon der Op-art ist eng. Fühlt man sich schon bei Culbert an, zum Beispiel, Takis fast zwangsläufig erinnert, so ist Richard Allen der Bridget Riley oft zum Verwechseln ähnlich. Derek Boshiers schöne Dreiecksplastik mit eingebauter Lichtquelle hat den Charakter von Minimal-art, die eine Art von Einfachst-Architektonik anstrebt, und Barry Martins kinetische Skulptur aus Spiegellichtern hat man im Grunde schon oft — von anderen — gesehen. Größe und Grenzen liegen dicht beieinander, dichter eigentlich als sonst in einer Kunstrichtung.

Aber hier geschieht alles auf höchstem Niveau. Sowohl die geometrie-bezogene, nüchtern-lineathafte Seite des Op als auch der dann wieder auf absurde Weise verspielte Schuß Jahrmarktsbudencharakter mit blitzendem Neonlicht kommen hier überzeugend zum Ausdruck. Augenfreude und Augentäuschung gehen hier Hand in Hand. **Heinz Ohff**

(Onnasch Galerie, Kurfürstendamm 62, bis 1. Dezember, Montag bis Sonnabend 10—18 Uhr 30)

DER TAGESSPIEGEL

31. Okt. 69

Die Onnasch-Galerie eröffnete Donnerstag abend eine Ausstellung mit Werken von 16 englischen Künstlern der jüngeren Generation. Die Schau hat den Titel „British Nuvements 69". Sie umfaßt 14 zum Teil kinetische oder luministische Objekte sowie Ölbilder und Siebdrucke. Sie wird bis zum 1. De-

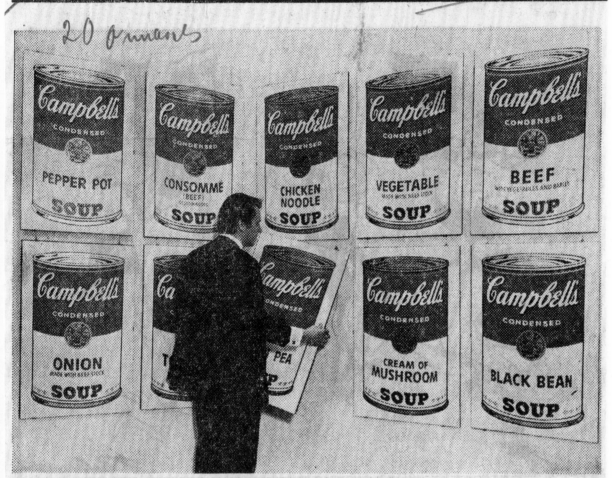

Ansonsten: Patrouillengefechte. Ein orna-
mental-wirkungsreicher Krushenick ficht gegen
ein sensibel farbabgestuftes „Kissenbild" des
Deutschen Gotthard Graubner, der kürzlich in

unter anderem, auch: „Anhaken". Heinz Ohl
(Galerie Onnasch, Kurfürstendamm 62, mit Aus-
nahme der Fontana-Sonderschau bis 31. Januar 1970,
Montag bis Sonnabend 10—18.30 Uhr)

20 prints

ANDY WARHOLS Siebdruck-Reihe täuschend realistisch konzipierter Suppenbüchsen gehört
bereits zum klassischen Bestand der „Popart". Der Galerist Reinhard Onnasch bei der Hän-
gung seiner vierten Accrochage, die wir nebenstehend würdigen. Photo: von Jaanson

Newspaper clipping,
"Gefechte zum Anhaken"
(Struggles to Note),
"Andy Warhol's deceptively
realistic series of prints,
depicting Campbell's soup
cans, was a canonical
work in the history of Pop
Art. Here we see gallerist
Reinhard Onnasch, during
the installation of these
pieces as part of his fourth
Accrochage."
Der Tagesspiegel,
3 December 1969

— Accrochage IV

Onnasch Galerie, Kurfürstendamm, Berlin
December 1969 — January 1970

Following the advice of a marketing agency, Onnasch adopts
publicity–oriented advertising strategies previously foreign to
the Berlin art world. To promote the gallery, he places full–page
announcements in important German daily papers, including
Berlin's *Tagesspiegel* and the *Frankfurter Allgemeine Zeitung*
and exploits the media attention given to the Neue National-
galerie in poster campaigns of its own. The *Tagesspiegel,* which
is distributed in front of the Nationalgalerie, includes an insert
in which the gallery announces that the art "seen here can be
purchased at the Onnasch Galerie on Kurfürstendamm."

In order to appeal to a new class of buyers, the gallery presents a number of exhibitions composed of higher quality, more modestly priced graphics, multiples, and editions. To allow for easier access to art, and its purchase, the gallery also offers buyers the opportunity to pay for their acquisitions in installments or to return works purchased after a year.

Considerable media interest follows this newcomer in discussions related to his art business and novel marketing strategies. German business magazine *Das Capital* publishes a double-page spread under the heading "Modernism as Investment. Art from the Crate," to discuss Onnasch's art offerings.

Inside pages,
"Moderne als Geldanlage.
Kunst aus der Kiste"
(Modernism as Investment.
Art from the Crate),
*Capital — Das deutsche
Wirtschaftsmagazin,*
no. 6, June 1971

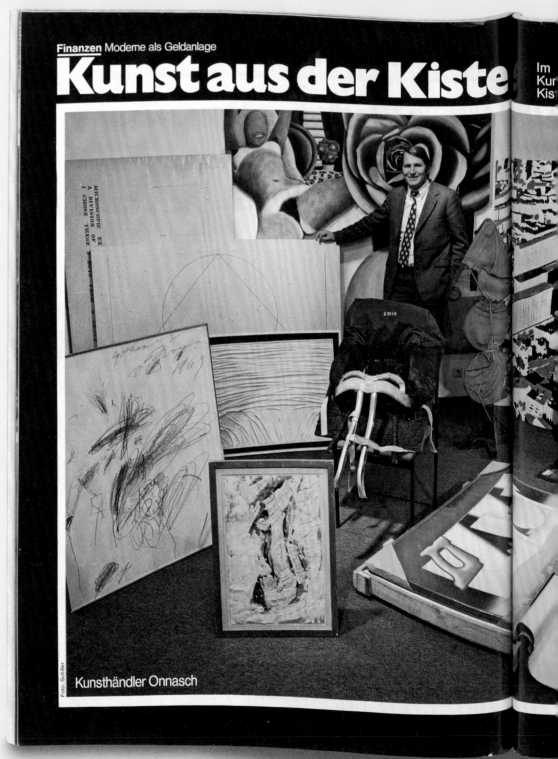

Finanzen Moderne als Geldanlage
Kunst aus der Kiste

Kunsthändler Onnasch

Foto: Schiller

"Cheaper by the dozen and moreover without any foreign ex-
change risk, art dealer and real estate developer Reinhard
Onnasch offers Pop and Op Art by the case as what is perhaps
the most interesting capital investment."

A few critical voices bemoan Onnasch's strategy of "art as
merchandise." The majority of the press praises the gallery's
unconventional business methods, asserting that its "moderate
price structure" will make owning art more democratic.

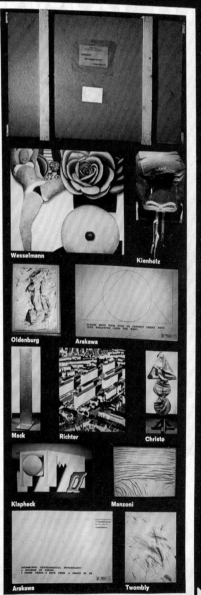

ger und obendrein noch ohne jedes Kursrisiko bietet der
obilienmakler Reinhard Onnasch Pop- und Op-Kunst in der
e wohl interessanteste Kapitalanlage".

Diese Kiste kostet 200 000 Mark

Kisteninhalt	
Wesselmann Zeichnung 200×171	45 000 Mark
Kienholz Objekt 112×56×28	28 000 Mark
Oldenburg Zeichnung 65×49,5	14 000 Mark
Arakawa Gemälde 183×124	9 000 Mark
Mack Objekt 184×31	9 000 Mark
Richter Gemälde 150×180	9 000 Mark
Christo Objekt 80×60	17 000 Mark
Klapheck Gemälde 80×120	32 000 Mark
Manzoni Gemälde 61×81	26 000 Mark
Arakawa Gemälde 183×124	9 000 Mark
Twombly Gemälde 100×81,5	15 000 Mark
Summe	213 000 Mark
./. Kistenrabatt	13 000 Mark
Kistenpreis	**200 000 Mark**

Wesselmann Kienholz
Oldenburg Arakawa
Mack Richter Christo
Klapheck Manzoni
Arakawa Twombly

In 1970, the gallery presents six one—man shows with works by Roland Goeschl, Richard Artschwager, Shusaku Arakawa, Richard Hamilton, Curt Stenvert, and Bob Law.

— Lucio Fontana

Onnasch Galerie, Kurfürstendamm, Berlin
December 1969 — January 31, 1970

— Roland Goeschl
Information, Dokumentation über
1 Jahr Berlin–Aufenthalt

Onnasch Galerie, Kurfürstendamm, Berlin
March 1970

— Richard Artschwager

Onnasch Galerie, Kurfürstendamm, Berlin
April 1970

richard artschwager

geboren 1924 washington. lebt seit 1949 in new york.

ausbildung
cornell university, ithaca, n. y.

einzelausstellungen
1965 leo castelli gallery, new york
1967 leo castelli gallery, new york
1968 konrad fischer, düsseldorf (plbs)
1969 galerie ricke, köln

gruppenausstellungen
1964 leo castelli gallery, new york
box, dwan gallery, los angeles
plastics show, albright-knox art gallery, buffalo
1965 pop and circumstance, mental health association,
the 4 seasons, new york
1966 primary structures, the jewish museum, new york
contemporary american sculpture selection I,
whitney museum of american art, new york
art in process, finch college, new york
the photographic image, the solomon r. guggenheim
museum, new york
1967 the 1960's: painting and sculpture from the museum
collection, the museum of modern art, new york
ten years, leo castelli gallery, new york
arp to artschwager, richard bellamy/noha goldowsky
gallery, new york
1968 cool art 1967, larry aldrich museum, ridgefield,
connecticut, documenta 4, kassel

auf anforderung übersenden wir ihnen unsere preisliste
sowie unser sonstiges galerieangebot

directions '68: options, milwaukee art center,
milwaukee/museum of contemporary art, chicago
1968 arp to artschwager, richard bellamy/noah goldowsky
gallery, new york
programm 1, galerie ricke, köln
kunstmarkt, köln (galerie ricke)
sculpture annual, whitney museum of american art,
new york
1969 6 künstler (artschwager, bollinger, buthe, kuehn,
serra, sonnier), galerie ricke, köln
shaped art, new york college of engineering, newark,
new jersey
new media: new methods, the museum of modern
art, new york (circulating exhibition)
galerie mickery, loenersloot
pop art, harvey gallery, london
kunst der sechziger jahre, wallraf-richartz-museum,
köln, (slg. Dr. Peter Ludwig)
galerie ricke, köln

onnasch galerie
1 bln 15, kurfürstendamm 62
Tel. 8835037 mo-sa 10-18.30 h

april 70 eröffnung 1. april 17-20 h

Invitation,
April 1970

— Shusaku Arakawa

Onnasch Galerie, Kurfürstendamm, Berlin
May 1970

— Richard Hamilton
Complete Graphics

Onnasch Galerie, Kurfürstendamm, Berlin
June 1970

richard hamilton

complete
graphics

Catalogue cover
and inside pages,
Richard Hamilton.
Complete Graphics,
Onnasch Galerie,
Berlin 1970

— Curt Stenvert

Onnasch Galerie, Kurfürstendamm, Berlin
July 1970

— 9 from the west coast

Onnasch Galerie, Kurfürstendamm, Berlin
November 1970

Catalogue cover,
*9 from the
west coast,*
Onnasch Galerie,
Berlin 1970

9 from the west coast

In November 1970 the gallery presents a group show with art—
ists from the American west coast. The exhibition *9 from the
west coast* includes works by Ron Davis, Robert Graham, Ed
Ruscha, William Pettet, Joe Goode, Billy Al Bengsten, Clark
Murray, Kenneth Price, and Tom Holland.

"The exhibition is part of Reinhard Onnasch's attempt to intro—
duce a dose of internationalism and currency into Berlin's art
life. If the nine artists can be considered representative of the
western American scene, the art life there exhibits an enviable
wealth and density." *(Berliner Leben, December 1970)*

onnasch
galerie

1 Berlin 15
Kurfürstendamm 62
Tel.: 883 50 37/38

BOB
LAW

1934 geboren, lebt in London, Autodidakt
1960 "TWO YOUNG BRITISH PAINTERS" ICA GALLERY. LONDON.
1960 "SITUATION" BRITISH ABSTRACT ART. RBA GALLERY. LONDON.
1961 "SITUATION" NEW LONDON GALLERY. LONDON.
1961-62 AWARDED FRENCH GOVERNMENT SCHOLARSHIP. (PAINTING)
1962-63 "RECENT BRITISH ABSTRACT PAINTING" ARTS COUNCIL
 TRAVELLING EXHIBITION.
1962 GRABOWSKI GALLERY, LONDON.
1963 RECENT PAINTINGS AND DRAWINGS, CHRISTCHURCH COLLEGE,
 OXFORD.
1967 ARTS COUNCIL PURCHASE AWARD.
1968 ARTS COUNCIL OF NORTHERN IRELAND, OPEN PAINTING
 EXHIBITION, BELFAST.
1967 GRABOWSKI GALLERY, LONDON.
1969 JOHN MOORES EXHIBITION, LIVERPOOL.
1970 KONRAD FISCHER, DUESSELDORF, GERMANY.

Einladung zur Eröffnung
am 1. Oktober 1970 um 19.30

Öffnungszeiten: Mo-Sa 10-18.30

Invitation,
October 1970

— Bob Law

Onnasch Galerie, Kurfürstendamm, Berlin
1970

— 20 Deutsche

Onnasch Galerie, Kurfürstendamm, Berlin
March 1971

(travels to Onnasch Galerie, Cologne, September 1971)

In the spring of 1971, the gallery opens a major exhibition with twenty German artists. With the help of fellow gallerists Alfred Schmela, from Düsseldorf, and Fred Jahn in Munich, Onnasch is able to present a large number of high–quality works from Joseph Beuys, Hans Haacke, Erwin Heerich, and Gerhard Richter to Franz Erhard Walther. The exhibition — which aims to present a representative cross section of important, characteristic works by German artists practicing in the sixties — is shown a few months later in Onnasch's newly opened gallery in Cologne and accompanied by an extensive catalogue with texts by art historian Klaus Honnef.

Reinhard Onnasch
during the exhibition,
20 Deutsche, March 1971.
In the background,
works by Sigmar Polke,
Gotthard Graubner,
and Franz Erhard Walther

Photo:
Hermann Kiessling

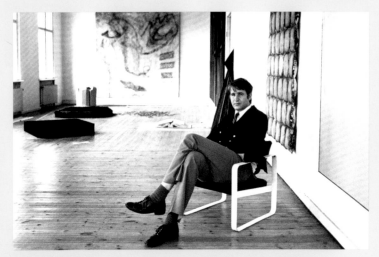

Berlin
1969
Onnasch
Nachtgalerie

Grolmannstrasse 53
Berlin

At the advice of Folker Skulima, Reinhard Onnasch opens a second Berlin space to complement the main gallery on the Kurfürstendamm. The Onnasch Nachtgalerie, or "Onnasch Night Gallery," located on Grolmannstrasse, opens on February 12, 1969 — in parallel with the gallery on Kurfürstendamm — with an exhibition of paintings and kinetics by Bill Culbert. This new gallery offers entirely new hours, remaining open from late in the evening until well past midnight. The space presents younger, barely established and emerging artists. Exhibitions are accompanied by varied performances intended to appeal to a new demographic.

— Bill Culbert
Paintings and Kinetics

Onnasch Nachtgalerie, Grolmannstrasse, Berlin
February 12 — March 28, 1969

— Amadeo Gabino

Onnasch Nachtgalerie, Grolmannstrasse, Berlin
April 11 — May 30, 1969

Invitation pamphlet,
April 1969

ausstellung
11. april · 30. mai
in der
onnasch
nachtgalerie

1 berlin 12 grolmanstr. 53
täglich ab 21 uhr
tel. 31 81 95

amadeo
gabino

usstellung
5. Mai - 30. Juni
n der
onnasch
nachtgalerie
berlin 12 grolmanstr. 53
- so ab 21 uhr
el. 31 81 95

jörg
hoffmann

onnasch
galerie

HOFFMANN

Invitation pamphlet,
May 1969

— Jörg Hoffmann

Onnasch Nachtgalerie, Grolmannstrasse, Berlin
May 15 — June 30, 1969

— Kinetische Objekte und
Multiples

Onnasch Nachtgalerie, Grolmannstrasse, Berlin
July 11 — August 31, 1969

— Hermann Waldenburg

Onnasch Nachtgalerie, Grolmannstrasse, Berlin
September 16 — October 15, 1969

— Multiples und Grafik

Onnasch Nachtgalerie, Grolmannstrasse, Berlin
September 1969

Cologne
1970 — 1974

Onnasch Galerie

Galeriehaus Köln
Lindenstrasse 18 — 20
Cologne

Only a year after opening the gallery in Berlin, Onnasch begins to consider expanding it. He soon decides on a new location — Cologne, known as the "art city." Cologne is extremely attractive to gallerists and, in late 1970, Onnasch moves into rooms on the ground floor of the Galeriehaus on Lindenstrasse.

The Galeriehaus on Lindenstrasse becomes a new, attractive gallery complex in Cologne's city center. Seven galleries and dealers, each with an entitely different specialty, are united under one roof: Hans–Jürgen Müller, Hans Neuendorf, Rolf Ricke, M. E. Thelen, Dieter Wilbrand, Heiner Friedrich, and Reinhard Onnasch.

The galleries insert collaborative announcements in international art journals and arrange for common openings. They forego individual invitations, instead publishing a monthly magazine, entitled *Galeriehaus Köln,* with information about openings, exhibitions, and events. This publication is discontinued in late 1971.

Onnasch's gallery opens in October 1971 with a Gianni Piacentino show. The new space in Cologne is mentioned in an October 1970 report on the "Cologne Art Market" in Cologne's *Stadt Anzeiger.*

Zu einem Gruppenbild mit Dame haben sich die Galerieinhaber beziehungsweise Geschäftsführer eingefunden. V. I. Reinhard Onnasch, Margot Schmidt (von der Galerie Friedrich), Rolf Ricke, Thomas Neuendorf, Dieter Wilbrand, Michael Nickel (Galerie Thelen) und Geschäftsführer Liemersdorf (von der Galerie Müller). NRZ-Foto: Prange

NRZ-Interview mit den „glorreichen Sieben" im Kölner Galeriehaus
Die Signale stehen auf US-Realismus
Von WOLF P. PRANGE

Newspaper clipping, "Die Signale stehen auf US–Realismus" (Signs Point to American Realism), *Neue Ruhr Zeitung / Neue Rhein Zeitung.* A photograph of the owners and gallery directors in front of the Galeriehaus Köln, 1971
Archive: ZADIK C2, XIII, 6. Zentralarchiv des internationalen Kunsthandels (ZADIK), Cologne

In contrast to Berlin, a city characterized by
its limited spaces and more classically
oriented art landscape, Cologne develops
into a vibrant center for contemporary
art within only a few years. The world's first
annual modern art fair had been held in
Cologne since 1967. This fair, the Kunstmarkt
Köln, brought a previously unknown
dynamism to the art market and was a
decisive factor in the expansion and success
of a number of galleries in the German–
speaking realm and the remainder of Europe.
Moreover, some of the leading avant–garde
galleries had taken up residence in Cologne,
among them include those of Rolf Ricke
and Heiner Friedrich, of Munich.
Equally important was that collectors were
situated in both Nordrhein–Westphalen, the
state in which Cologne is located, and
the nearby Benelux countries in far higher
density than elsewhere. Some of the most
important German art collectors lived in
the Rhineland and their purchases helped to
support the art market.

Reinhard Onnasch later describes his Cologne period as the
most interesting and suspenseful time of his career as a galler–
ist. In the Galeriehaus on Lindenstrasse, he presents important
solo shows of American artists Edward Kienholz, George Segal,
Harvey Quaytman, Duane Hanson, Richard Jackson, and William
Copley. Onnasch continues to collaborate with some of these
artists for decades.

— Gianni Piacentino

Onnasch Galerie, Lindenstrasse, Cologne
October 1970

— Richard Hamilton
Gesamtgrafik

Onnasch Galerie, Lindenstrasse, Cologne
January — February 1971

Edward Kienholz working
on *The Commercial #2*
during the installation
of his exhibition, March 1971
Photo: Norbert Nobis, Hanover

— Edward Kienholz
10 Objekte von 1960 bis 1964

Onnasch Galerie, Lindenstrasse, Cologne
March 5 — April 1971

Beginning on March 5, 1971, the gallery presents its first exhibi-
tion of works by Edward Kienholz, showing objects produced
by the American artist between 1960 and 1964, as well as the
conceptual tableau *The Commercial #2*. The exhibition is ac-
companied by a catalogue with a text by Heiner Bastian. An
excerpt from this catalogue is published in the March issue of
the gallery magazine.

This 1971 exhibition marks the beginning of a close friendship
between the gallerist and Kienholz. After receiving a grant from
the DAAD (Deutsch Akademische Auslandsdienst) in 1973, Kienholz relocates
and settles in Berlin — where Onnasch, with his real estate firm,
is still in residence.

Catalogue cover,
Edward Kienholz,
Onnasch Galerie,
Cologne 1971

— George Segal

Onnasch Galerie, Lindenstrasse, Cologne
April 30 — June 28, 1971

George Segal and
Reinhard Onnasch
during the opening,
April 1971

Photo:
Friedrich Rosenstiel

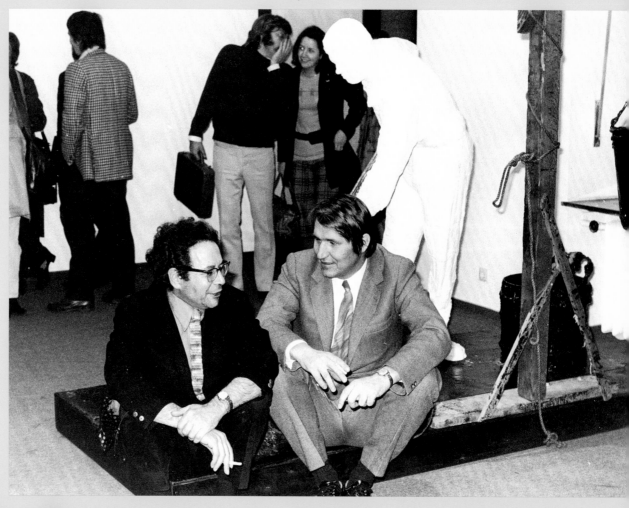

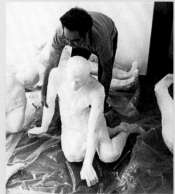

George Segal
during the installation,
April 1971

Photo:
Friedrich Rosenstiel

george segal

Catalogue cover
and inside pages,
George Segal,
Onnasch Galerie,
Cologne 1971

On April 30, 1971, the gallery opens the first exhibition of George Segal, showing, among other things, the sculpture group *Artist in His Studio*, 1968 and *The Laundromat*, 1966 / 67. Segal works on site, and the installation process is documented by the Cologne–based photographer Friedrich Rosenstiel.

The exhibition is accompanied by a catalogue with a brief text by the artist.

printed in w-germany by schnelldruck-preuss (berlin)
copyright 1971 onnasch galerie

Interview GEORGE SEGAL

Jede Generation von Künstlern muß nach einem Weg suchen, die Bedeutung ihrer eigenen Erfahrungen darzustellen.

In dem Bemühen sich selbst zu finden, stellten immer mehr Künstler fest, daß es keine schlechten Sujets gibt. Das Sujet ist nicht entscheidend, weil es mehr oder weniger das Sprungbrett für andere Antworten ist. Wenn man sich einmal dazu entschlossen hat, daß alles Gegenstand seiner Arbeit sein kann, dann ist man nicht auf die Darstellung edler Dinge begrenzt. Man ist nicht daran gebunden, reiche Menschen zu portraitieren. Man ist nicht auf religiöse Themen beschränkt, um eine Kirchenwand zu gestalten. Man kann sich mit der Tasse und Untertasse am Frühstückstisch beschäftigen. Man kann sich mit dem Scheinwerferlicht eines Autos beschäftigen, das auf einen zukommt. Man kann sich mit der Frau im Bett neben sich beschäftigen. Man kann sich mit einer Toilette beschäftigen. Mit einem Schlafzimmer. Mit der Autobahn, der Stadt, den Straßen, mit den Rissen auf dem Bürgersteig, mit seinen Hunden und Katzen. Man kann sich mit allem beschäftigen, was einem physisch und optisch jeden Tag begegnet, zusammen mit seinen eigenen Empfindungen. Nun, wenn man hiervon ausgeht, dann ist die Ware eines Supermarktes genauso wertvoll wie irgendeine Bucht oder romantische Naturlandschaft.

Die Menschen mißverstehen Pop-Malerei. Sie beurteilen sie auf der Ebene von Reklametafeln und kommerziellen Abbildungen. Das ist keine richtige Einschätzung der wirklichen Absichten, die hinter der Pop-Kunst stehen. Es gibt eine Freiheit in der Themenstellung und eine Freiheit im Material. Ich fühle mich frei, jedes Material aus der Welt in meiner Arbeit zu verwenden. Ich kann machen, bauen oder verwenden was ich finde. Ich kann alles für meine Aussage verwenden, was mich interessiert. Die Seite einer Mauer, einen Tisch, einen Stuhl, eine Person. Ich kann mich mit allem, was es in der realen Welt gibt, beschäftigen, vom Schwersten bis zum Leichtesten. Ich kann mich damit beschäftigen, auf einer starken persönlichen Ebene, historischem Mythos, sozialem Inhalt. Ich habe die

Interview GEORGE SEGAL

Every generation of artists has to thrash around for a way to state the quality of their particular experience.

In the struggle to find themselves, quite a few artists along the line decided that there was no bad subject matter. The subject matter wasn't crucial because it was morlor less a springboard for other responses. Once you decide that anything is subject matter, you are not limited to noble things. You are not limited to portraits of rich men. You are not limited to religious themes to line a church wall. You can deal with the cup and saucer in front of you at the breakfast table. You can deal with the headlights on a car approaching you. You can deal with the woman in bed next to you. You can deal with a toilet. You can deal with a bedroom. You can deal with the highway, the city, streets, cracks in the sidewalk, your dogs, cats. You can deal with anything you encounter physically and visually every day, plus your own sensations. All right, if you start from that point, then the contents of a supermarket are as valid as some beach or romantic natural landscape. People misread pop paintings. They criticize them in terms of billboards and commercial images. That is not an accurate evaluation of the real attitudes behind the pop works.

There is the liberation of subject matter, and the liberation of materials. I feel free to use any material in the real world in my work. I can make, build, or incorporate what I find. I can use the expressive qualities of anything that attracts me. The side of a wall, a table, a chair, a person. I can deal with anything in the real world – from heavy to floating. I can deal with it on an intense personal level, historic myth, social content. The choice is mine. It doesn't guarantee good art.

As naturalistic as my work is, I still make a lot of hidden transformations. I am wrenching and twisting qualities that are buried in objects, in their shape and their color and their texture. This is aside from the associations with objects as we use them. We use a chair to sit on, but there are 10.000 kinds of chairs. I am sitting on a kitchen chair. It would be different if

Wahl. Das gewährleistet nicht unbedingt gute Kunst.

So naturalistisch meine Arbeit ist, so gibt es doch eine Menge verborgener Umsetzungen. Ich versuche alle Werte herauszupressen und herauszuwinden, die in den Objekten stecken. In ihrer Gestalt, in ihrer Farbe und in ihrer Struktur. Dies weicht ab von unserer Vorstellung von den Objekten, wie wir sie gebrauchen. Wir benutzen einen Stuhl, um darauf zu sitzen, aber es gibt 10.000 Arten von Stühlen. Ich sitze auf einem Küchenstuhl. Und es ist etwas anderes, wenn ich auf einem Stuhl von Ludwig XVI. sitzen würde mit seidenem und samtenem Sitz.

Meine ersten Skulpturen waren traditionell. Ich machte die Form und den Innenbau darunter. Ich war an den Figuren interessiert, den Gesten, der Bewegung. Ich entdeckte, daß ich an noch etwas anderem interessiert war, etwas wie Genauigkeit, Klarheit und Echtheit. Ich wollte die wirkliche Form verwenden. Jeder Bildhauer hat sein Problem: Welcher Art soll sein Innenbau sein? Ich entschloß mich dazu, den Menschen zu nehmen, weil ein Mensch unbegrenzt Variationen ermöglicht.

Ich versuchte einige Male, eine Figur aus verschiedenen Teilen zusammenzusetzen, und das ist sonderbar. Wenn man eine ganze Figur nimmt und den Finger eines anderen daransetzt, dann steht er wie ein schlimmer Daumen ab. Es gibt eine unglaubliche Konsistenz in jedem von uns armseligen Gestalten menschlichen Fleisches. Unsere Finger haben etwas mit der Gestalt unserer Ohren zu tun. Wenn man sich einmal mit einer menschlichen Form derartig befaßt hat, stellt man fest, daß jeder Mensch in sich selbst fest verbunden ist. Es gibt eine Reihe sonderbarer subtiler Wahrheiten über die menschliche Gestalt. Nimm eine Schaufensterpuppe, diese furchtbaren, leblosen Kreaturen in den Warenhaus-Schaufenstern. Sie beginnen mit der Form eines wunderschönen Knies, perfekten Brüsten, Kopf oder Hals, und wenn man all diese traumhaften Perfektionen zusammenbringt, dann endet das mit einer unmöglich aussehenden Kreatur.

George Segal
Onnasch-Galerie, 1971

I were sitting on a Louis XVI chair with silk and velvet seat.

My first sculptures were traditional. I made the form, and the amature underneath. I was interested in figures -- the gesture, movement. I discovered I was interested in something else -- some sense of precision, of hard edge, of reportage. I wanted to deal with real form. Every sculptor has his problem: what is the armature going to be? I simply decided that my armature was going to be a person, because a person is capable of infinite variations.

I tried combining parts of one figure to make a composite a couple of times, and that's weird. If you take a whole figure and put somebody else's finger on it, it sticks, out literally like a sore thumb. There's an incredible consistency in each of us miserable hunks of human flesh. Our fingers have something to do with the way our ears are shaped. Once you start dealing with a human figure in this way, you find that each person is connected with himself. There are a lot of funny, subtle truths about a human figure. Take a mannikin, those horrible lifeless creatures in store windows. They start out with a cast of a beautiful knee and perfect breasts or head or neck, and put all these dream perfections together and end up with an impossible looking creature.

George Segal
Onnasch Galerie, 1971

Biographie mit Angabe wichtiger Einzelausstellungen

1924	geboren am 26. November in New York City
1940	Umzug nach New Brunswick in New Jersey
1941 - 46	Studium an der Cooper Union School of Art und Rutgers University
1947	Pratt Institute of Design
1949	New York University (Bachelor of Arts in Art Education)
1958	erste in Gips ausgeführte Plastiken mit Darstellung von Personen in natürlicher Größe
	Ausstellung: Hansa Gallery, New York
1959	Ausstellung: Hansa Gallery, New York
1960	Ausstellung: Green Gallery, New York
1961	erste vom Modell direkt abgeformte Plastik (man at the table)
1962	Ausstellung: Green Gallery, New York
1963	Master of Arts, Rutgers State University, New Brunswick, N. J.
	erster Europa-Aufenthalt
	Ausstellung: Douglass College Art Gallery, New Brunswick, N. J.
	Ausstellung: Green Gallery, New York
	Ausstellung: Galerie Ileana Sonnabend, Paris
	Ausstellung: Galerie Alfred Schmela, Düsseldorf
1964	Ausstellung: Green Gallery, New York
1965:	Ausstellung: Sidney Janis Gallery, New York
1967	Ausstellung: Sidney Janis Gallery, New York
1968	Ausstellung: Sidney Janis Gallery, New York
	Ausstellung: Museum of Contemporary Art, Chicago
	Teilnahme 4. Dokumenta, Kassel
1969	Ausstellung: Sidney Janis Gallery, New York
1971	Ausstellung: Onnasch-Galerie, Köln

In Vorbereitung: Retrospektivausstellung in mehreren Museen in Europa
Arbeiten befinden sich in den wichtigsten internationalen Sammlungen und Museen zeitgenössischer Kunst.
George Segal lebt mit seiner Frau und zwei Kindern auf einer Farm in New Brunswick, New Jersey

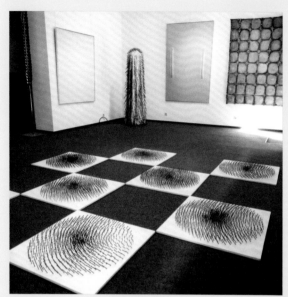

View of the exhibition,
20 Deutsche,
with works
by Gotthard Graubner
and Günther Uecker
Photo:
Friedrich Rosenstiel

— Harvey Quaytman

Onnasch Galerie, Lindenstrasse, Cologne
July 2 — August 1971

— 20 Deutsche

Onnasch Galerie, Lindenstrasse, Cologne
September 3 — October 1971

In September 1971, the gallery presents the show *20 Deutsche*, previously displayed in the Berlin gallery spaces as an ongoing exhibition since March. The exhibition includes works from the sixties by artists including Joseph Beuys, Gerhard Richter, Franz Erhard Walther, Sigmar Polke, Gotthard Graubner, and many others.

The exhibition opens during Kunstmarkt Köln, and causes a considerable stir.

In the September issue of the magazine *Galeriehaus Köln,* the gallery announces, that for organizational reasons, the Berlin and Cologne venues will be combined.

Opening
of the exhibition,
20 Deutsche,
September 1971
Photo:
Friedrich Rosenstiel

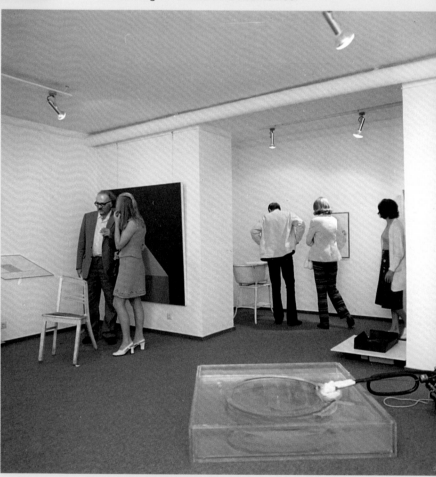

— Arakawa
Bilder 1968 / 69 und frühe Gouachen

Onnasch Galerie, Lindenstrasse, Cologne
November — December 31, 1971

— Panamerenko
Der Mechanismus des
Meganeudons

Onnasch Galerie, Lindenstrasse, Cologne
January — March 1972

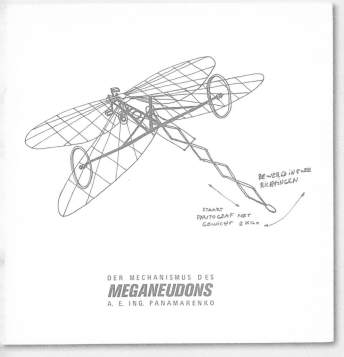

Catalogue cover,
*Der Mechanismus des
Meganeudons.
A. E. Ing. Panamarenko,*
Onnasch Galerie,
Cologne 1972

View of the exhibition,
*Der Mechanismus des
Meganeudons.
A. E. Ing. Panamarenko,*
January 1972

Photo:
Friedrich Rosenstiel

— Hans Hofmann

Onnasch Galerie, Lindenstrasse, Cologne
April 1972

— Carl Andre, Dan Flavin,
Don Judd, Sol LeWitt,
Fred Sandback

Onnasch Galerie, Lindenstrasse, Cologne
June 1972

— C. O. Paeffgen

Onnasch Galerie, Lindenstrasse, Cologne
September 1972

Catalogue cover,
C. O. Paeffgen,
Onnasch Galerie,
Cologne 1972

— Duane Hanson

Onnasch Galerie, Lindenstrasse, Cologne
October — November 15, 1972

In October 1972 a Duane Hanson exhibition opens. For the show, Hanson produces new works in Cologne. He finds models for his sculptures, whom he immortalizes as specific types, in the gallery itself: "the mason," "the cleaning lady," "the man reading," and "the secretary." A catalogue is issued for the exhibition with illustrations of the new works and a text by Udo Kultermann. Hanson's *Woman with Shopping Bags* is also exhibited at Kunst-markt Köln.

Duane Hanson
amongst his
sculptures in the
gallery space,
October 1972
Photo:
Friedrich Rosenstiel

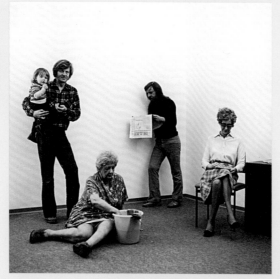 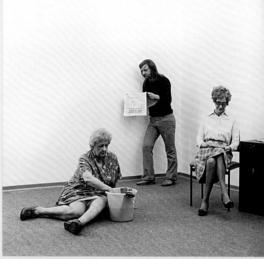

Duane Hanson
during installation,
October 1972
Photo:
Friedrich Rosenstiel

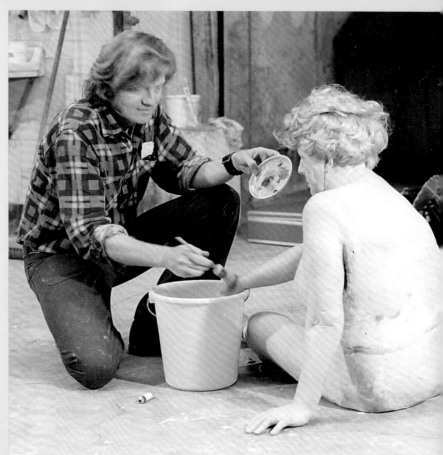

The gallery issues its first catalogue in June 1970 for the opening of Richard Hamilton's show in the Kurfürstendamm space in Berlin. Helmut Ostrower's proposal establishes the gallery's publication concept, in both format and design, for the next few years. The books are skillfully crafted to fit in the palm of one's hand; almost square, stapled brochures, they generally began with an introductory text or a brief interview with the artist. Twelve to eighteen pages present illustrations of the exhibited works, mostly in black and white, but, over the years, increasingly in color. With few exceptions, all fifty of the catalogues published by the gallery, up until the late eighties, are similarly designed and based upon Ostrower's original concept. Occasionally, Onnasch and his coworkers are able to engage prominent curators, museum scholars, or even artists as writers. Heiner Bastian contributes to the catalogue of the first Ed Kienholz exhibition, Klaus Honnef produces all the texts for *20 Deutsche,* while Peter Frank and Al Hansen write for the George Brecht catalogue, and Hans van der Grinten writes on Erwin Heerich.

As a rule, an artist's most recent works are published for the first time in gallery catalogues, and these serve as important sources of information about the artist and the gallery for clients, journalists, and curators. Many of the catalogues do without explanatory texts altogether and are simply pictorial. Published in a print run of at least 1,000 copies, they are distributed to the gallery's visitors during the run of the exhibition and sold in the gallery for a nominal fee. Its catalogues, like its invitations and posters, are recognizable as products of the Onnasch Galerie thanks to a striking logo: a large, round "O" within a square. Though in the first year the width of the line of the square's sides was slightly modified, the logo remains nearly constant, and this circle in a square also appears as an identifying feature on the gallery's door plate.

Catalogue cover and inside pages, *Duane Hanson,* Onnasch Galerie, Cologne 1972

Duane Hanson

catalogue designed by onnasch galerie
foto friedrich rosenstiel
printed in w-germany by buch- und offsetdruckerei fritz höbeler kg · köln
copyright 1972 onnasch galerie

— Anatol
Arbeitszeit bei Onnasch

Onnasch Galerie, Lindenstrasse, Cologne
December 1972

Reinhard Onnasch
and Anatol in
front of the gallery,
December 1972
Photo:
Friedrich Rosenstiel

— Edward Kienholz

Onnasch Galerie, Lindenstrasse, Cologne
February 1973

In his second exhibition in the Onnasch Galerie in Cologne, Kienholz presents two important tableaux: *The Eleventh Hour Final*, 1968 and *The Tadpole Piano Pool with Woman Affixed also*, 1972. The exhibition is accompanied by a catalogue with brief texts about the works shown.

Edward Kienholz
during the installation
of *The Tadpole
Piano Pool with Woman
Affixed also*,
February 1973
Photo:
Friedrich Rosenstiel

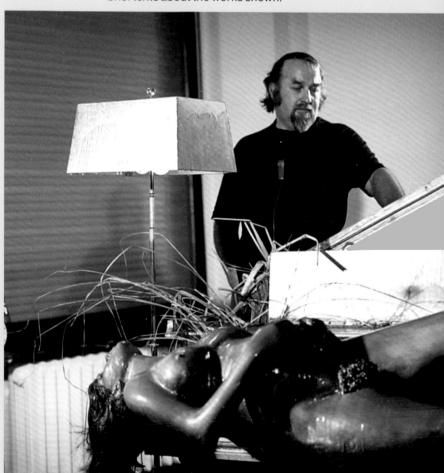

Catalogue cover
and inside pages,
Edward Kienholz,
Onnasch Galerie,
Cologne 1973

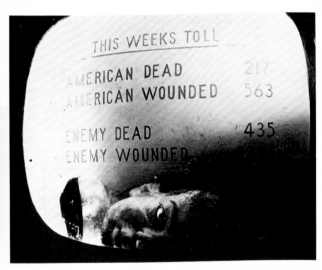

Nahansicht

THE TADPOLE PIANO POOL
WITH WOMAN AFFIXED ALSO
(1972)

Das Kaulquappen-Klavier-Aquarium mit einer noch hinzugefügten Frau ist die letzte Arbeit von Kienholz, die im Oktober des letzten Jahres beendet wurde. Sie wurde so konstruiert, daß ein richtiges Klavier mit galvanisiertem Metall (rostfreier Stahl an dem inneren Aquariumteil) bedeckt und ein Gips- und Fiberglas-Abguß einer schwangeren Freundin hinzugefügt wurde. Das Stück wurde dann mit Natur-Wasser gefüllt und mit Wasserpflanzen und Kaulquappen vervollständigt.

Es ist beabsichtigt, daß sich die Kaulquappen zu Fröschen entwickeln und dann im Raum herumspringen. Jetzt ist es notwendig, kleine Fische zu benutzen, um die Kaulquappen zu ersetzen, die — wie alle Frösche — während des Winters schlafen. Es ist aber zu hoffen, daß ein neuer Frühling kommt und eine neue Regeneration.

The tadpole piano pool with woman affixed also is the latest work by Kienholz being completed in october of last year. It was constructed by covering an actual piano with galvanized metal (stainless steel on the interior pool portion) and attaching a plaster- and fibre glass cast of a pregnant friend. The piece was then filled with natural water and "finished" with water-plants and tadpoles. It is intended that the tadpoles mature into frogs and the sculpture then jump about the room.

At this time it is necessary to use small fishes as substitute tadpoles as all frogs are hibernating during winter but it is hoped that there will come yet another spring and another regeneration.

— Hockney. Gesamtgrafik

Onnasch Galerie, Lindenstrasse, Cologne
April 1973

— Markus Lüpertz
Dithyrambische Bilder

Onnasch Galerie, Lindenstrasse, Cologne
May — June 1973

— Norbert Tadeusz. Bilder

Onnasch Galerie, Lindenstrasse, Cologne
September 1973

— Richard Jackson

Onnasch Galerie, Lindenstrasse, Cologne
1973

In his Cologne exhibition, Richard Jackson realizes a wall instal-
lation. A canvas with its front side facing the wall is secured at two
points and drawn across the wall to produce a colored ellipse.

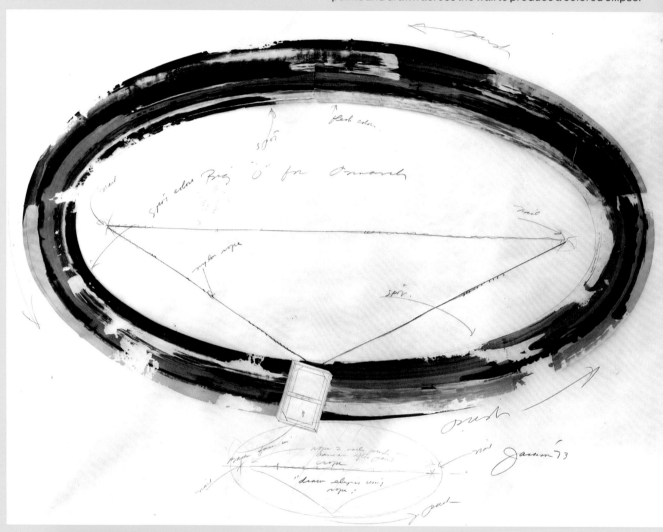

Richard Jackson,
Big "O" for Onnasch,
1973

View of the exhibition,
Richard Jackson, 1973.
On the wall
Richard Jackson,
Untitled,
1973—1974
(Big "O" for Onnasch),
1973

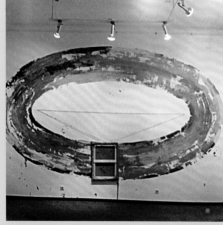

— William Copley
Western Songs

Onnasch Galerie, Lindenstrasse, Cologne
July — September 30, 1974

— Gianni Piacentino

Onnasch Galerie, Lindenstrasse, Cologne
December 1974

During the Berlin period, Onnasch toyed with the idea of opening a branch gallery in New York. Then, in 1973, the gallery leases a loft in SoHo. Beginning in mid–1973 only a few exhibitions are presented in the Cologne Lindenstrasse space, and little documentation of this period exists.

The Cologne gallery is completely shut down in 1974.

New York
1973 — 1975

Onnasch Gallery
139 Spring Street
New York

In September 1973, the Onnasch Gallery opens on 139 Spring Street in New York. Onnasch hires Hildegard Lutze to work with him on the artistic program. Her coworker, Marianne Barcellona, documents the gallery's exhibitions and events in photographs.

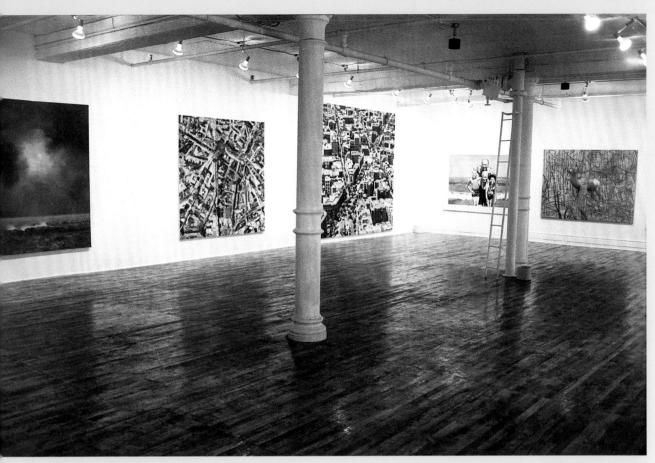

View of the exhibition,
Gerhard Richter,
September 1973
*Photo:
Marianne Barcellona*

— Gerhard Richter

Onnasch Gallery, Spring Street, New York
September 15 — November 15, 1973

The Onnasch Gallery opens with works by Gerhard Richter — the artist's first solo show in New York. Most of the seventeen works presented were contributed by the artist and a few came from Onnasch's own collection. The show leaves the critics bewildered, however, and only one of the two Townscapes is sold.

When Reinhard Onnasch first renovated the spacious third–floor loft on Spring Street, he hired Hildegard Lutze, whom he had known from Berlin, to serve as director.

The Gallery initially focused on introducing German artists to New York public. Ultimately, the exhibition of works by Gerhard Richter was the New York gallery's sole exhibition devoted to a German artist.

Onnasch began acquiring Richter's work for his collection in the sixties, and a number of his works were included in the Cologne / Berlin 1971 exhibition *20 Deutsche.*

Gerhard Richter
during the opening
of his exhibition,
September 1973
*Photo:
Marianne Barcellona*

— George Brecht
Works 1957 — 1973

Onnasch Gallery, Spring Street, New York
November 22, 1973 — January 15, 1974

George Brecht had come to know Reinhard Onnasch in Cologne. The exhibition at the Onnasch Gallery, Brecht's last in the United States, is accompanied by the small catalogue *El Sourdog Hex*. It is followed the next year by another exhibition in the Cologne gallery. With this show, the Onnasch Gallery also becomes known to New York Fluxus artists. A large number of the works shown in New York and Cologne are now in the Onnasch Collection.

The New York space subsequently presents exhibitions of work by George Brecht, Elaine Sturtevant, William N. Copley, Edward Kienholz, and Gianni Piacentino. Onnasch is close to most of these artists: as a collector, gallerist, and friend. He tries selling works by other German artists, like Markus Lüpertz, in the gallery's back room.

View of the exhibition,
George Brecht.
Works 1957 — 1973,
November 1973
Photo:
Marianne Barcellona

In the summer of 1974 *New York* magazine ran an article about the SoHo gallery scene entitled "The Germans Are Coming!" Shortly before, gallerist Heiner Friedrich had opened an exhibition space on Wooster Street with an installation by Walter de Maria. In May 1974, René Block inaugurated his gallery on West Broadway with the Joseph Beuys performance *I like America and America likes me.*

Due to a lack of commercial success and financial difficulties, Onnasch closed his Spring Street gallery in April 1975. In 1977, René Block also decides to return to Germany.

Catalogue cover
and inside pages,
El Sourdog Hex,
Onnasch Gallery,
New York 1973

EL SOURDOG HEX

By the end of the sixties, SoHo had become
an important center and catalyst for
contemporary art. This urban no–man's land,
with its predominantly abandoned warehouses
characterized by cast–iron architecture and
once occupied by the textile and lighting
industries, had attracted artists, filmmakers,
and dancers looking for undivided spaces and
affordable rents. In this largely unpopulated,
industrial neighborhood, not approved for
residential use, artists moved into huge lofts
to live and work. Non–commercial exhibition
and performance spaces like 98 Greene
Street and 112 Greene Street opened.
After years of anxiety about forced evictions,
the area's residents finally managed to have
rezoned the district as a residential area. In
1973, SoHo was declared a "Historic District"
and its cast–iron buildings were placed
under landmark protection. After Paula Cooper
opened the first commercial gallery there in
1968, the area south of Houston Street
began to attract uptown gallerists as well.

Leo Castelli, Ileana Sonnabend, Andre
Emmerich, and Virginia Dwan opened new ex–
hibition spaces in huge lofts. The arrival of
international commercial galleries in the early
seventies was indicative of the gentrification
of the previously industrial district. European
gallerists attracted to New York were drawn
to SoHo's charismatic aura.

GEORGE BRECHT

Works 1957-1973

Onnasch Galerie
New York, November 1973

139 Spring Street
New York, New York 10012
(212) 431-6810

Lindenstrasse 18
5000 Köln 1
(0221) 24 13 18

In January and February 1974, following the George Brecht exhibition, Hildegard Lutze organizes a series of important performances, hoping both to introduce the Onnasch Gallery as a venue for interdisciplinary artistic productions, and to appeal to publics interested in happenings, performances, and film. Lutze invites five artists to use the gallery for performances held in the following five weeks.

Ray Johnson, the founder of Mail–Art, stages a *Buddha University Meeting* in which nothing happens, except for the gathering of a large crowd. Jack Smith presents a slide show and Ralston Farina performs one of his *Time/Time* events. During Al Hansen's happening entitled *Gaga Art Flux–Fest,* Eleanor Antin's *100 Boots* and Andy Warhol's *Soup Cans* both hang for sale on the gallery walls. Bob Watts's *Performance* is an expansive installation based on the natural elements of fire, water, air, and earth.

The events and performances are noted by a number of critics. Three are documented by Marianne Barcellona.

Hildegard Lutze
in the gallery during
the exhibition,
Gerhard Richter, 1973
Photo:
Marianne Barcellona

By hiring Hildegard Lutze, a key player of the New York — Berlin connection, Reinhard Onnasch brought in a director intimately familiar with the New York art scene. Born in Wuppertal in 1937, Lutze studied sculpture in Berlin and elsewhere. In 1970 she followed her husband, the artist Dieter Froese, to New York, and began to take part in exhibitions and performances in alternative, non–commercial exhibition spaces in SoHo. Extravagant and eccentric, "Lutze," as she called herself, quickly became a part of the New York scene. After separating from Froese, she accepts the invitation to direct the Onnasch Gallery in collaboration with Marianne Barcellona.

A flamboyant hostess, Lutze was acquainted with any number of artists; her apartment became a first stop for German artists arriving in the city. She was particularly close to the underground filmmaker Jack Smith and, in 1974, accompanied him to Cologne, where he presented one of his slide shows, similar to that performed at the Onnasch Gallery.

In the summer of 1974, after the Bill Copley show, Lutze ended her association with the gallery. In 1976 she was involved in organizing the exhibition *SoHo. Downtown Manhattan* at the Akademie der Künste in Berlin. In the early eighties she returned permanently to Berlin, where she died in 1993.

Ray Johnson,
*A Buddha
University Meeting,*
view of the event,
January 19, 1974
Photo:
Marianne Barcellona

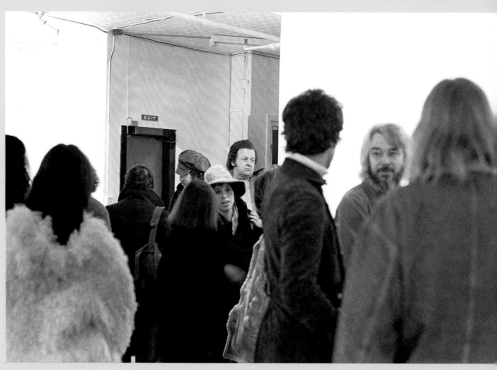

— Ray Johnson
A Buddha University Meeting
Onnasch Gallery, Spring Street, New York
January 19, 1974

— Jack Smith. A Boiled Lobster Sunset Slide–Show

Onnasch Gallery, Spring Street, New York
January 25, 1974

Jack Smith and
Marianne Barcellona
during the
performance,
January 25, 1974
Photo:
Marianne Barcellona

Jack Smith was a major figure in the underground film scene, known for his controversial film *Flaming Creatures,* 1963 and his slide shows, performed mainly in his apartment. Thanks to Lutze's invitation to present *A Boiled Lobster Sunset Slide–Show,* the underground filmmaker finds an audience in the art world as well. At the Onnasch Gallery, in addition to his slide show, Smith exchanges slices of toast decorated with swas-tikas for dollar bills. He presents a similar performance a few months later at Artists Space, an influential organization for the downtown alternative art scene.

Al Hansen,
Gaga Art Flux–Fest,
February 8, 1974.
In the background,
Andy Warhol's *Soup Cans.*
Photo:
Marianne Barcellona

— Ralston Farina. Time / Time

Onnasch Gallery, Spring Street, New York
February 1, 1974

— Al Hansen
Gaga Art Flux–Fest

Onnasch Gallery, Spring Street, New York
February 8, 1974

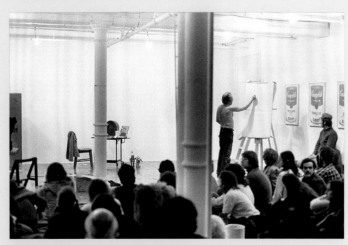

— Robert Watts
Flux Year / Gemini / 74 / Part 1
Onnasch Gallery, Spring Street, New York
February 15, 1974

— Sturtevant. Various Studies for
Beuys Actions, Objects and Films
Onnasch Gallery, Spring Street, New York
February 23 — March 16, 1974

View of the exhibition,
*Sturtevant. Various
Studies for Beuys Actions,
Objects and Films,*
February 1974
Photo: Marianne Barcellona

Sturtevant showed works at the Everson Museum of Art in
Syracuse, New York, in November 1973, and, in February 1974,
accepts Lutze's invitation to exhibit at the Onnasch Gallery
on Spring Street. She presents her remade works of Joseph
Beuys, including, among others, *Beuys Fat Felt Sculpture with
Batteries and Gelatine,* 1974.

After the show Sturtevant withdraws from the art world. Only
in the mid–eighties does she begin to exhibit her work again.

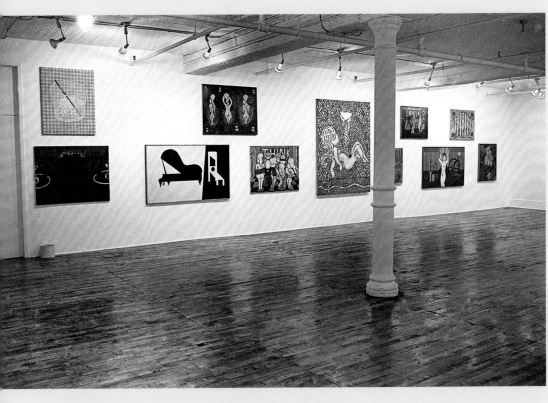

View of the exhibition,
Bill Copley.
Works 1948 — 1972,
March 1974
Photo: Marianne Barcellona

— Bill Copley. Works 1948 — 1972

Onnasch Gallery, Spring Street, New York
March 30 — May 25, 1974
(traveled to Moore College of Art, Philadelphia, September 13 — October 11, 1974)

William N. Copley's show at the Onnasch Gallery is mainly com-
posed of erotic pictures selected with Marianne Barcellona and
Hildegard Lutze at his New York studio. Following the New York
exhibition, Onnasch presents *William Copley. Western Songs* in
Cologne and, almost ten years later, *Copley's Post-Raphaelite*
Paintings in the reopened gallery in Berlin. Major groups of
works from these shows are now in the Onnasch Collection.

Catalogue cover
William Copley,
Onnasch Gallery,
New York 1974

Bill Copley,
Marianne Barcellona,
and Hildegard Lutze
in the artist's studio, 1974
Photo:
Marianne Barcellona

WILLIAM COPLEY

Onnasch Galerie
New York

Moore College of Art Gallery
Philadelphia

— Edward Kienholz. Watercolors

Onnasch Gallery, Spring Street, New York
February 22 — March 8, 1975

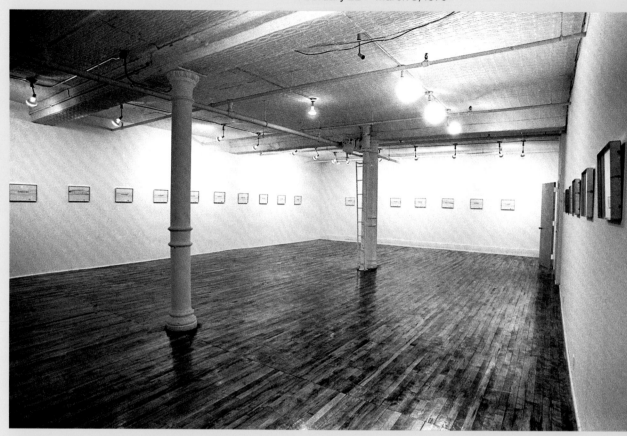

View of the exhibition,
*Edward Kienholz.
Watercolors,* February
1975

*Photo:
Marianne Barcellona*

Edward Kienholz exhibits a large number of his watercolors, which he uses as a means for exchange or payment. As in his infamous *Barter Show,* installed in 1969 at the Eugenia Butler Gallery in Los Angeles, Kienholz bartered watercolors for the object, or the amount of money, named on each work on paper. Reinhard Onnasch exchanges his red Mercedes for the cor—responding watercolor.

Edward Kienholz,
*Onnasch's Used
Mercedes–Benz,* 1974

Edward Kienholz,
$312, 1974

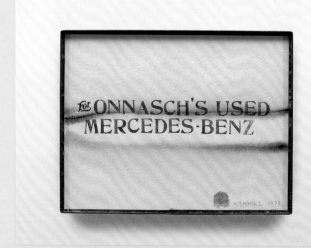

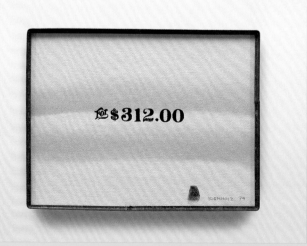

View of the exhibition,
Gianni Piacentino.
Sculptures and Paintings,
March 1975
Photo:
Marianne Barcellona

— Gianni Piacentino
Sculptures and Paintings

Onnasch Gallery, Spring Street, New York
March 15 — 29, 1975

The last show in the Spring Street space features sculptures and paintings by Gianni Piacentino. Reinhard Onnasch had already shown the Italian artist's works in his Cologne gallery in 1970. Known in the late sixties as a pioneer of Minimalism in Italy, Piacentino exhibits works that move between the bounds of art and design.

As was the case for the exhibitions of George Brecht and Bill Copley, another catalogue, in the gallery's standard square format, was published on the occasion of the show.

The contemporary economic situation, exacerbated by the oil crisis, prompts Onnasch to close the New York gallery at the end of March 1975. He withdraws completely from the com— mercial gallery business and once again devotes himself to his collection.

Reinhard Onnasch and
Gianni Piacentino during
the installation of the
exhibition, March 1975
Photo:
Marianne Barcellona

Catalogue cover,
Gianni Piacentino,
Onnasch Gallery
New York, 1975

Cover and
spread from the
catalogue

KÖLNER KUNST MARKT 1972
3.—8. OKTOBER
COLOGNE ART FAIR 1972
KUNSTHALLE
COLOGNE FOIRE D'ART 1972

Onnasch-Galerie

5 Köln 1
Lindenstraße 18

Telefon (02 21) 24 13 18

In unseren Beständen führen wir
von folgenden Künstlern Originalarbeiten:

Arman	Spoerri	Grafik
Arakawa	Segal	
Andre	Twombly	Dine, Hamilton,
Brecht	Tinguely	Hockney, Johns,
César	Warhol	Jones, Lichtenstein,
Dine		Oldenburg, Rauschenberg,
Flavin		Rosenquist, Warhol
Fontana	Beuys	
Kienholz	Graubner	
Kruschenick	Haacke	
Kienholz	Hoerich	
Sol Lewitte	Klapheck	
Manzoni	Koberling	
Panamarenko	Lüpertz	
Piacentino	Mack	
Quaytman	Palermo	
Rapssé	Polke	
Riley	Richter	
	Rot	
	Ruthenbeck	
	Schulze	
	Walther	
	Weworka	

Durchgeführte Ausstellungsprogramme
(Kataloge vorhanden):

Richard Hamilton – Gesamtgrafik, 1975
George Segal – Skulpturen, 1971
Edward Kienholz – Oh exte und
Concept Tableaux No 2, 1971
Hans Haltmann – Bilder, 1922
Shusaku Arakawa – Bilder, 1971
Harvey Quaytman – Bilder, 1971
Cionic Piacentino – Objekte, 1972
Panamarenko – Flugobjekt, 1972
Andre, Flavin, Judd, Sandback, Sol Lewitte –
Objekte, 1972
20 Deutsche – Bilder und Objekte, 1971
Beuys, Girke, Graubner, Hoecke, Heerich,
Klapheck, Koberling, Krieg, Lüpertz, Mack,
Palermo, Pfahler, Polke, Richter, Rot, Ruthenbeck,
Schultze, Uecher, Walther, Weworka
Duane Hanson – Figuren, 1972
(in Vorbereitung: Postfigen, Meret Oppenheim,
Kienholz, Piacentino)

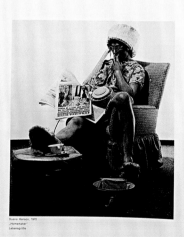

Duane Hanson, 1970
"Homemaker"
Lebensgröße

Shusaku Arakawa, 1969
"Hard and soft"
104 x 124 cm

Carl Andre, 1969
"Equivalent"
275 x 57 x 13 cm

Dan Flavin, 1964
"Alternate diagonals of March 2"
(to Don Judd)
270 cm Länge

George Brecht, 1961
Play incident
95 x 36 cm

Edward Kienholz, 1963
"A star is birthed"
174 x 122 x 12 cm

Meret Oppenheim, 1967
"Dämon à tête d'animal"
59 x 35 x 40 cm

In 1970 and 1971, the Onnasch Galerie participates in the second Frühjahrsmesse Berlin and the third Internationale Frühjahrsmesse Berliner Galerien. In the fall of 1971, the gallery first takes part in the Cologne Art fair (Kölner Kunstmarkt, October 5 – 10). While the Berlin art fairs feature galleries specializing in classical Modernism, the Cologne Art fair, which features a number of high-profile avant-garde galleries, is far more receptive to contemporary art. In 1973, the Galerie participates in the newly established art fair in Basel and, a few months later, again exhibits at the seventh Cologne Art fair (September 29 – October 6), this time with an emphasis on Edward Kienholz.

In October 1974, the gallery participates in the art fair for the last time. The fair, now under the new name Internationaler Kunstmarkt Köln (October 19 – 24), takes place in the Rheinhallen.

Marianne Barcellona
at the Cologne
booth, October 1973.
In the background, works
by Edward Kienholz
Photo:
Marianne Barcellona

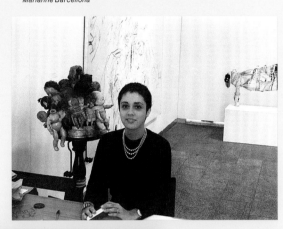

Art fair booth with
The Birthday (1964)
by Edward Kienholz,
October 1973
Photo:
Marianne Barcellona

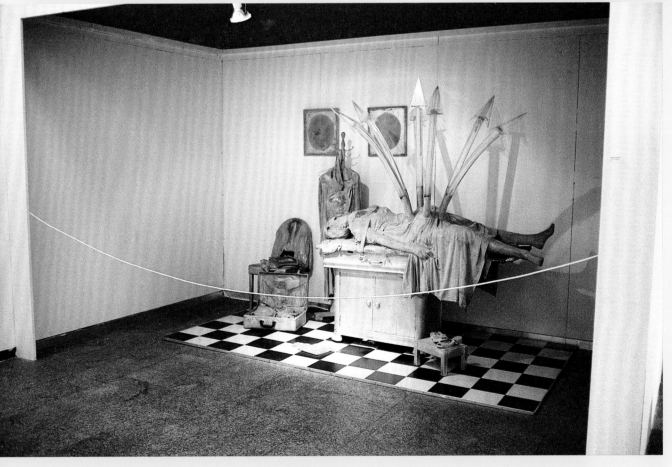

The Onnasch Collection

During his time as a gallerist, Onnasch acquired, for his own collection, numerous works by the artists with whom he collaborated. As was common at other galleries, one of the exhibition conditions at Onnasch was a guarantee to the gallerist. Usually the purchase was agreed upon before the opening. Beginning in the nineteen-sixties, many gallerists' collections came into being this way, including the Rolf Ricke Collection, the Paul Maenz Collection, and the Heiner Friedrich Collection.

As a collector, Onnasch remains in close communication with galleries at home and abroad, who provide contact with new artists and broker works for his growing collection. Within a few years Onnasch forms an extensive collection, notably of art from the sixties. Artists featured in the collection include the Americans George Segal, Bill Copley, Richard Serra, and George Brecht; the Germans Erwin Heerich, Markus Lüpertz, Bernd Koberling, Gerhard Richter, and Dieter Roth, and the Italian Gianni Piacentino. In addition, the collection includes important works by Robert Rauschenberg, Joseph Beuys, David Hockney, Jim Dine, Claes Oldenburg, Tom Wesselmann, Andy Warhol, Ed Kienholz, Dan Flavin, Morris Louis, Frank Stella, Mark Rothko, Piero Manzoni, Cy Twombly, Ed Ruscha, Sigmar Polke, Panamarenko, Duane Hanson, Dan Graham, Robert Mangold, and Richard Long.

— Aspekte der 60er Jahre

Nationalgalerie Berlin
February 2 — April 23, 1978

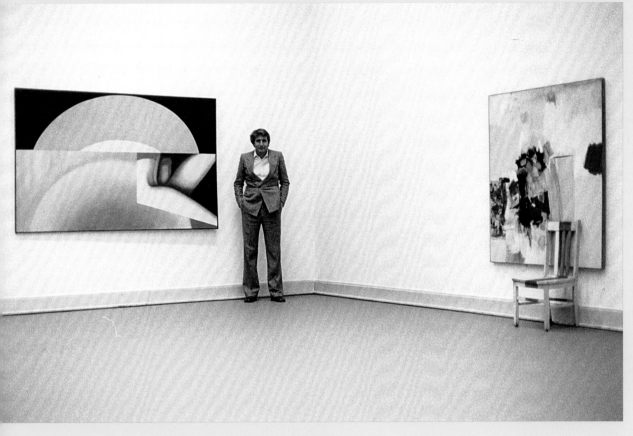

Reinhard Onnasch during
the exhibition of works
from his collection at
the Neue Nationalgalerie
Berlin, February 1978
(with *Brighter than the Sun*,
1962 by James Rosenquist and
Robert Rauschenberg's *Pilgrim*,
from 1960)

Photo: Benjamin Katz

In 1978, Dieter Honisch, director of the Neue Nationalgalerie
Berlin, invites Reinhard Onnasch to exhibit a selection of works
from his collection at the museum. The show, entitled *Aspects
of the Art of the Sixties,* presents not only works from the sixties,
but also includes important works produced outside of that
decade, such as Mark Rothko's *Central Green,* 1949 for example,
and works by Robert Mangold from the seventies. Following
that show, a number of works pass into the Nationalgalerie's
collections on permanent loan.

View of the exhibition,
*Aspekte der
60er Jahre,* Neue
Nationalgalerie Berlin,
February 1978

*Photo:
Reinhard Friedrich*

View of the exhibition,
*Aspekte der
60er Jahre,* Neue
Nationalgalerie Berlin,
February 1978

*Photo:
Reinhard Friedrich*

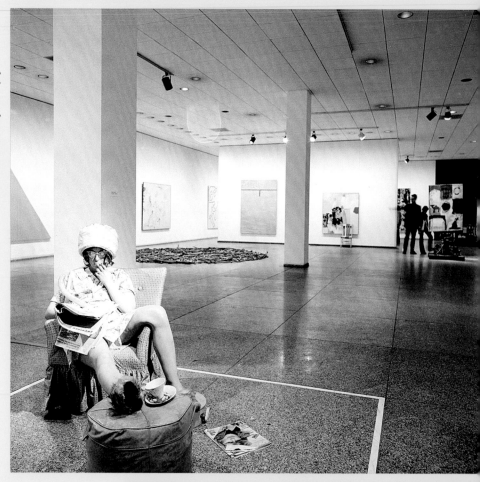

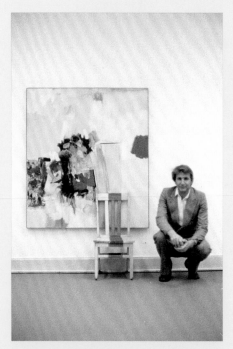

Reinhard Onnasch with
Robert Rauschenberg,
Pilgrim, 1960 during
the exhibition, *Aspekte
der 60er Jahre,*
Neue Nationalgalerie
Berlin, February 1978

*Photo:
Benjamin Katz*

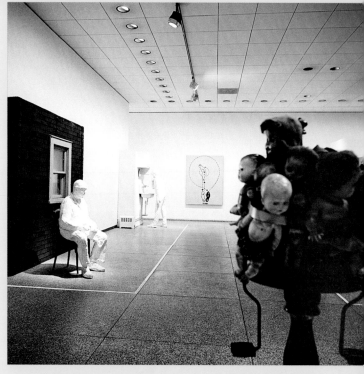

View of the exhibition,
*Aspekte der
60er Jahre,* Neue
Nationalgalerie Berlin,
February 1978

*Photo:
Reinhard Friedrich*

"Onnasch's collecting zeal, as presented in this exhibition, is distinguished from that of other notable collectors by its variety, occasionally also by its disregard for 'top pieces,' and preferably a personal interest. Accordingly, the collection can provide a relatively representative overview not only of Pop but also of various other forms of artistic expression in the nineteen–sixties."

Peter Hans Göpfert, "Noch einmal Pop, als sei er etwas Neues," *Die Welt*, 6 February, 1978

VEB
ZEITUNGSAUSSCHNITTDIENST GLOBUS

Die Welt
Ausgabe B
– 6. Feb. 1978

Die Berliner Nationalgalerie zeigt erstmals die Totale der Kölner Sammlung Onnasch

Noch einmal Pop, als sei er etwas Neues

In der Berliner Neuen Nationalgalerie klingelt fortwährend das Telefon: Es ist in einer Collage von Tom Wesselmann installiert, die kulissenartig mit einem eingebauten Heizkörper und einer Tür die Wand eines Zimmers „nachstellt" — darauf räkelt sich, ganz und gar malerisch — ein Frauenakt, „Great American Nude No. 44". Das Objekt ist eines der 77 Exponate aus der „Sammlung Reinhard Onnasch", die bis zum 23. April unter dem Titel „Aspekte der 60er Jahre" im Mies-van-der-Rohe-Bau zu sehen sind.

Von diesen Werken sollen 36 anschließend zehn Jahre lang in die ständigen Sammlungen der Nationalgalerie integriert werden. Von ähnlichen Leihgaben-Sortimenten werden auch das Essener Folkwang- und das Museum in Mönchengladbach profitieren. Aber gerade für das Berliner Institut kommt diese Aktion „Kunst auf Pump" wie gerufen. Sie könnte zugleich ein neues Signal setzen. Reinhard Onnasch, ein junger Berliner Immobilienkaufmann, hatte sich in der Stadt mit einer „Nachtgalerie" und vor allem „Deutschlands größter Etagengalerie" am Kurfürstendamm als Kunsthändler betätigt. Er verlegte diese Aktivität, von der er sich „persönlich eine Bereicherung versprach", anschließend nach Köln und New York. Beide Galerien sind inzwischen wieder geschlossen. Onnasch gehört zum Kreis der ersten Mitglieder des neu gegründeten „Vereins der Freunde der Nationalgalerie".

Diesem kommt besondere Bedeutung zu, denn Berlin ist mit privatem Mäzenatentum bestenfalls spärlich gesegnet — ein Mangel, den schon Werner Haftmann beklagt hat. Gerade Onnaschs Leihgaben zeigen aber, daß sich ein privates Engagement für die Museen mobilisieren läßt. Und so sehr Vereine in Berlin immer wieder ein umständliches Vehikel darstellten: Im Hinblick auf eine Belebung und Bereicherung der Nationalgalerie kann man sich nur Verbesserungen erhoffen.

Onnaschs Sammeleifer, wie er sich in dieser Ausstellung präsentiert, unterscheidet sich von anderen namhaften Kollektionen durch Vielseitigkeit, gelegentlich auch durch den Verzicht auf „Spitzenstücke", durch die Bevorzugung individueller Interessen. Dadurch aber kann die Sammlung einen verhältnismäßig repräsentativen Überblick nicht nur über Pop, sondern auch über diverse andere Formen künstlerischer Artikulation in den sechziger Jahren geben.

Die Geometrismen von Stella, die Gips-Realitäten von Segal und die Schrift-Paintings von Ruscha sind ebenso selbstverständlich vertreten wie eine hypernaturalistische Hausfrau des Duane Hanson, die Winkel-Optik Wewerkas oder halbwegs verpackte Verkehrszeichen von Christo — Erinnerung an eine Zeit, in welcher der bulgaro-amerikanische Einwickler noch in bescheidenen Dimensionen dachte.

Mag sein, daß in einer Sammlung, die insgesamt 270 Werke umfaßt, einige Komplexe, etwa die Kartonplastiken von Erwin Heerich, überproportioniert vertreten sind. Mag sein auch, daß sich ein weltstädtisches Museum wichtigere Arbeiten von Warhol und Oldenburg wünschen würde, als Onnasch sie besitzt. Aber Berlins Kunstgänger sind allemal schon für Appetithappen dankbar, wenn sie schon nicht am großen Art-Dinner teilhaben können.

Daß diese Sammlung überdies nicht dem sterilen Zwang unterliegt, sich nur im Hinblick auf einen engen Zeitraum zu spezialisieren, wird schon durch die Tatsache angedeutet, daß in ihr ebenso ein Beispiel der kontemplativen Malerei Rothkos (von 1949) einen Platz gefunden hat wie eine große mit Holzstücken ausgelegte Kreisfläche von Richard Long (von 1977) oder die heitere Flugmaschine „Donnerwolke" des Panamarenko (von 1971).

PETER HANS GÖPFERT

Ein „Objekt" des Amerikaners Edward Kienholz in der Sammlung Onnasch.
FOTO: REGINE WILL

Newspaper clipping, "Noch einmal Pop, als sei er etwas Neues. Die Berliner Nationalgalerie zeigt erstmals die Totale der Kölner Sammlung Onnasch" (Pop Again, As if it were Something New. Berlin's Nationalgalerie presents the complete Onnasch Collection), *Die Welt*, 6 February 1978

Archive: Zentralarchiv, Staatliche Museen zu Berlin-Preussischer Kulturbesitz; SMB-ZA, V/Dok. SMB 4.15.2 NNG

Reinhard Onnasch in conversation with Ernst Busche

Originally published in German as "Das Sammlerporträt: Reinhard Onnasch",
in *Kunstforum International,* vol. 25, no. 1 (1978).

A Collector's Portrait

Reinhard Onnasch, born in Görlitz in 1939 and raised in Kiel, first came to Berlin to study business administration in 1960. It was there, in 1969, while pursuing a career as a realtor and developer, that he began his activity as a gallerist. In 1971, he moved his art dealing activities to Cologne and, in the following year, closed the Berlin gallery. In 1973, he opened the New York branch, which was later closed, along with the Cologne gallery, in 1975. The heavyweights in Onnasch's collection are the Americans George Segal, Bill Copley, Richard Serra, and George Brecht and, above all, Germans Erwin Heerich, Markus Lüpertz, Bernd Koberling, Gerhard Richter, and Dieter Roth, as well as the Italian artist Gianni Piacentino. Moreover, along with such highlights as Rauschenberg, Beuys, Hockney, Dine, Oldenburg, Wesselman, Warhol, Kienholz, Flavin, Morris Louis, Stella, Rothko, and Manzoni, the collection includes a cross section of what is both good and expensive in today's international art market: from Twombly to Ruscha, Hanson, Graham, Spoerri, Wewerka, Polke, Boltanski, Panamarenko, Nauman, and LeWitt to Noland, Riley, Mack, et cetera. His most recent purchases include a Robert Mangold, a Richard Long and, as a new showpiece, the Kienholz environment entitled *Roxys.* At the moment, a large part of the collection, from which some twenty-seven works are on permanent loan to the National-galerie, is on exhibit in Berlin.

Ernst Busche

Reinhard Onnasch

Mr. Onnasch, when the exhibition of your collection opened in the Nationalgalerie last week, you looked a little like a happy boy who had finally been given the toy train he had been wishing for on Christmas. Does this at all describe what you were feeling?

Perhaps that is somewhat overstated — or understated — for, to me, Christmas is not such a happy event. But the exhibition is something I welcome, to be sure, when I consider that, for the last ten years, I have collected either for the storeroom or for my gallery activity, ultimately without the proper appreciation. In that context, everything is immediately interpreted commercially and looked at negatively by my competitors and those who envy me.

So, this consecration of your collection by the museum is the culmination of your collecting activity?

Yes; it's the high point so far. But one shouldn't overrate this exhibition. I want to continue to collect in this vein and, as such, it is not meant to mark a conclusion but rather the beginning of a process and shift in my ambitions.

By giving a number of works to the Nationalgalerie, you are engaging in museum policies at the highest level. How compatible are private and public collecting activities?

Museums are almost always behind in their acquisitions and purchases. This means, for example, that Dieter Honisch [director of Berlin's Nationalgalerie] argues for the purchase of a Cubist Picasso picture for however many millions and is also able to prevail over the acquisition committee. But it is only with difficulty that he can promote a Twombly picture, let us say, and he has been harshly criticized for purchasing the Beuys work, which, after all, cost only a fraction of the price of a Cubist Picasso. But, even so, everybody gets up in arms about the "waste of public funds."

So, your work tends to supplement museum practice rather than compete with it?

Yes. But it is my opinion that, someday, museums themselves will have to get into the act more aggressively, though they will then have to pay much higher prices. But, again, at that point it will no longer be considered a "waste of public funds," and will then be sanctioned. Once the art is verified, when it has been recognized for decades, or possibly even centuries, people are prepared to spend a lot of money for it and nobody is bothered by it. By making pieces available to museums that are not covered by the acquisition budget, or do not accord with the committee's acquisition policy, I am providing substantial assistance to a number of museum personnel, to museum directors who want to keep abreast of things but, who are simply prevented from doing so by their ridiculously small budgets.

When did your interest in art and your collecting activity begin?

It was in 1968, when I was still somewhat "green," so to speak. I rented the gallery spaces on the Kurfürstendamm, a splendid floor of more than 500 square meters, and simply had in mind the aim to do something different, something completely outside the framework of my previous work. The gallery business was virtually forced upon me by these spaces. It wasn't as if I had been fixated on art and wanted, specifically, to make money from it. I began to collect and slid into it a bit and discovered my love of the business. It was a lengthy process, that was not the case in 1968. I found a collaborator in Folker Skulima, who helped introduce me to the business and already knew what he was doing; he had once had a gallery in Spain. I traveled around with him a lot and had a look at galleries in Germany, Paris, and London. We talked a great deal about art, saw a lot and talked with other art dealers. You get involved very quickly; you develop preferences. It is simply a perfectly natural process. The first major purchases were then around 1970 and 1971.

Ernst Busche

You collect work from the sixties almost exclusively. Was that still considered avant–garde when you began collecting, or was it already somewhat old news?

The Ströher and Ludwig collections were also first exhibited here in 1968.

How old were you when you began collecting?

What was it that so fascinated you about the art of the sixties?

You are emphasizing the revolutionary aspect, if you will; did that accord with your personal attitude at the time?

How would you characterize your collection? It is striking — happily so — that you have a great number of European artists from this period, including Germans, so stamped by America, and that gaudy Pop tones do not predominate so much — even in the Pop works — but that rather elements are characteristically reduced, as, for example, in Conceptual Art or Arte Povera.

Reinhard Onnasch

Yes; that was already changing, it was taking on a first patina. Before, there had been documenta IV, in 1968, which was a major milestone for the recognition of this period around 1960. And, at that time, museums also began to take an interest in this art, if only on a small scale.

Yes, in 1968, Ströher made the major acquisition of the Kraushar Collection, perhaps the most extensive collection of Pop Art to date, and for a pittance when you think about it today. And this collection — it was called "Ströher" but it was essentially the "Kraushar Collection" — traveled through a number of cities. It was also seen here in Berlin, in the Nationalgalerie. I must say that it impressed me greatly.

Ten years younger than I am now. Twenty–eight. I first worked with Berlin artists, younger artists, and also had Expressionist prints, for example, or print editions by Max Ernst or Picasso, things that could be sold relatively easily and that formed a commercial basis. But I soon lost interest in these things; they bored me a little. They held no meaning for me in the long run, aside from their commercial aspects.

Well, as I said, I got into it later, after it was actually over and so I could already look at it from a certain distance. What fascinated me were the major changes, the confrontations that took place at the time, real provocations, for example, people like Tinguely, Christo, or Yves Klein with his Action Art — not only the mono–chrome pictures, but what was decisive, what got noticed were his body prints, which he made with naked women and musical accompaniment in front of people in formal dress. Much the same was true in America with Pop Art; it was a challenge to American abstractionism, so celebrated at the time was the New York School. In Europe it was Tachism. For a period of ten years, abstract artists were exhibited almost exclusively and, as an artist at the time, you could do nothing but paint abstract pictures; decomposed pictures were considered the terminal point of painting. In opposition to this came the movements of the sixties, suddenly doing something altogether contrary and different. And that I compare to Dada, where things were simply turned upside down: the concept of art was expanded.

That was an important time not only in the realm of art, as I see it, but also in politics. I'm thinking of the Kennedy era, of the music, the beginnings of pop music, the Beatles: these things are already playing a major role, in all realms. And I believe this will be increasingly recognized in future.

I never considered that, whether something is reduced or not, but I've actually always only been interested in artists as creative people. And I've also bought fewer single pictures but rather committed myself to specific artists or to works of a specific time when I've bought something. There are Pop pictures in the collection that could, in fact, seem somewhat gaudy. A picture that Mr. Honisch didn't hang, for example, is a Rosenquist from 1961; he said he didn't like it at all, that it was too vivid. This was not so decisive for me. It only has to have a quality, a consistency,

Ernst Busche Reinhard Onnasch

that creates the foundation. I've never considered whether something is reduced or whether it's realistic, whether it's abstract or minimal or Pop.

So a spontaneous connection to the work or to the artist?

Yes, spontaneous — or reflected to the extent that I have placed the artist in his environment and his time. Then, it is crucial to have something from an artist's important creative periods. Although there are also artists — as for example my last purchase, that is the Mangold, a picture he had just finished — who have improved over a long period of time and then it no longer really matters what year it is. I wouldn't limit myself to buying only works produced between 1960 and 1970 but want instead to leave that open.

How did your dual role as dealer and collector influence the building of your collection?

It was actually like this: originally, I had these pictures for the gallery to sell, at least the majority of them. But, as an art dealer, I also wanted to have and offer for sale only things I believed in, not only in terms of quality but also with respect to price. There are artists whom I admire very, very much, who nevertheless strike me as simply overpriced. One is Roy Lichtenstein, for example — I don't have a single Lichtenstein in my collection because he simply struck me as too expensive. To me, he's an important figure of the Pop era but also, certainly, overvalued in terms of price.

Are you still very active as a dealer? Your galleries are closed, after all.

The galleries are closed but I am still dealing. That is to say, I am looking after a few larger collections in Germany.

Is there no conflict of interest with the Nationalgalerie if you exhibit there, loan works to it, and, at the same time, function as a dealer?

In all this time, I have only sold a single picture to the Nationalgalerie and that was truly years ago. I otherwise have nothing to do with the Nationalgalerie as an art dealer. It's the same with the other museums. I admit that it is sometimes a little complicated for me with museums: they somehow have a funny feeling if the collector / dealer issue does happen to come up. I would not want to have any sort of unpleasantnesses, also for me personally.

When you began collecting, art — and particularly its economic aspects — seemed very much a part of the political discussion. Catchword: "Art as Commodity." Did that influence you at that time to the point that, perhaps, you even deliberately went into dealing in defiance of this argument, opened the gallery and went on collecting?

You're probably referring to the student unrests around 1969 and 1970, a time when any sort of commercial activity was considered despicable. I feel this soon passed and that it didn't influence me because those are specious arguments. We live in a social system that is relatively equitable, after all, and part of this is commerce and assessing the value of work. We live in a monetary system, and that's simply part of it. Pictures cost money, and even a left-leaning artist is not about to give his pictures away for nothing.

How much have your pictures cost?

I honestly can't answer that precisely, but it is considerably less than you would perhaps assume. Very roughly: something around two-and-a-half million marks.

Will the collection, as presented in the catalogue, be preserved?

I don't want to sell the collection — individual pieces perhaps, but there are specific things whose importance to me has changed. For example, I have a few small Beuys works that I would sell in order to get a large, important work in exchange, one that would also be suitable for a museum, say. All that I have should not be frozen for eternity. That would be just as dogmatic a way of looking at things as collecting only pictures from the sixties.

Ernst Busche

Reinhard Onnasch

As a dealer, you have surely had an influence on the art business. Have you also done so as a collector?

Oh, I don't know — not much. The art market is too international for that. Among younger artists, sometimes perhaps, or regional artists. I suppose my purchases from Markus Lüpertz and Erwin Heerich could have set something in motion and it could also be the same with Richter, but not Twombly or Rauschenberg, not Beuys either. The purchase of a single expensive work hardly changes anything on the market.

You indicated that the works now on display in the Nationalgalerie were selected by Mr. Honisch. Who is choosing the works that will remain here in Berlin on permanent loan?

That is Honisch's job as well. I don't get involved at all. It's the business of the museum to decide what fits with its policies or activities. I first offered the entire collection to Mr. Honisch and he then selected what he wanted.

Do you plan to make loans available to other museums as well?

Yes. A larger number are going to the new museum in Mönchen-gladbach rather than to the Nationalgalerie. The Morris Louis, the large Noland, the Stella, and many more; I consider Dr. Cladders to be a very, very fine museum man, one with whom I strongly identify, in regards to looking at art or to the presentation of art-works within a museum. I'm very excited about this new museum.

What advantages do you get from your loans?

The works don't have to go into storage, the museums are liable for theft, et cetera, so I save some in insurance premiums, and I am not tempted to sell pictures. Otherwise, aside from name recognition, I don't get any advantages from them. And, I also don't have any business agreements with Honisch as far as picture purchases are concerned. In any case, he represents his own interests and preferences and that is just as it should be.

Meanwhile, we now have the Ludwig, Hack, Sprengel, and Ströher museums. Will there soon be an Onnasch Museum somewhere?

No. I can guarantee that there won't be.

(Translated by Russell Stockman)

Reinhard Onnasch
in conversation
with Dieter Honisch

Ten Questions for
Reinhard Onnasch

Originally published in German as "Zehn Fragen an Reinhard Onnasch,"
in *Aspekte der 60er Jahre,* Nationalgalerie Berlin, 1978.

Catalogue cover,
Aspekte der 60er Jahre.
Aus der Sammlung
Reinhard Onnasch,
Nationalgalerie Berlin
Staatliche Museen
Preussischer Kulturbesitz,
1978, with an image
of Duane Hanson,
Housewife, 1969 — 1970

Dieter Honisch

Mr. Onnasch. You were a businessman who suddenly decided to open a gallery, virtually switching professions to deal contemporary art. What led to this dramatic change?

Largely unnoticed by the public, you acquired an important collection over the years, which consisted primarily of art dating from the sixties. Why did you focus on this particular decade?

Your collection is not exclusively limited to art from the sixties. In the present show we are exhibiting — at your express wish — on display are both, a Mark Rothko painting from 1949 and, at the other extreme, a 1976 picture by Robert Mangold. Isn't this somewhat inconsistent?

Reinhard Onnasch

When I first opened a gallery in Berlin, in 1968, I only had a relatively vague notion of the whole endeavor, not only about what I wanted to do in this gallery, but also about the art trade and contemporary art itself. What mattered, at the time, was doing something besides the dull business of building apartment houses, with which I had first hoped to get rich.

As I said, at the beginning I had no concrete notion of my gallery program. In the Berlin gallery, I exhibited everybody with stature and a name — that is to say, mostly "classical Modernism." But, very soon, my interest shifted to newer art. And, to some extent, I developed a specialization. It was after 1971, when I relocated the gallery to Cologne, that I began to almost exclusively exhibit contemporary art. I was fascinated by the competition between the various art movements in the early sixties and their repercussions. It was my enthusiasm for this period of upheaval that ultimately led me to build my own collection.

Perhaps you will allow me to make a few comments about this period. In the fifties, both in Europe and America, abstract art was the rule. It was this, the exclusive dominance of a kind of painting known in Europe as Tachism or Informel and, in the United States, as Abstract Expressionism, that provoked opposition. The revolt against the art establishment of the postwar period was first initiated around 1960 in Paris by Nouveau Réalisme and in London and — to an even greater extent — New York by Pop Art.

In that initial phase, the artists of the early sixties were not concerned with financial sucess. They produced their works with genuine commitment, with the intent to provoke the art public — who had accepted and committed to a singlular style — and distinguigh themselves by creating a different aesthetic. Widespread and heated debate surrounding these issues, both in America and in Europe, while conversations expanded to even involve the so-called "man in the street."

The rapid breakthrough of Pop Art was countered, in turn, by Minimal Art, which was was still, only, in the early sixties, around 1963. Conceptual Art, whose first works were produced after 1965, built upon Minimalism, and, to some extent, led it to a logical conclusion. And then, around 1968, everything was once again completely turned upside down, this time by the Photorealists. It is the rapid succession of competing movements, each genuinely concerned with the further development of art, that makes this period so exciting. To my mind, the only time that parallels the dynamism of the sixties was at the beginning of the century, say, between 1910 and 1920.

Although more than ninety percent of the works in my collection date from the sixties — mostly the beginning of the decade — there are some pieces, as you rightly note, that were not produced in the years between 1960 and 1970. This said, I consider these pieces important as illustrations of what happened in the sixties. As you know, Mark Rothko worked until well into the sixties and had a major influence on the second generation of Color Field painters, including Kenneth Noland, Morris Louis,

and Frank Stella, as well as Bob Ryman and Cy Twombly. The New York School of so–called Abstract Expressionism, developed shortly after the Second World War and mainly pioneered by Jackson Pollock, Barnett Newman, Hans Hofmann, Clyfford Still, Sam Francis, Franz Kline, and Robert Motherwell, in addition to Rothko, paved the way for the upheaval in American art that occured around 1960. Pop Art, as I already noted, had developed as a kind of protest against the American style of abstract painting that had triumphed around the world in the fifties. It was these early painters of the New York School — with their new ideas and their incredible self–assured energy — who brought about the dominance of American art over that of Europe. Works by those early masters can hardly be had any longer and, if so, only at immense prices.

I am happy that, with Rothko's *Central Green,* at least one painting from this great early phase in American art is in my collection.

Now as for the late Mangold: Mangold's first characteristic works date from 1963. I followed his work from the very beginning, for, to me, it establishes new accents important for the development of abstract American painting. I believe that Mangold's most recent pictures document, even more clearly than his early works, the concept he consolidated over the years. Mangold is unquestionably an artist of the sixties, even though I am most impressed by his more recent pictures. Rothko and Mangold are illustrations of the fact that, though the focus of my collection is meant to be the art of the sixties, it cannot be dogmatically limited to works created in that decade. To avoid overflow, to be sure — at least for the moment — I would like to refrain from including artists in the collection who were not yet active in the sixties or were so no longer.

How did you arrive at the major holdings in your collection? I am thinking of Segal, for example, Gerhard Richter, or even Dieter Roth, as well as Brecht, Kienholz, Heerich, and Lüpertz. Did they result from chance acquaintance with particular artists or were these quite deliberate purchases?

I have always been more interested in individual figures, even if they felt no attachment to a specific movement, than in trends like Pop Art, Nouveau Réalisme, Minimal Art, Photorealism, et cetera. It was by coming to know the artists you mention, most of whom I presented in solo shows in my Cologne and New York galleries, that actually most impressed me. Naturally, this could not but influence the creation of strong points, and focuses, within the collection.

It interests me that although their influence on Europe in the sixties was overwhelming, you have, by no means, collected only Americans, and that your collection also includes a significant proportion of Europeans, and even Germans, who certainly did not have it easy in those years.

The Americans dominated the art scene in the sixties. No question. But it is by no means the case, as some American art critics have maintained, that nothing of importance was happening in Europe at the same time. There were not as many new stylistic trends that caused a stir, to be sure, but there were, rather, individual artists, strong personalities. Beuys, for example, did not initiate a new stylistic direction, but, in the long run, is hardly less important than Robert Rauschenberg, who is generally understood to be the father of American Pop Art. The issue of nationality has never seemed particularly important to me. That said, the nationality of the individual collector is never without influence.

Dieter Honisch

It strikes me that your collection is by no means limited to a particular field — as is that of Wilhelm Hack, for example, or that of Peter Ludwig, who more or less tried to acquire masterpieces — but rather reflects highly individual biases. On the one hand, that is perhaps a special strength but, on the other, seen from a museum worker's standpoint, it is — and forgive the expression — a weakness as well.

Until now, people were only aware of your collection through occasional loans, displayed in certain exhibitions. You've now made portions of it available as long–term loans to the Nationalgalerie, as well as to other museums. Are you following any specific principle in doing this?

As a member of the newly revived Friends of The Nationalgalerie, I am, myself, most grateful to you for providing greater possibilities for private initiatives in Berlin. It is somehow so fitting that you have extended your generous loan to a venue that owes a large part of its older holdings to just such generosity. Do you feel that your gesture might have further consequences, particularly in Berlin, a city you know so well?

How do you, yourself, see the relationship between private and public collections? In the Bundesrepublik, and in Berlin, unfortunately, tax laws do not encourage the kind of private patronage that American museums, for example, rely on almost exclusively. The tax authorities see the fact that museums are financed with tax monies as a hindrance; if they were to encourage private donations as well, it would amount to a twofold taxation advantage. How do you feel about this?

What are your plans for the future? Would you like to continue to enlarge your collection or, as you've done with us here, would you like to commit it, in its current form, to specific museums on a long–term basis?

Reinhard Onnasch

You bring up a problem that has occupied me a great deal, es–pecially recently.

I consider it the private collector's privilege to be able to follow, with greater freedom, his own personal bent. From a museum's standpoint that may be, as you say, a weakness. But I somehow see it differently.

Most public collections attempt to exhibit well–known artists. And so the same names appear in museums over and over again. This leads to a certain uniformity. Private collections should act as a counterbalance. I try, quite deliberately, to place accents, particularities intended to give the collection a look of its own. This said, I also hope that the well–known artists are also adequately represented.

Two years ago, or so, I stopped staging exhibitions in Cologne and New York. I was then faced with the question of how to make my collection accessible to the public. Any number of German museums are eager to show avant–garde art but, in their collect–ing, are frequently hampered by rather conservative acquisition committees and modest budgets. Loans from my collection can be of help here — or, that is my hope. For the collection to be distributed among several museums, means that there is a greater flexibility. If the focus of a given museum changes, the loans can always be exchanged or supplemented. In general, my aim is to see the art of the sixties, which is so important in my opinion, more fully represented in German museums.

It is encouraging that a circle of private sponsors has again been formed, thanks, above all, to your initiative, Professor Honisch. I would greatly welcome other Berlin collectors to make loans available to the Nationalgalerie or to provide finan–cial assistance for its acquisitions. The immediate success of the revived Friends of The Nationalgalerie gives one reason to hope. In any case, I think it a positive step when a national museum attempts to secure private support for its activities.

We, in Germany, have become too accustomed to the fact that museums are exclusively state institutions. In the United States, for example, museums of this kind are the exception. It would be nice if private initiatives could be encouraged through taxation measures. But, sadly, there may be too little general interest to bring about the relevant legislation.

My immediate goal is to preserve the collection as it is and, as far as is possible, make its works accessible to the public through long–terms loans to museums. I would like it if other institutions, besides the Nationalgalerie, would agree to accept such loans.

(Translated by Russell Stockman)

After the show in Berlin's Nationalgalerie, Onnasch is repeatedly invited to exhibit selections from his collection in the context of collector shows, making single works or whole groups of works available to public exhibition venues as long–term loans.

— Gianni Piacentino
Painting and Sculpture 1965 — 81
Bilder und Objekte 1965 — 81
Gesellschaft für Aktuelle Kunst in der Weserburg, Bremen, October 1981

Catalogue cover,
Gianni Piacentino.
Painting and Sculpture
1965 — 1981.
Bilder und Objekte,
Gesellschaft für
Aktuelle Kunst e.V. /
R. Onnasch
Collection (ed.),
Bremen / Berlin 1981

In 1981 and 1982 two solo shows, including large numbers of works by Gianni Piacentino and Edward Kienholz on loan from the Onnasch Collection, are presented in the Gesellschaft für Aktuelle Kunst (GAK) in the Weserburg, Bremen. Onnasch repeatedly exhibited both artists in his galleries in Cologne, New York, and Berlin and acquired many of their works for his own collection.

— Edward Kienholz
Roxys and other works

Gesellschaft für Aktuelle Kunst in der Weserburg, Bremen
January 17 — February 14, 1982

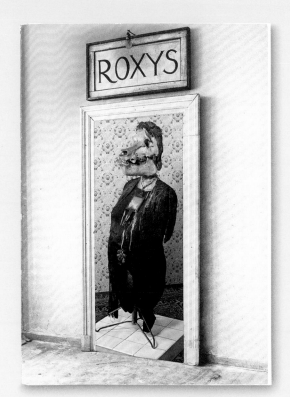

View of the exhibition,
Edward Kienholz.
Roxys and other works
January 1982

Onnasch had shown Edward Kienholz's work in Cologne in 1971 —
the first gallery exhibition of Kienholz sculptures in Europe — and
again in 1973. The artist's work was one of the highlights of the
Onnasch Collection. In the seventies Onnasch was able to
buy Kienholz's magnum opus, *Roxys,* which was first shown
in Europe at Documenta IV in Kassel. The collector describes
the purchase of this work as a fluke, which then becomes the
centerpiece of an exhibition presented by the Gesellschaft
für Aktuelle Kunst.

A comprehensive catalogue was produced for the show, with
texts on the exhibited works by Nancy Reddin Kienholz.

Catalogue cover,
Edward Kienholz. Roxys
and other works,
Gesellschaft für Aktuelle
Kunst e.V. / Reinhard
Onnasch Collection (ed.),
Bremen / Berlin 1982

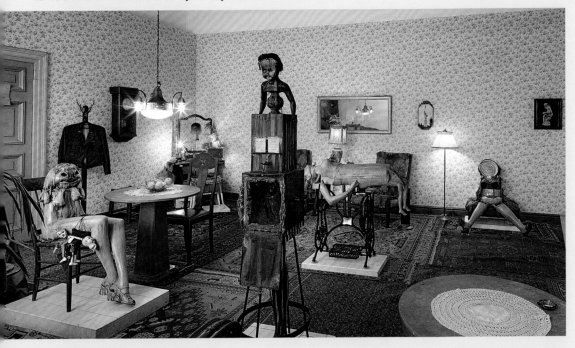

Edward Kienholz, *Roxys,*
1960 — 61.
Installation view,
El Sourdog Hex, Berlin 2009
Photo: Lepkowski Studios, Berlin

Invitation with a
reproduction
of Gerhard Richter,
Helga Matura,
1966
Archive:
Ulmer Museum, Ulm

Poster for the exhibition,
Werke der 60er Jahre aus der
Sammlung Reinhard Onnasch,
Berlin, with a reproduction
of Sigmar Polke, *Liebespaar,*
1972
Photo: Oleg Kuchar, Ulm
Archive: Ulmer Museum, Ulm

— Werke der 60er Jahre
Sammlung Reinhard Onnasch

Ulmer Museum, Ulm
December 4, 1983 — January 22, 1984

In December 1983, a selection from the collection is shown
at the Ulm Museum under the title *Werke der 60er Jahre.* The
exhibition includes works by Daniel Buren, Jim Dine, Bernd
Koberling, George Krushenik, Sol LeWitt, Markus Lüpertz, Heinz
Mack, Bruce Nauman, Lowell Nesbitt, Kenneth Noland, Sigmar
Polke, and Gerhard Richter.

Important works from the Onnasch Collection are put on per-
manent loan to the Museum Abteiberg in Mönchengladbach,
which then presents several exhibitions from the collection's
holdings.

— Dan Flavin, Morris Louis,
Brice Marden, Richard Serra,
Richard Tuttle —
Neue Dauerleihgaben aus der
Sammlung Reinhard Onnasch,
Berlin
Städtisches Museum Abteiberg, Mönchengladbach
June 19 — August 25, 1985

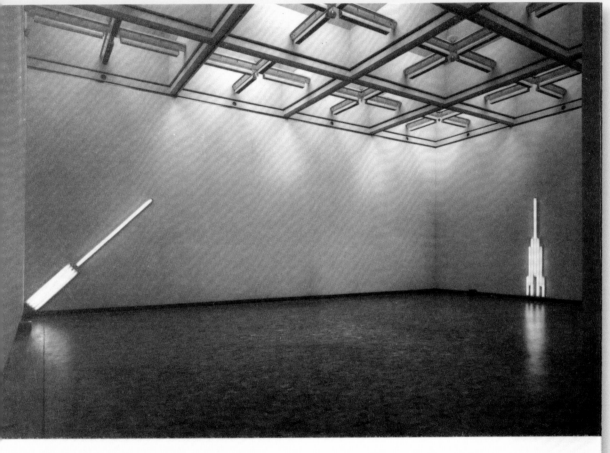

1

2

View of the exhibition,
*Dan Flavin. 4 Werke in
fluoreszierendem Licht aus
der Sammlung
Reinhard Onnasch, Berlin*
(Dan Flavin. Four Fluorescent
Works from the Reinhard Onnasch
Collection, Berlin).
Photographed by Ruth Kaiser
and reproduced in
the exhibition catalogue,
Städtisches Museum
Abteiberg Mönchengladbach,
1990

— Dan Flavin
4 Werke in fluoreszierendem
Licht aus der Sammlung
Reinhard Onnasch, Berlin
Städtisches Museum Abteiberg, Mönchengladbach
September 2 — October 28, 1990

Reinhard Onnasch in conversation with Rainer Höynck

Promoting Art Is Everybody's Business

Originally published in German as "Kunstförderung ist auch Sache des Bürgers,"
in *Berliner Kunstblatt,* no. 40 (1983).

Rainer Höynck

Reinhard Onnasch

There are pictures on view for the first time in Berlin, exhibited in our spaces at Niebuhrstrasse 5, which are just now being expanded — my floor at Schlüterstrasse 55 — and, then, there are also a few things that the Nationalgalerie accepted as permanent loans in 1968 that are occasionally exhibited. The major works, of course, one cannot yet know, since what will be considered major and what will not; that, the future will decide. But, the works of the moment are now in West German museums: the Staatliche Gemäldesammlung in Munich, the Museum Folkwang in Essen, the Museum Mönchengladbach, the Lehmbruck Museum in Duisburg, the Kunsthalle Bielefeld, the Kunsthalle Kiel, and a few others.

Aren't there sometimes conflicts? On the one hand you would like to have what you own and, on the other, you want to make your collection accessible for the enjoyment of others. You seem to dually occupy these positions: the function of the patron who benefits others — artists and viewers — and the function of the collector, who collects because he loves art.

Yes, this is a collision of interests. Love, patronage, are iron-clad things. But, for me, the finances are quite clearly the greater problem. I collect pictures from the fifties and sixties — Western European, American art — that now cost a great deal of money; and the exhibition business also cost an unbelievable amount of money. What you can afford, what you would like to have — this problem is a given, of course and not so much for me, as a patron of young artists, but more for established things, where the financial questions really come to the fore.

Is there a fixed budget that you or your tax advisor establish or are there spontaneous decisions? Do you sometimes do something mad because you're just suddenly excited by some piece? Are you more calculating, more emphatic or sometimes one, sometimes the other?

Yes, sometimes one, sometimes the other, although in the last few years I've become somewhat more hardheaded: fewer spontaneous decisions, more considered things. But there are, very occasionally, larger purchases and decisions about exhibitions that come more from the gut — or the heart, if you will — and not so much from strategy, from reason.

Are there sometimes sales? For every collector would like to get rid of something, delight in some rapid increase in value, and then, with the money earned, possibly buy something new. Then perhaps you get the feeling, which one has to have in this profession: you've optimized the profit and you wonder whether to take something from it and reinvest it in art?

From the realm of the collection, which I would not want to think of as somehow fixed, very little has been recently sold. This is, again, owing to various considerations: namely that what people want is still increasing in value and that other things that I would actually like to sell are not so much in demand at the moment. Tastes continue to fluctuate.

It is my ambition to build up an extensive, accurate spectrum of the art of the sixties, then make it accessible to a larger public and preserve it.

The gallery mainly represented artists who had been in the "business" for a longer time, some of them for twenty years, and then, from among some 200 artists who interest me and who constantly and conscientiously keep practicing, I again and again seek out works I consider worth exhibiting and that I would like to further.

But if you yourself have established the limits, Mr. Onnasch, could you not lift them again?

Of course, I have to! I have to be ready at all times to revise my point of view and to rethink and to turn to other things. That's the great part, the fun, the spontaneity, so that you happen upon completely different things.

Rainer Höynck

With the Museum Bröhan's opening on October 14, there are also concerns in the Senate about how to encourage greater patronage. Senator Hassemer has even appointed someone to explore what one can do with patronage, inasmuch as state sponsorship of art is limited. Do you think this is a proper state response? Would you even seek imitators, or would you even see to it that there are imitators?

Who do you have to advise you: various art dealers, some single person you trust? Or have you over time — to come back to the example of Bröhan once again — become an expert yourself, so that no one in your own collecting realm can say what is top notch and what is negligible, because you know that yourself?

Reinhard Onnasch

Yes. I'm of the opinion that art cannot remain solely a state responsibility. It must, primarily, be the business of the citizen — at least with respect to its contents — also of museums — to make it available. If we could get to the point where only the structure itself is financed by the state and its contents — as in previous centuries or in other countries, the United States, for example — ultimately come from the people, from their collections, that would be a real step in the right direction.

Yes; that's precisely what I have done. Behind it, of course, there were years of work, years of dealing with the material, a lot of traveling, not excluding the important auction venues — New York, London, Paris — always training and developing my own eye and making my own decisions. Not taking any advice.

(Translated by Russell Stockman)

Berlin
1982 — 1987

Reinhard Onnasch
Ausstellungen

Niebuhrstrasse 5
Berlin

In May 1982, Onnasch opens new gallery spaces on Niebuhr–strasse in Berlin. The inaugural show is a solo exhibition of early pictures by Lowell Nesbitt. In his resumption of gallery activity, Onnasch is assisted by Illona Lindenberg, who serves as the gallery's artistic director.

The newly reopened gallery's program is set by artists with whom Onnasch had already worked in the seventies, both in Cologne and in New York: William N. Copley, George Segal, Ed Kienholz, Markus Lüpertz, and Gianni Piacentino. New, mainly German artists are added: Bernd Koberling, Erwin Heerich, Christian–Ludwig Attersee, Markus Oehlen, and Peter Bömmels.

Thanks to Onnasch's extensive contacts with artists and galler–ies in both the Federal Republic and the United States, the newly opened gallery also manages to present important exhibitions with such international artists as Robert Matta Echaurren, John Wesley, Richard Serra, and Kenneth Noland.

— Lowell Nesbitt
Frühe Bilder 1965 — 1972

Reinhard Onnasch Ausstellungen, Niebuhrstrasse, Berlin
May 19 — June 5, 1982

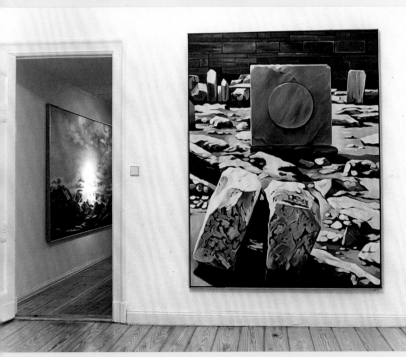

View of the exhibition,
Lowell Nesbitt.
Frühe Bilder 1965 — 1972,
May 1982

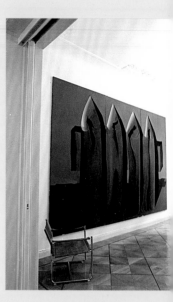

Catalogue cover,
*Matta. What is the Object
of the Mind? Zum
einhundertsten Todestag
von Charles Darwin,*
Reinhard Onnasch
Ausstellungen, Berlin
1982

— Markus Lüpertz. Grüne Bilder

Reinhard Onnasch Ausstellungen, Niebuhrstrasse, Berlin
June 16 — July 10, 1982

— Matta. What is the Object of the Mind? Zum einhundertsten Todestag von Charles Darwin

Reinhard Onnasch Ausstellungen, Niebuhrstrasse, Berlin
September 15 — October 15, 1982

Matta during the
opening, with a copy
of the catalogue,
*What is the Object
of the Mind?*
September 1982
*Photo:
Hermann Kiessling, Berlin*

The gallery resumes its publishing activity. For many of the
shows on Niebuhrstrasse catalogues are produced in the
standard square, booklet format first designed in the seventies.

— Bernd Koberling. Inseln
Bilder aus den Jahren 1969 / 70
und 1980 / 82

Reinhard Onnasch Ausstellungen, Niebuhrstrasse, Berlin
October 18 — December 4, 1982

— Cheep! John Wesley. Bilder
aus den Jahren 1962 — 1982

Reinhard Onnasch Ausstellungen, Niebuhrstrasse, Berlin
December 8, 1982 — January 12, 1983

Cheep! 1962, 183 x 183 cm, Öl auf Leinwand

JOHN WESLEY
— CHEEP! —

Bilder von 1962 – 1982

8. Dezember 1982 – 12. Januar 1983 · Montag bis Freitag 15.00 – 18.00 Uhr
Samstag 10.00 – 14.00 Uhr

REINHARD ONNASCH AUSSTELLUNGEN

Niebuhrstraße 5 · 1000 Berlin 12 · Telefon 030 - 8 82 77 18

Poster,
1982

— Dieter Roth. Ladenhüter aus den Jahren 1965 — 1983

Reinhard Onnasch Ausstellungen, Niebuhrstrasse, Berlin
January 16 — March 12, 1983

In January 1983, Dieter Roth and his son Björn travel to Berlin to set up the *Ladenhüter* exhibition on Niebuhrstrasse. Among other works on view are Roth's *Flacher Abfall* (Flat Waste) and the *Olivetti – Yamaha – Grundig – Combo.*

Dieter und Björn Roth
during the installation of
Dieter Roth. Ladenhüter,
January 1983
Photo:
Jürgen Junker–Roesch

Dieter Roth
during installation,
January 1983
Photo:
Jürgen Junker–Roesch

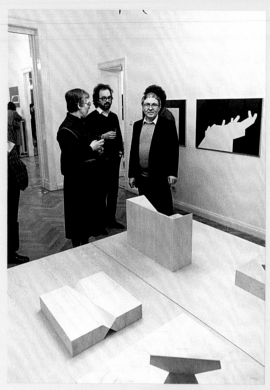

Erwin Heerich
during the opening
of his exhibition,
*Plastische Modelle und
Diagrammzeichnungen,*
March 1983

— Erwin Heerich
Plastische Modelle und
Diagrammzeichnungen

Reinhard Onnasch Ausstellungen, Niebuhrstrasse, Berlin
March 16 — April 30, 1983

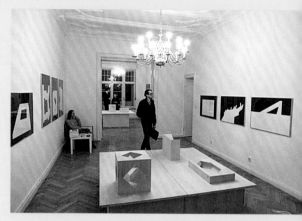

View of the exhibition, *Erwin Heerich.
Plastische Modelle und
Diagrammzeichnungen,* March 1983

— William N. Copley
Post–Raphaelite Paintings

Reinhard Onnasch Ausstellungen, Niebuhrstrasse, Berlin
May 3 — June 11, 1983

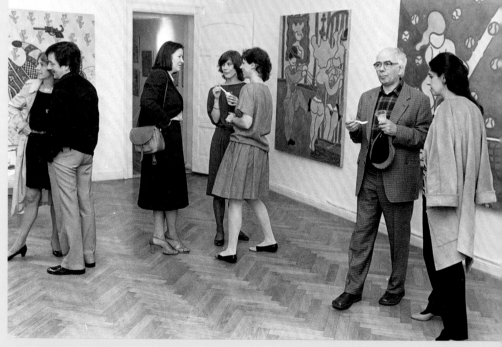

Gisela Onnasch,
Illona Lindenberg, Johannes
Geccelli and his wife, and
Werner Gleich during
the opening of the exhibition,
*Post–Raphaelite
Paintings by William N. Copley,*
May 1983

— Gianni Piacentino

Reinhard Onnasch Ausstellungen, Niebuhrstrasse, Berlin
June 16 — August 27, 1983

— Richard Serra. Skulpturen und Zeichnungen, 1967 — 1983

Reinhard Onnasch Ausstellungen, Niebuhrstrasse, Berlin
September 17 — October 21, 1983

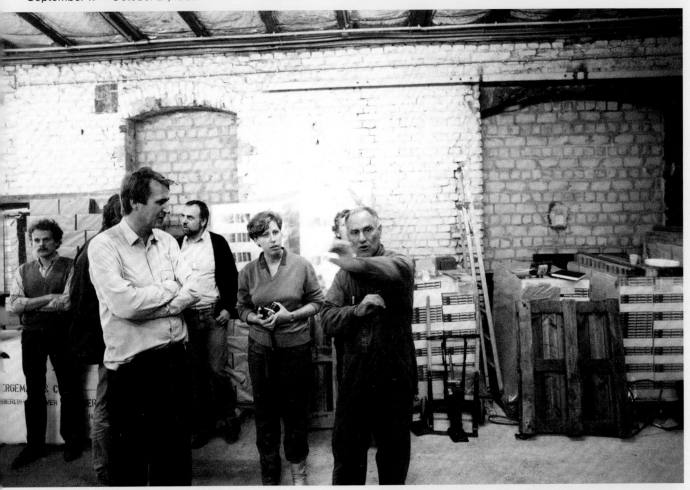

Richard Serra with Reinhard Onnasch
and Illona Lindenberg during the
installation of his exhibition, *Skulpturen
und Zeichnungen, 1967 — 1983*,
September 1983

Photo:
Hermann Kiessling, Berlin

In September 1983, the exhibition *Richard Serra. Sculptures and Drawings, 1967 — 1983* opens. The monumental steel and lead sculptures *Do It*, 1983; *Strike*, 1970; *Floor Pole Prop*, 1969; and *Corner Prop*, 1969 are set up under Serra's direction in the gallery's storeroom inside Bergemann & Co. In the gallery spaces on Niebuhrstrasse, Serra exhibits, among other things, the *Candle Piece*, 1967; *To Lift*, 1967; and *Triangle Belt Piece*, 1967.

The exhibition is accompanied by a catalogue with numerous installation views and a text by Michael Pauseback.

Richard Serra during
the installation in
the storage space at
Bergemann & Co.,
September 1983
Photo:
Hermann Kiessling, Berlin

95

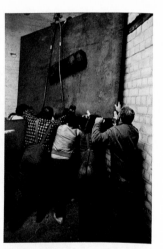

1 DO IT, 1983

Catalogue cover
and inside pages, *Richard Serra.
Skulpturen und Zeichnungen,
1967 — 1983,*
Reinhard Onnasch Ausstellungen,
Berlin 1983

— Christian—Ludwig Attersee
Der Wettergatte
Bildauswahl 1980 — 1983

Reinhard Onnasch Ausstellungen, Niebuhrstrasse, Berlin
October 24 — December 3, 1983

— George Segal
Menschen im Environment
1963 — 1973

Reinhard Onnasch Ausstellungen, Niebuhrstrasse, Berlin
December 17, 1983 — January 28, 1984

Farmworker 1963 · 244 x 244 x 107 cm

Catalogue, inside pages,
*George Segal. Menschen im
Environment. 1963 — 1972,*
Reinhard Onnasch
Ausstellungen, Berlin 1983

Catalogue cover,
Markus Oehlen.
Neue Arbeiten,
Reinhard Onnasch
Ausstellungen,
Berlin 1984

— Markus Oehlen
Neue Arbeiten

Reinhard Onnasch Ausstellungen, Niebuhrstrasse, Berlin
February 6 — March 17, 1984

Markus Oehlen
and Reinhard Onnasch
in the gallery,
February 1984
Photo:
Manfred M. Sackmann, Berlin

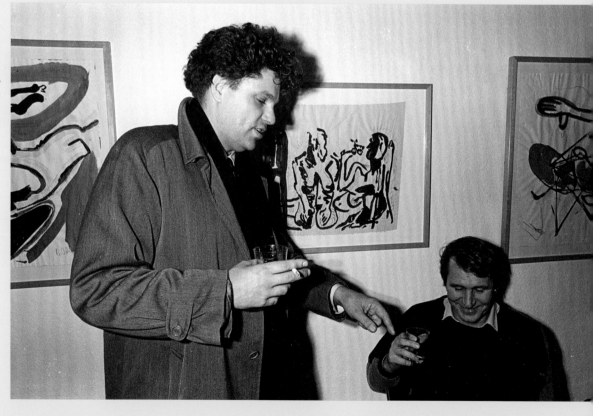

— Ed Kienholz
Arbeiten von 1957 — 1963

Reinhard Onnasch Ausstellungen, Niebuhrstrasse, Berlin
March 26 — April 28, 1984

Kienholz in his
Berlin studio, 1980
Photo:
Werner J. Hannappel

— Kenneth Noland
Neue Bilder 1984

Reinhard Onnasch Ausstellungen, Niebuhrstrasse, Berlin
September 22 — November 3, 1984
(traveled to the Galerie Wentzel, Cologne, November–December 1984)

KENNETH NOLAND

Catalogue cover,
Kenneth Noland.
Neue Bilder 1984,
Reinhard Onnasch
Ausstellungen,
Berlin 1984

Berlin 1984 — 1987

Reinhard Onnasch Galerie

Fasanenstrasse 47, Berlin

The exhibitions on Fasanenstrasse were not documented in photographs. In December 1987, Onnasch abandons his activity as a gallerist.

— Bernd Koberling

Reinhard Onnasch Galerie, Fasanenstrasse, Berlin
December 1984 — January 12, 1985

— Dan Flavin

Reinhard Onnasch Galerie, Fasanenstrasse, Berlin
March 22 — April 27, 1985

— Kurt Kappa Kocherscheidt Neue Arbeiten

Reinhard Onnasch Galerie, Fasanenstrasse, Berlin
May 2 — June 22, 1985

— Jens Jensen. Rag-Flags

Reinhard Onnasch Galerie, Fasanenstrasse, Berlin
June 28 — July 21, 1985

— Markus Oehlen

Reinhard Onnasch Galerie, Fasanenstrasse, Berlin
September 14 — October 19, 1985

— Johannes Geccelli Neue Bilder

Reinhard Onnasch Galerie, Fasanenstrasse, Berlin
October 26 — November 23, 1985

— Hans Peter Adamski Stilleben & Kranke Kinder Bilder 1985

Reinhard Onnasch Galerie, Fasanenstrasse, Berlin
December 7, 1985 — January 18, 1986

— Richard Tuttle

Reinhard Onnasch Galerie, Fasanenstrasse, Berlin
March 24 — April 18, 1986

In late 1984, the gallery moves from Niebuhrstrasse to larger spaces on Fasanenstrasse and opens with an exhibition of twenty-four works by the Neo-Expressionist painter Bernd Koberling. Before the end of 1987, the new Reinhard Onnasch Galerie on Fasanenstrasse will present nearly twenty shows of German and international artists. The Kurt Kappa Kocherscheidt, Markus Oehlen, Hans Peter Adamski, Markus Lüpertz, Klaus Kumrow, and Maria Lassnig shows and the two group exhibitions, entitled *Neue Formen* and *Chamberlain. Halley. Kiecol. Tuzina*, are accompanied by catalogues.

— Markus Lüpertz
Pierrot Lunaire

Reinhard Onnasch Galerie, Fasanenstrasse, Berlin
June 7 — July 12, 1986

— Kurt Kappa Kocherscheidt
Trumm und Splitter

Reinhard Onnasch Galerie, Fasanenstrasse, Berlin
July 12 — September 6, 1986

— Klaus Kumrow

Reinhard Onnasch Galerie, Fasanenstrasse, Berlin
September 20 — October 25, 1986

— Neue Formen. 5 Junge Maler

Reinhard Onnasch Galerie, Fasanenstrasse, Berlin
November 21, 1986 — January 10, 1987

— Peter Halley

Reinhard Onnasch Galerie, Fasanenstrasse, Berlin
1987

— On Kawara

Reinhard Onnasch Galerie, Fasanenstrasse, Berlin
1987

— Maria Lassnig. Innerhalb und
Ausserhalb der Leinwand

Reinhard Onnasch Galerie, Fasanenstrasse, Berlin
April 3 — May 3, 1987

— Günther Förg

Reinhard Onnasch Galerie, Fasanenstrasse, Berlin
May 9 — June 13, 1987

— John Chamberlain,
Peter Halley, Hubert Kiecol,
Günter Tuzina

Reinhard Onnasch Galerie, Fasanenstrasse, Berlin
July 24 — September 5, 1987

— Markus Oehlen. 1987

Reinhard Onnasch Galerie, Fasanenstrasse, Berlin
November 28 — December 23, 1987

Onnasch Collection

In conjunction with *Edward Kienholz. Roxys and other works* — a 1982 exhibition at the Gesellschaft für Aktuelle Kunst in Bremen that included significant loans from the Onnasch Collection — the idea arises to house contemporary art in the Weserburg Bremen on a permanent basis and to open, thereby, an imagined "collectors' museum." Originally, there is even talk of a museum devoted solely to the Onnasch Collection. Some years later, a museum of this kind is realized. In 1991, Onnasch's collection, with those of other collectors, comes to form the basis of the wide-ranging, lively institution — Europe's first collectors' museum, the Neues Museum Weserburg Bremen.

View of Lawrence Weiner, *Having been built on sand,* 1978, installed at the Neues Museum Weserburg Bremen, 1991

Photo: Joachim Fliegner

The concept of a permanent exhibition made up exclusively of works from private lenders is a novum in Europe. The Weserburg comprises a former coffee-roasting company's four warehouses on the Teerhof Peninsula. The building had been used since the firm's closing by various social and cultural institutions, including the Gesellschaft für Aktuelle Kunst founded in 1980. The Weserburg is later transformed into a museum by architect Wolfram Dahms.

— Opening of the Neues Museum Weserburg Bremen, with permanent loans from the Onnasch Collection

September 6, 1991

The Neues Museum Weserburg opens on September 6, 1991, under the direction of founding director Thomas Deecke.

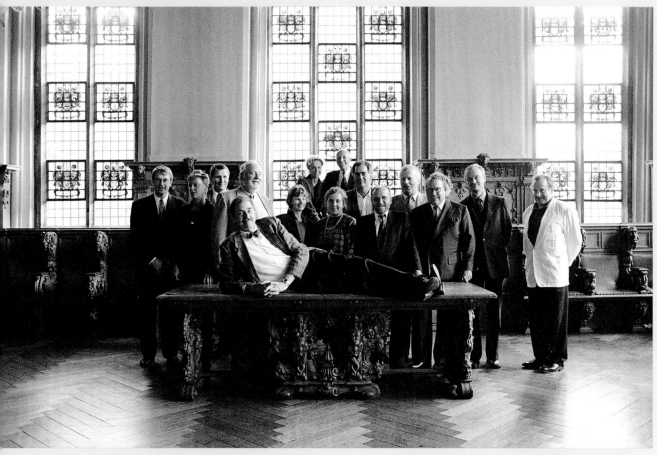

In addition to numerous permanent loans from the Onnasch Collection, the museum exhibits works of Arte Povera, Pop, and Minimal and Conceptual Art from various private collections, loaned by Hans–Hermann Stober, Hartmut Ackermeier, Georg Böckmann, Klaus Lafrenz, Anna and Gerhard Lenz, Hans Grothe, and several others.

On the occasion of the exhibition, which includes permanent loans from the Onnasch Collection, a comprehensive catalogue is compiled and published in 1992.

Portrait of collectors and founding director Thomas Deecke at a celebratory dinner in the town hall, on the occasion of the opening of the Neues Museum Weserburg Bremen
(Reinhard Onnasch, third from the left; Thomas Deecke on the table),
September 1991
Photo: Benjamin Katz

Reinhard Onnasch in conversation with Christine Breyhan

On the occasion of the opening of the Neues Museum Weserburg in Bremen, Christine Breyhan conducted the following interview.

Originally published in German in *Bestände Onnasch*, Neues Museum Weserburg, Bremen / Berlin 1992.

Catalogue, *Bestände Onnasch*,
Bernhard Kerber (ed.), Neues
Museum Weserburg, Bremen
1992

BESTÄNDE ONNASCH

Christine Breyhan

Reinhard Onnasch

You were the first collector involved in the planning of the Neues Museum Weserburg Bremen. How did you come up with the idea?

This museum grew out of a concept relating to a Kienholz exhibition held in 1981, some ten years ago. We exhibited *Roxys,* and others of the artist's works, in the Gesellschaft für Aktuelle Kunst (GAK) in the Weserburg and, later, showed works by the Italian artist Gianni Piacentino as well. It was then we thought of turning the building into a museum.

Wasn't it originally intended to house only your collection?

Yes; there was a plan to establish an Onnasch museum. But both the city government and I, myself, had certain reservations. The city worried about what would happen if I withdrew my collection. So, in conversations beginning in 1987, and held with Thomas Deecke, among others, we developed the idea of appealing to various other collectors who might participate. And then, there were enough of us involved, that should one or the other decide to remove his works, it wouldn't be devastating. The museum would continue to function and there would be a number of others who would gladly step in. This makes for excitement, and constantly changing juxtapositions of the collections — in short, a lively museum.

You worked professionally as a gallerist?

I started with a gallery in Berlin in 1968 and later, in 1970, I moved to Cologne. In 1971, I opened a gallery in New York and was the first German to do so in the city. It was a very exciting time. I exhibited German artists in America — for example, Gerhard Richter in 1971 — and American artists in Germany. The first Americans I showed were Artschwager, Arakawa, Kienholz, Segal, Copley, and Hans Hofmann. Today, I am a part owner of the Jablonka Gallery in Cologne, which mainly exhibits international, new avant-garde art.

Have you focused on specific stylistic trends?

No and quite deliberately. It is my opinion that if one collects only a single stylistic trend, one necessarily limits oneself. I have always avoided that. I have tried to collect unusual works from various artistic movements in competition with each other. The sixties were a period of conflicting styles — Pop Art and Minimal Art, for example, were being developed at the same time — or the one shortly after the other. The art scene was extremely lively.

How did you happen to collect a tableau like Kienholz's *Roxys?*

That I managed to get it was a stroke of luck. *Roxys* was actually supposed to be added to the Ströher collection. But somehow Ströher didn't care for the work. When it was offered to me I was immediately enthusiastic, and took it. That was in 1971.

Now *Roxys* has landed in the museum, and can no longer be entered, though that was the artist's original intention. Has the work been somewhat compromised?

Yes, this is true. But *Roxys* had already been included in a great number of museum exhibitions. First in Europe at documenta, in Kassel; then in London, Stockholm, Zurich, Paris, Dusseldorf, and, finally, for several years in Strasbourg. The problem is that works get knocked about. They don't get any fresher. And this is readily apparent. The installation *The Beanery,* in Amsterdam's Stedelijk Museum, has suffered markedly. It was initially not a problem for Kienholz to rework something, or even replace it. But he is not always available and he, too, has grown older. So, in Bremen, he chose a staging of his environment that doesn't exclude the viewer but still protects the work.

Christine Breyhan

Reinhard Onnasch

It's been thirty years since *Roxys* was created. Has it become dated?

Of course! Time turns things into museum pieces. But luckily museums have changed a great deal in the last few years. They have become more vital; they are exhibiting much more contemporary art. It used to be that an artist had to have died before he made it into a museum.

That is very positive but the very artists who once resisted being hung in museums now no longer oppose it. Don't artists become dated faster this way as well?

When I started, in 1968, things were highly political. Artists were also politically engaged. They were hostile to the art trade and to the whole museum business. And this led to very interesting approaches. Much of Conceptual Art would not have been possible without such an impetus.

There is one American art critic, Seth Siegelaub, who at the time championed a number of American and European artists — Daniel Buren and Lawrence Weiner, for example — who had consistently refused to be commercialized. At the time it was considered an impossibility that these artists would ever be taken up into a museum's collection. It wasn't the same with Kienholz. But, ultimately, he's also a generation older.

The museum business is booming. It can no longer do without collectors. Does the collector fill a gap? Does he step in with works lacking in museum collections?

The problem is that art has become very expensive, and especially in the last decade. Government agencies are simply not prepared to pay such prices for art. Purchasing budgets have remained relatively stable and have not increased along with the rise in prices. It's for this reason that many collectors are asked to fill the gaps. I have always done so quite happily, for I would rather show my works than have them lay around in a storeroom.

And, simultaneously, artists are encouraged by having their work on display and collectors are given professional exposure. But isn't there the danger that the state might relinquish its task of promoting the arts?

Here, in the museum, we have had this very discussion with the senator for culture. We have agreed on a compromise and concluded that the Neues Museum Weserburg Bremen should also have its own purchasing budget. It is small, to be sure, but I hope it will grow so that the museum can acquire a collection of its own, at least a foundation.

To what extent is the art market influenced by the public exhibition of private collections?

Private collections have been very greatly influenced by various factors: by galleries, art critics, museums, but also the artists themselves, who demand preference over other artists. It is all interconnected. Thanks to instant worldwide communication there are essentially only five hundred to one thousand people around the world who effectively influence the art market. This troubles me at times, and it also troubles me a great deal that, in the world's museums, the same art is exhibited over and over again. Because they often try to be cutting edge, museums can become boring, simply because they are arbitrary. The public display of cutting edge collections naturally reinforces this tendency.

Is your personality reflected in your collection? Is it a form of self-expression?

Perhaps you could see it as such; I've never thought about it. My collecting is very spontaneous. I could never concentrate on collecting only Minimal Art, for example, or only realism, et cetera. Of course one can concentrate exclusively on a single stylistic direction, and there are notable examples of this, but such a mode would not suit my temperament. I collect impulsively, but not — I feel — without a plan.

Christine Breyhan

Reinhard Onnasch

Have you found that once you manage to place someone under the spell of art he becomes more accepting?

It is my opinion that the fine arts are enormously thought provoking and that, in turn, creates acceptance. One expands one's horizon and thereby becomes more tolerant, if one deals intensively with individual artists.

Isn't everything always in flux even with well-established artists?

Surely. That's what is exciting, that there are always surprises. You often think that something can't go any further and that art has reached an endpoint. When painting was abandoned in Tachism it was said, for example, that painting was over, passé. And there were similar assertions in response to abstract painting in America, the great New York School of the fifties. Then, suddenly, there was the revolution embodied by Pop Art and, once again, painting survived. Then came the experimentation of Minimal and Conceptual Art, and so on it goes. It even survived Art Brut. One may not recognize it but there are always new aspects and approaches that are important. Needless to say, even so-called "arrived" art is reclassified and reevaluated accordingly. For example, by the fact that young artists refer to it.

Do you see something of the *zeitgeist* in all this?

Yes. Again and again one is forced to recognize that there are various artistic activities that come from wholly different intellectual approaches specific to the times. The interchange that takes place between artists is also important in terms of art theory. There have always been people representing the various points of view and there always will be.

Does a collector become an expert over the years?

Yes. If one attends to it properly one is constantly learning and seeing things faster, and can also more readily distinguish between quality and mediocrity, even in the work of young artists. To be sure, one also has to distinguish between originals and forgeries early on. Plagiarism has been a problem through all of art history.

Can you let go of a work if you've discovered one of higher quality?

My collection is in constant flux. I sell pieces and buy new ones to take their place. If people are paying huge prices for work that I consider overvalued, I can part with it so as to use the money to buy newer or older art that I feel is undervalued.

You must be prepared to take risks. Has your success ratio always been good?

When you deal with new art you can't only think in terms of success ratios, for success ratios don't always depend on the work's quality but often rather on who is championing something, which dealers are promoting it, what the critics are saying, how museums are reacting. Artists sometimes suddenly adopt a new style, and many have stopped painting altogether. Of course there are always a few pieces that don't hold up one hundred percent but, actually, my success ratio has been quite good.

(Translated by Russell Stockman)

— Kurt Kocherscheidt. Werke
aus der Sammlung Onnasch und
weiteren Leihgaben

Neues Museum Weserburg Bremen
March 4 — May 2, 1993

— Claes Oldenburg
Geometrische Mäuse

Neues Museum Weserburg Bremen
March 16 — August 30, 1993
(traveled, with additional loans from the Onnasch Collection to Portikus Frankfurt)

— Richard Long. Skulpturen,
Fotos, Texte, Bücher

Neues Museum Weserburg Bremen
November 28, 1993 — February 13, 1994

Curated by Thomas Deecke and Peter Friese, the exhibition in-
cludes floor sculptures from the Onnasch and Lafrenz Reinking
collections, as well as works from the collections of Christel
and Klaus Maas (Moers) and Konrad Fischer (Dusseldorf). It is also
accompanied by a catalogue.

— Lawrence Weiner
Tatsächlich. Skulpturen aus der
Sammlung Onnasch.
Bücher aus dem Archive for Small
Press & Communication im Neuen
Museum Weserburg Bremen

Neues Museum Weserburg Bremen
October 1, 1999 — January 16, 2000

Catalogue,
*Tatsächlich. Skulpturen
und Bücher
von Lawrence Weiner,*
Neues Museum Weserburg
Bremen 2000

— The Onnasch Collection
Aspects of Contemporary Art

Museu d'Art Contemporani de Barcelona
November 7, 2001— February 24, 2002

In 2001— 2002 a portion of the collection is shown in the
Museu d'Art Contemporani de Barcelona (MACBA) and the Museu
Serralves in Porto.

Views of the
exhibition,
*The Onnasch
Collection. Aspects
of Contemporary Art,*
Museu d'Art
Contemporani de
Barcelona (MACBA),
November 2001
Photo: Rocco Ricci

— The Onnasch Collection
Aspects of Contemporary Art

Museu de Arte Contemporânea de Serralves, Porto
March 22 — June 23, 2002

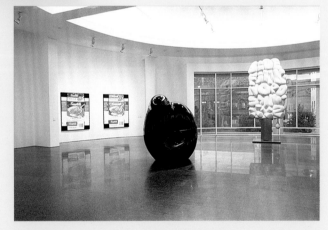

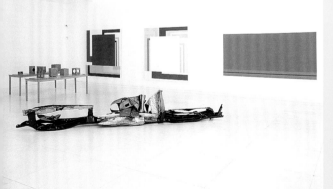

View of the exhibition,
*The Onnasch Collection.
Aspects of
Contemporary Art,*
Museu de Arte
Contemporânea
de Serralves, Porto,
March 2002
*Photo: Rita Burmester /
Fundação de Serralves*

Pieces from the collection can be seen on permanent loan in vari—
ous European museums, among them the Kunsthalle Hamburg;
the Fondation Beyeler in Riehen, near Basel; and the Museo
Nacional Centro de Arte Reina Sofia in Madrid.

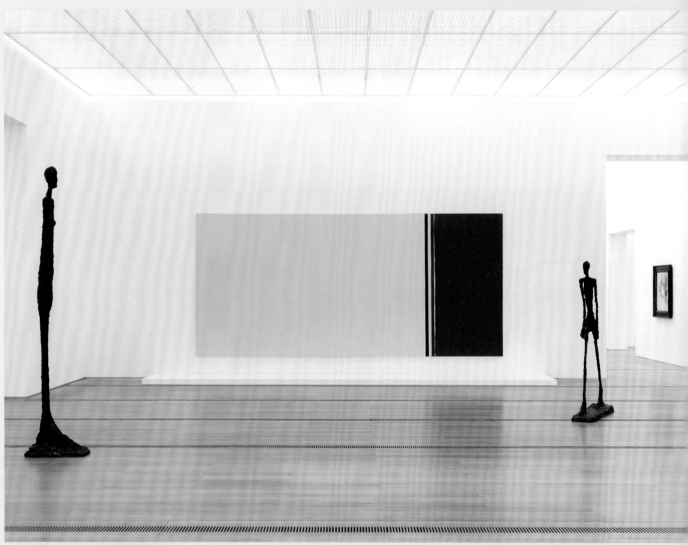

View of Barnett Newman, *Uriel*,
1955, installed at Fondation
Beyeler, Riehen / Basel, 2009.
On the left Alberto Giacometti
Grande femme IV, 1960;
on the right Alberto Giacometti,
L'Homme qui marche II, 1960;
in the background
Pablo Picasso *Verre, bouteille,
guitare ('Ma Jolie')*, 1914
Photo:
Adriano A. Biondo

Berlin
2007 — 2009
El Sourdog Hex e. V.
Zimmerstrasse 7
Berlin

In 2007 Reinhard Onnasch establishes the art society and exhibition space El Sourdog Hex on Zimmerstrasse in Berlin–Mitte. The name El Sourdog Hex goes back to George Brecht's play on words and exhibition at the Onnasch Gallery in New York in the winter of 1973. The exhibition space opens with works by George Brecht.

— George Brecht
El Sourdog Hex
El Sourdog Hex, Zimmerstrasse, Berlin
January 22 — March 2, 2007

View of facade of
El Sourdog Hex,
during the exhibition,
*George Brecht.
El Sourdog Hex,*
January 2007
Photo:
Stephan Janz, Berlin

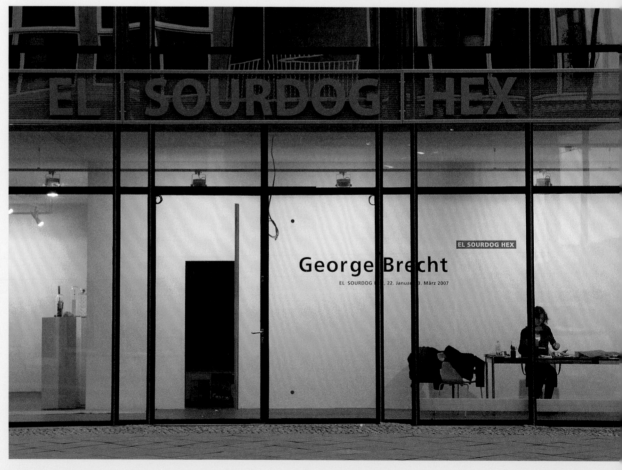

For three years Onnasch presents selections from his collection in changing one–man exhibitions. El Sourdog Hex closes at the end of December 2009 with an exhibition of Edward Kienholz's key work *Roxys.*

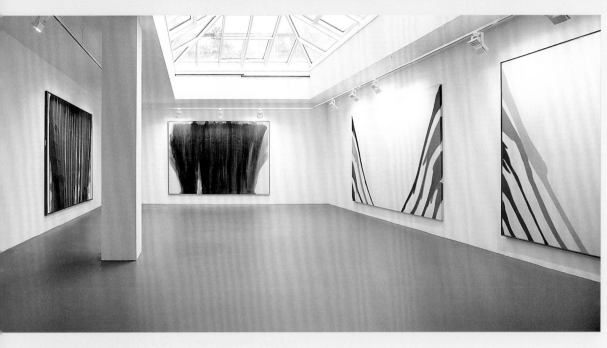

View of the exhibition,
*Morris Louis —
Kenneth Noland.
Colourfield Painting,*
March 2007
*Photo:
Lepkowski Studios, Berlin*

— Morris Louis —
Kenneth Noland
Colourfield Painting

El Sourdog Hex, Zimmerstrasse, Berlin
March 12 — April 28, 2007

— Stefan Wewerka. H + D Türen,
Eckstühle, Abendmahl

El Sourdog Hex, Zimmerstrasse, Berlin
May 7 — June 30, 2007

— Jason Rhoades. Multiples

El Sourdog Hex, Zimmerstrasse, Berlin
July 9 — September 1, 2007

Reinhard Onnasch
and Suzanne Lenze
during the exhibition,
*Jason Rhoades.
Multiples,* 2007.
In the background,
Jason Rhoades,
Spaceball, 1997
*Photo:
Stephan Janz, Berlin*

— **Bernd Koberling**
Landschaftsbilder
El Sourdog Hex, Zimmerstrasse, Berlin
September 10 — October 27, 2007

— **Roberto Matta**
What is the Object of the Mind?
El Sourdog Hex, Zimmerstrasse, Berlin
November 5 — December 29, 2007

— **Claes Oldenburg**
The Store, and later
El Sourdog Hex, Zimmerstrasse, Berlin
January 8 — February 23, 2008

— **Erwin Heerich. Schilderwald**
El Sourdog Hex, Zimmerstrasse, Berlin
March 3 — April 26, 2008

— **Lowell Nesbitt**
Landscapes and Cityscapes
El Sourdog Hex, Zimmerstrasse, Berlin
May 5 — June 28, 2008

— **Lawrence Weiner**
Seven Statements in One
El Sourdog Hex, Zimmerstrasse, Berlin
September 8 — November 1, 2008

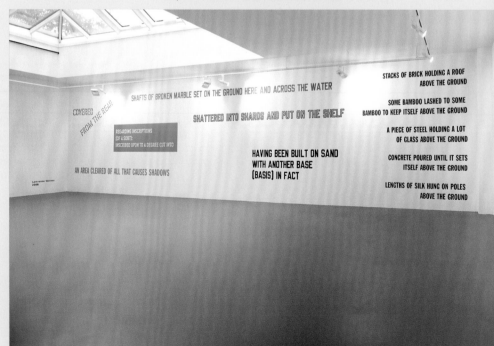

View of the exhibition,
Lawrence Weiner.
Seven Statements in One,
July 2008
Photo:
Lepkowski Studios, Berlin

— Gianni Piacentino
Homage to Wright Brothers

El Sourdog Hex, Zimmerstrasse, Berlin
November 10 — December 27, 2008

— William N. Copley
Western Songs

El Sourdog Hex, Zimmerstrasse, Berlin
January 5 — February 28, 2009

— Markus Lüpertz
Dithyrambische Malerei

El Sourdog Hex, Zimmerstrasse, Berlin
March 9 — April 25, 2009

— Peter Halley
Cells and Conduits

El Sourdog Hex, Zimmerstrasse, Berlin
May 4 — June 27, 2009

— Howard Kanovitz
Death in Treme

El Sourdog Hex, Zimmerstrasse, Berlin
July 6 — August 29, 2009

— Keith Sonnier
Light Installations

El Sourdog Hex, Zimmerstrasse, Berlin
September 7 — October 31, 2009

— Edward Kienholz. Roxys

El Sourdog Hex, Zimmerstrasse, Berlin
November 9 — December 30, 2009

View of the exhibition,
Edward Kienholz. Roxys,
November 2009
Photo:
Lepkowski Studios, Berlin

Reinhard Onnasch in conversation with Thea Herold and Katrin Wittneven

First published in *Nineteen Artists,* Kerber, Berlin 2009, as an abbreviated version of the original interview published in German in *BerlinBlock 1,* no. 11, 2009.

Museums renowned worldwide view Reinhard Onnasch's collection with envy. This pioneer among private art collectors has traditionally maintained a rather low profile and public exhibitions of his treasures have been something of a rarity. Until now …

Herold / Wittneven

Reinhard Onnasch

Mr. Onnasch, the idea for your temporary gallery space at Zimmerstrasse came to you during a sleepless night. Has staying awake been rewarded?

I had long been considering how to finish nearly four decades of art exhibition activities on a high note. It's true that the concept for the El Sourdog Hex exhibition space was completed in a single night — including all the artists and the works. Over a three-year period, eighteen exhibitions were to reflect the artistic movements and the reasons behind my various stays in Berlin, Cologne, and New York. The objective was a sort of rendering of accounts. As a businessman might say, "What's the balance?"

And what conclusion have you drawn? You've seen many pieces again for the first time in years.

The plan has actually worked out exactly as I had hoped, in particular because the impression that's made is not of a completed whole but rather of something very disparate instead. The stances taken by Edward Kienholz, Keith Sonnier, Lawrence Weiner, and Jason Rhoades could hardly be more at odds. But this is precisely what has always interested me about art.

You began collecting art early on in life. How did you get started?

I worked in real estate back when I was a student in the early sixties. It didn't take me long to realize that I was bored by working solely in the property business. Brokering homes for people was pretty dry and predictable, while art was the complete opposite. I traveled a great deal, simply because there were still so few galleries in Berlin at the time. One could experience interesting art and establish contact with artists and gallery owners in Munich, the Rhineland area, and, of course, in New York.

You opened your first gallery in 1969 in Berlin, followed then by others in Cologne and New York.

My first gallery was genuinely chaotic: a real mix-and-match place. It opened with a celebration presenting the works of every artist I knew personally. I was utterly surprised by what a financial success it turned out to be. Some 1,700 people attended the opening, though by today's standards the selection of works was pretty mediocre. Things got more serious once I made my way to Cologne and New York, although usually I sold almost nothing at those exhibitions. The market wasn't there for the types of work I had on offer. But there were certain pieces that I wanted to keep anyway.

From a gallery owner's perspective, don't you effectively make a loss if you keep the best works for yourself?

No, I didn't look at it that way. I was always more of a collector than a dealer. It was a time when people could still afford to buy truly outstanding works of art, since prices were much lower in the sixties. When the real estate business was good, I always managed to put money aside to procure art. That's how I started my collection. I still have a few works that haven't ever been displayed.

I certainly believe it: Your collection is said to consist of some 1,000 pieces, and the list of artists reads like a who's who of contemporary art history: Barnett Newman, Clyfford Still, Joseph Beuys, Gerhard Richter, Sigmar Polke. Where are all these works?

I've had to part with some of them during tougher times. Others are in storage in Cologne, and a few are on loan to museums. That was one of the things that prompted the exhibition space. Art kept in storage can't be appreciated by the public.

Was it relevant for your assessment of the works that you knew the artists personally?

No. My interest was always in the work itself, not the artist. The art, the work produced by the artist, always took precedence. That's what I had to grapple with. Sure, there were people like Gerhard Richter, Joseph Beuys, and especially Ed Kienholz, with whom I discussed the finer points of art. I really had no idea what I was doing when I started out.

Herold / Wittneven

Reinhard Onnasch

But you had a keen sense of intuition. People say that your margin of error is 0.0%. How did you learn to separate good art from the rest?

By traveling as much as I could, seeing as much as I could, and talking to people. I was constantly reevaluating my own opinion. I have tried to engage with art and artists all over the world. My goal has always been to spot something truly unique. But you have to find your own way to get there. That's how to find "your" art.

Wouldn't it have been interesting as a gallery owner to profit even more from your intuition?

I was never one to push or hype an artist. That wasn't in my nature. The painstaking work of putting together a catalogue, negotiating with museums and the like wasn't for me. But I could always buy a picture from an artist, sometimes four at a time. And I was also capable of parting with them. Back in the sixties I got a call from Gerhard Richter, who told me how he hadn't slept all night because I owned too many of his pictures. He felt that this gave me undue influence over his market. So I gave half the pictures back to him.

Today it would be almost inconceivable for a gallery owner to present his collection at the Neue Nationalgalerie in Berlin, as you did in 1978.

The circumstances were very different then. I had pieces by Richter, Polke, and Beuys that the museum's director, Dieter Honisch, was eager to show. No purchasing commission would have approved those works at the time. Despite the fact, Honisch wanted to proceed in this way to put on an exhibition that accurately reflected contemporary art at the time, and that's precisely what he did. But it wasn't a commercial move.

Did you consciously take it upon yourself to bring German art to the United States and vice versa, or did that happen simple by coincidence?

There was no strategy as such. It was more of a coincidence. Look. Not everything was successful. The seventies were a very bleak time. I was out of money and I had to close the gallery. There wasn't always an upward trend.

...like there is today?

Yes, I suppose so. But the prices art commands today won't last. Lately, it almost seems like a young artist who only first picked up a brush six weeks ago can sell a picture for 20,000 Euro.

Yet despite the many ups and downs, you've managed to hold on to the highlights of your collection. Have you hidden them from yourself?

Once you get your hands on a Barnett Newman masterpiece, you never let it go.

Clearly, the value of art cannot be reflected in figures. What makes a work of art valuable in your eyes?

When I come across something new, something that instantly electrifies me, I pursue it and I don't let up. I have never discovered artists, only art. [laughs]

Has a work of art ever led you astray?

Sure, there have been times when I was smitten too quickly. Then it wears off and you sell the piece again. That's another advantage of being a collector as opposed to a dealer. Attachments are easier to unravel.

You've mentioned that freedom right up to today, even in regard to museums. Other collectors of your stature have long since affiliated themselves with a particular institution. You've only made one exception, for the Neues Museum Weserburg in Bremen from 1991 to 2005.

Yes, Bremen was a special case. There was a museum there, but it had no art. I was able to be of service by providing them with my collection until they had their own. I'm not opposed to entering into that sort of arrangement if my quality standards are met and doing so coincides with my aims. Be that as it may, a truly long-term agreement would be out of the question.

Wouldn't you like to see your collection on permanent display at one of Berlin's museums?

No. I envision problems in that kind of situation. It's essential that collectors maintain a certain degree of distance from museums.

If the prospect of your collection becoming part of a museum's permanent exhibition is ruled out, what do you see as the next step?

I don't know, to be truthful. I don't have a plan yet. I'll just take things as they come.

(Translated by Samson & Fritaud Text)

Plates

— Larry Bell
b. 1939

— George Brecht

1926 — 2008

*Table with
Rainbow Leg*
1962 — 63
Painted wood table,
sunglasses, and
a packet of tobacco
24 ⅝ × 17 ¾ × 16 inches
(62.4 × 45.1 × 40.6 cm)

Clothes Tree
1962 — 63
Painted wood coat rack,
hats, umbrellas,
and raincoat
76 × 27 ½ × 27 ½ inches
(193 × 70 × 70 cm)

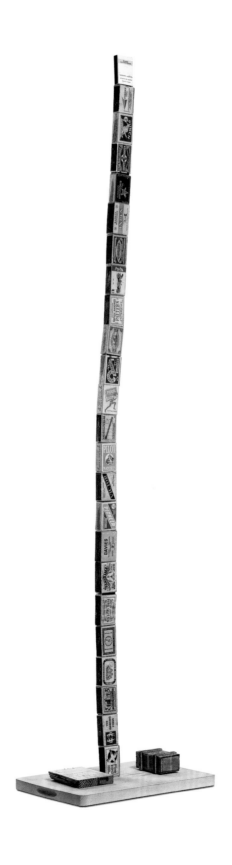

Little Anarchist Dictionary
1969
Wood and matchboxes
45 ¼ × 11 ⅜ × 7 ⅛ inches
(115 × 29 × 18 cm)

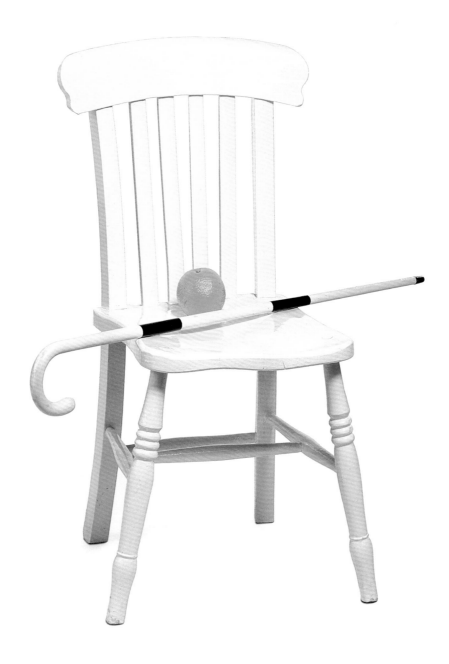

Chair Event
1960
Painted chair, walking stick,
and orange
34 ⅝ × 18 ⅞ × 37 ⅜ inches
(88 × 48 × 95 cm)

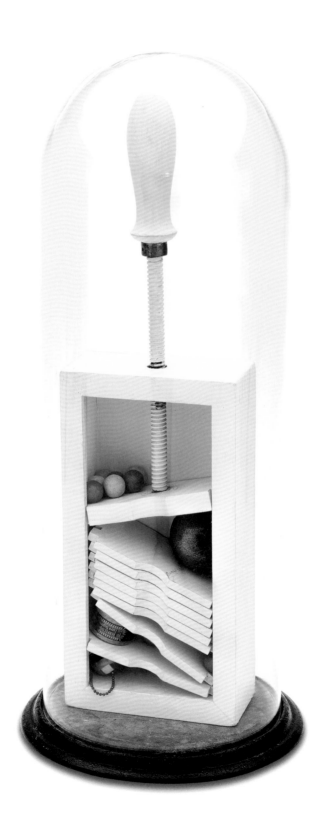

*Perfectionne
Extra Superior*
1970
Small paper press,
colored balls,
velvet, plastic, and
metal
15 ¾ × 8 ¼ inches
(40 × 21 cm)

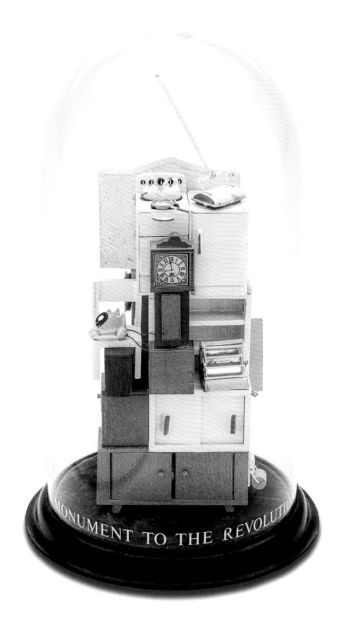

*Monument to
the Revolution*

1970
Glass, wood, fabric,
and plastic
11¼ × 6½ inches
(28.5 × 16.5 cm)

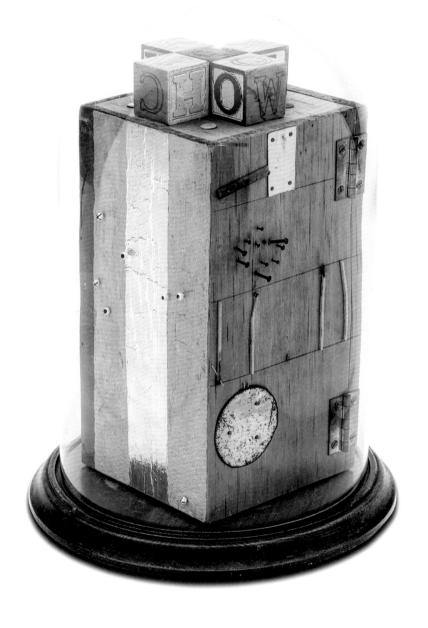

Redemption
Dome

1959
Wood, glass, metal, paint,
aluminum foil,
paper, pins, and steel nails
13 × 9½ inches
(33 × 24 cm)

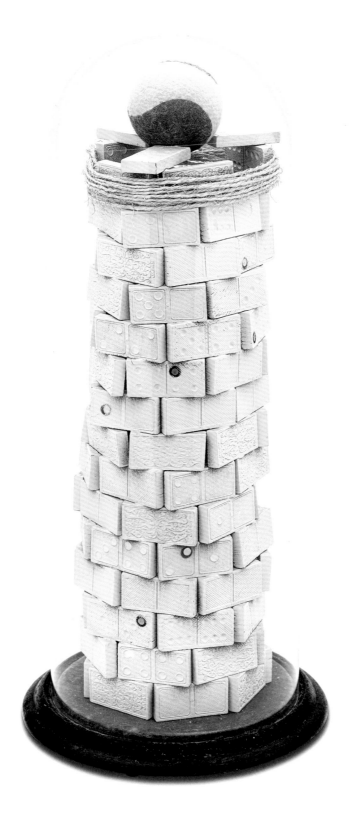

*White Domino Piece
with String and
Blue and White Ball*

1969
Wood, fabric, rope,
paint, Domino pieces, glass,
and ball
17 ¾ × 8 ¼ inches
(45 × 21 cm)

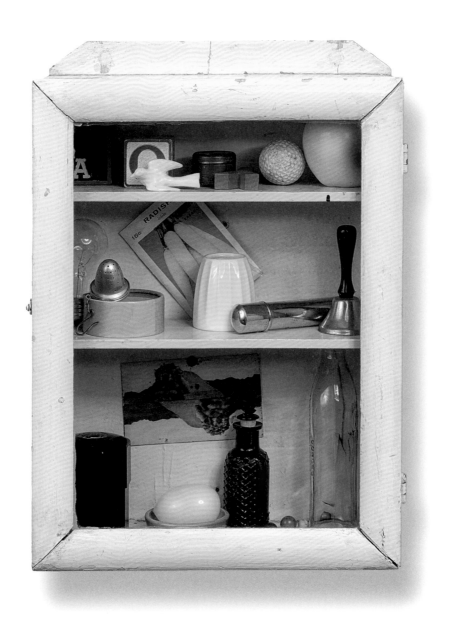

*Medicine
Cabinet*
1960
Wood, glass, paper,
plastic, and metal
14 ⅝ × 11 ⅜ × 4 ⅜ inches
(37 × 29 × 11 cm)

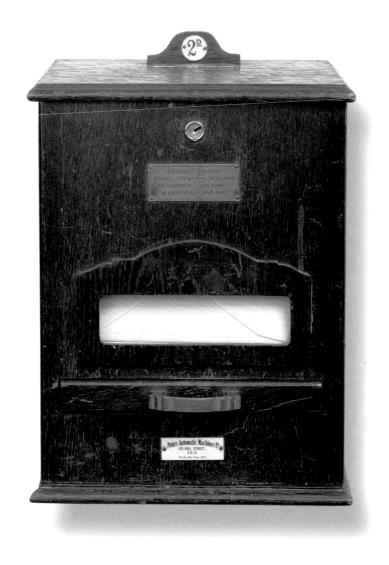

Dispenser

1960
Glass, wood, metal,
and paper
11 × 8 ⅝ × 7 ½ inches
(28 × 22 × 19 cm)

The Case

1959
Wood, glass, paper,
string, and metal
7 ⅞ × 16 ⅛ × 11 ¾ inches
(20 × 41 × 30 cm)

— Daniel Buren
b. 1938

*Peinture
acrylique blanche
sur tissu
rayé blanc et vert*
1970
Acrylic on canvas
60⅜ × 55½ inches
(153.5 × 141 cm)

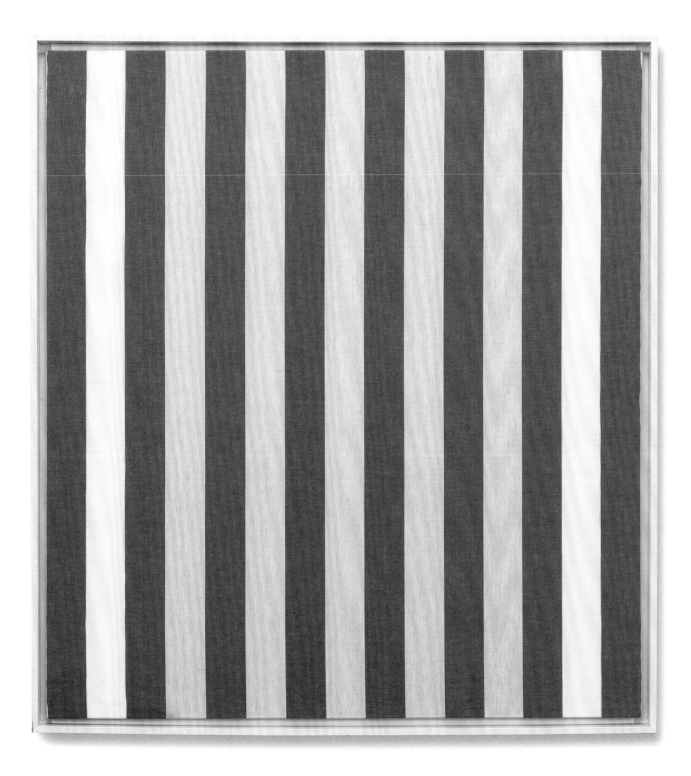

— Christo

b. 1935

*Wrapped
Road Sign*
1963
Fabric, rope, and
wooden road sign with
plastic reflector
56¼ × 22 × 18¼ inches
(143 × 56 × 46.5 cm)

— William N. Copley
1919 — 1996

*"Give me that piece of chalk with which
you mark the baseball score — you
shall see the lovely Madeline upon the
barroom floor," from "The Face on
the Barroom Floor" by H. Antoine D'Arcy*
1966
Acrylic on canvas
45¼ × 35 inches
(115 × 89 cm)

*"Don't go into the lions' cage tonight,
Mother darling, the lions are ferocious
and may bite," from "Don't go into
the Lions' Cage Tonight, Mother Darling"*
1966
Acrylic on canvas
35 × 45¼ inches
(89 × 115 cm)

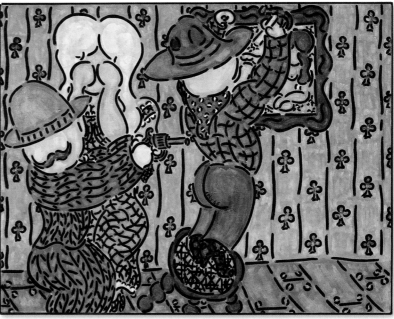

"Root-a-toot-toot, three times she shot right through that hardwood door," from "Frankie and Johnnie" — Unknown

1966
Acrylic on canvas
45¼ × 35 inches
(115 × 89 cm)

"Says my Nellie dressed in blue, 'Your trifling days are through — now I know that you'll be true, god damn your eyes,'" from "Sam Hall" — Unknown

1966
Acrylic on canvas
45¼ × 35 inches
(115 × 89 cm)

"'Twas a dirty little coward shot Mr. Howard, and laid Jesse James in his grave," from "The Death of Jesse James" — Unknown

1966
Acrylic on canvas
35 × 45¼ inches
(89 × 115 cm)

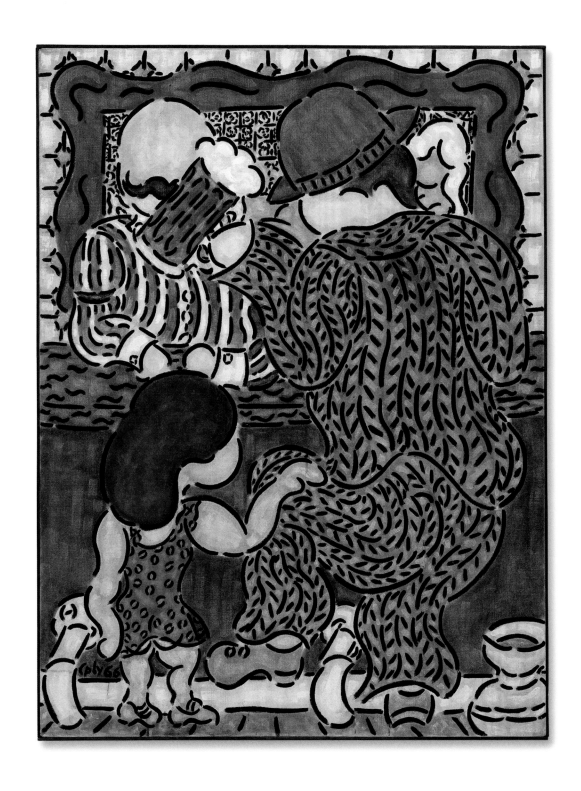

"Father, dear Father come home with me now, the clock in the steeple strikes one" from "Come Home, Father"
by Henry Clay Work
1966
Acrylic on canvas
59×35 inches
(150×89 cm)

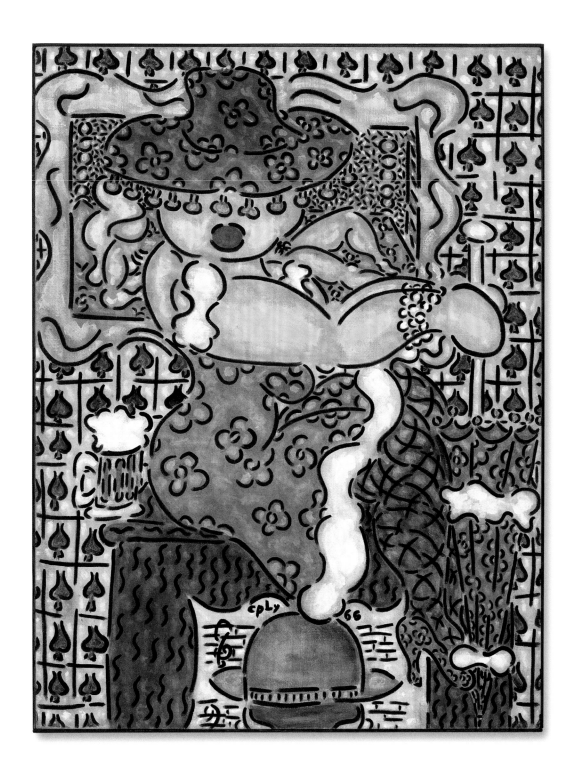

"And watching his luck was his light-o-love, the lady that was known as Lou." from "The Shooting of Dan McGrew" by Robert W. Service

1966
Acrylic on canvas
45 ¼ × 35 inches
(115 × 89 cm)

— Hanne Darboven

1941 — 2009

Kurt Schwitters

1987

Ink on paper, offset on cardboard,

424 pages

Each: 16 ½ × 11 ¾ inches

(42 × 29.7 cm)

Overall dimensions variable

MILIEU ›80‹ — 87 — : heute
MILIEU ›80‹ — 87 — : heute

heute
MILIEU ›80‹ — 87 — : heute
MILIEU ›80‹ — 87 — : heute

heute
MILIEU ›80‹

23. 9. 87

seite – 308 – 39. woche 87

30. 9. 87

seite – 316 – 40. woche 87

seite – 324 –

24. 9. 87

seite – 309 – 39. woche 87

1. 10. 87

seite – 317 – 40. woche 87

seite – 325 –

25. 9. 87

2. 10. 87

— Mark di Suvero

b. 1933

Homage to Brancusi
1962
Wood and steel
79 × 21¾ × 52 inches
(200.6 × 55.2 × 132.2 cm)

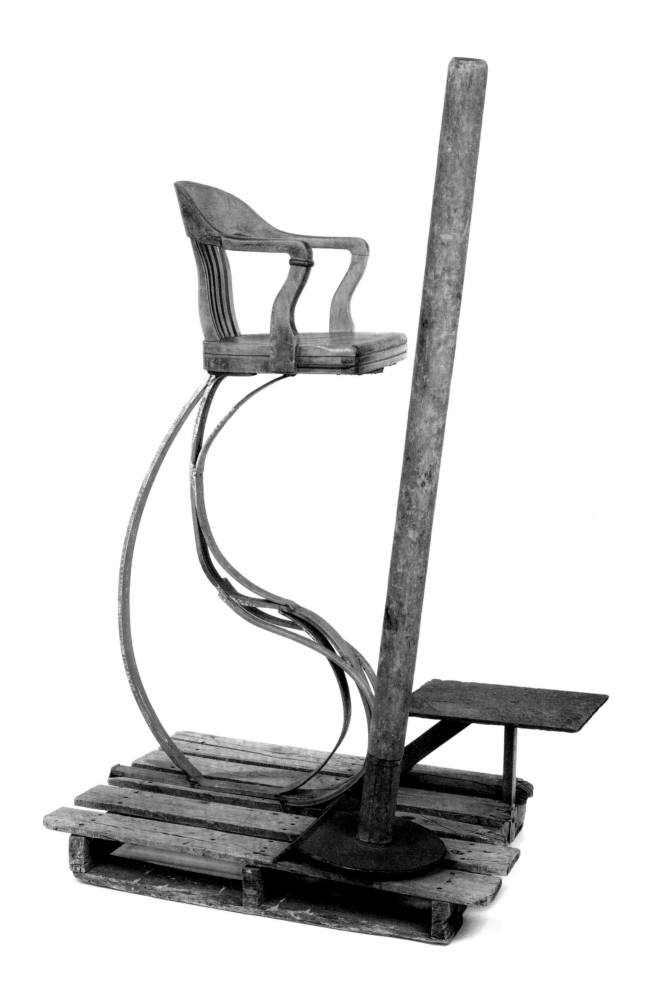

Long nose pliers

1962
Oil on canvas
with objects
82⅝×59 inches
(210×150 cm)

Hair

1961
Oil on canvas
72 × 72 inches
(183 × 183 cm)

Flesh chisel

1962
Oil on canvas and
wood with object
83⅞ × 60¼ inches
(213 × 153 cm)

The hammer acts

1962
Wood panel, oil, hammer,
and steel nails on canvas
84 7/8 × 75 1/8 inches
(215.5 × 190.9 cm)

— Dan Flavin

1933 — 1996

Untitled
1968
Red and blue
fluorescent light
Ed. 3 / 3
Height:
120 ⅛ inches
(305 cm)

— Richard Hamilton
1922 — 2011

Toaster deluxe 4

2008

Inkjet, stainless steel, polycarbonate,
on Somerset Velvet for
Epson paper 505 gsm, GM WaterWhite
Museum glass, tulipwood, brass,
expanded neoprene, polyethylene
Framed: 34 ⅞ × 28 ⅞ inches
(88.5 × 73.3 cm)

Toaster —
deluxe study IX
2008
Epson inkjet print on
Somerset satin paper and
mirror chrome laminate
Framed: 18 ⅛ × 14 ⅝ inches
(46 × 37 cm)

Toaster —
deluxe study X
2008
Epson inkjet print on
Somerset satin paper and
mirror chrome laminate
Framed: 18 ⅛ × 14 ⅝ inches
(46 × 37 cm)

Toaster —
deluxe study XIII

2008
Epson inkjet print on
Somerset satin paper and
mirror chrome laminate
Framed: 18 ⅛ × 14 ⅝ inches
(46 × 37 cm)

Toaster —
deluxe study XV

2008
Epson inkjet print on
Somerset satin paper and
mirror chrome laminate
Framed: 18 ⅛ × 14 ⅝ inches
(46 × 37 cm)

— Edward Kienholz

1927 — 1994

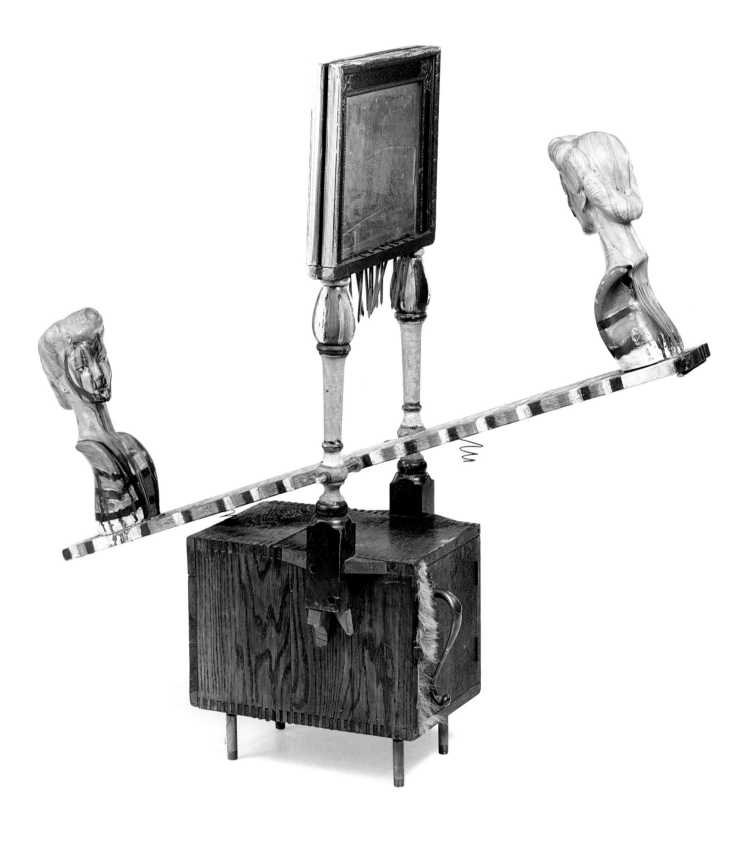

The Carnivore
1962
Floor tiles, metal,
fur, adhesive tape,
and resin
38 ¼ × 51 ⅛ × 19 ¼ inches
(97 × 130 × 49 cm)

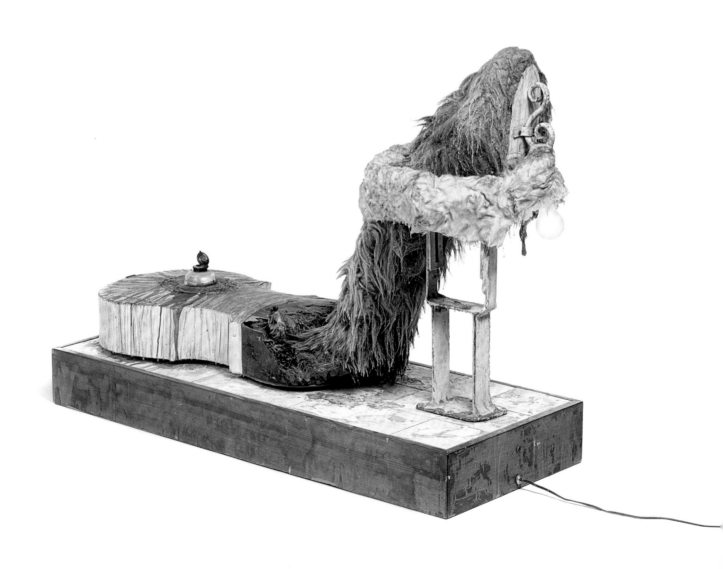

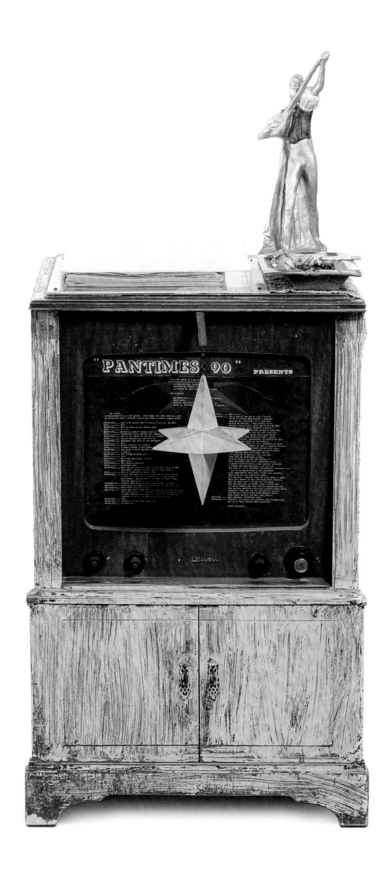

The Big Eye
(Homage to H.S.)

1961
Painted TV console,
newspaper article,
figurine, and plastic
55⅞ × 24 × 29⅞ inches
(142 × 61 × 76 cm)

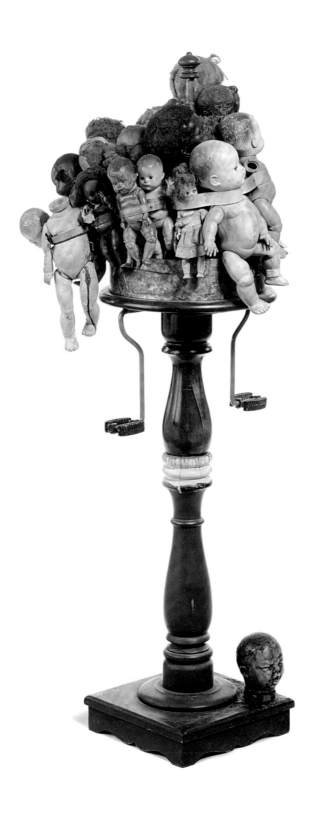

The Future as an
Afterthought
1962
Paint and resin on plastic
and rubber doll parts
with sheet metal, tricycle
pedals, and wood
53 ⅞ × 20 ⅞ × 16 ⅞ inches
(137 × 53 × 43 cm)

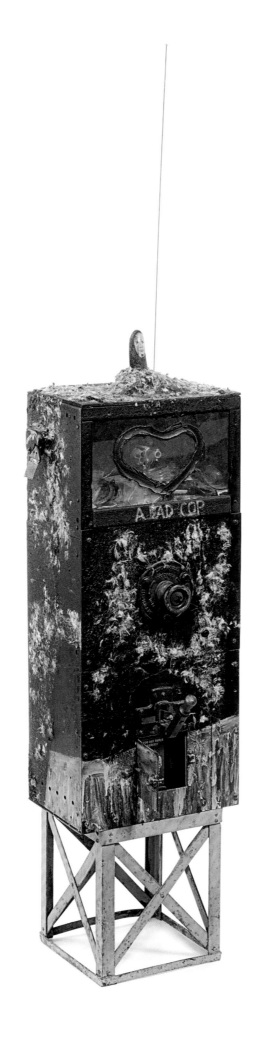

A Bad Cop
(Lieutenant Carter)

1961
Metal case, photograph,
pistol, wood, tar, feathers,
and resin
55⅛ × 16½ × 11¾ inches
(140 × 42 × 30 cm)

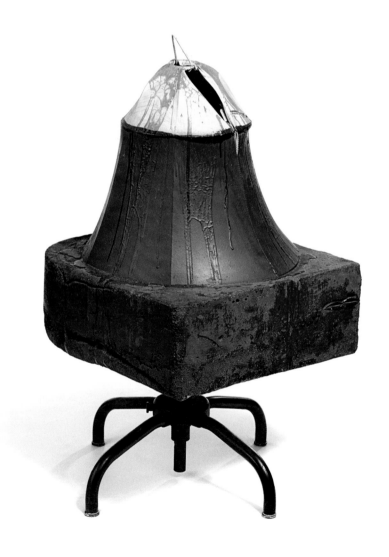

Rip van Stender
1962
Metal stand, concrete,
lampshade, and resin
23⅝ × 23⅝ × 33⅞ inches
(60 × 60 × 86 cm)

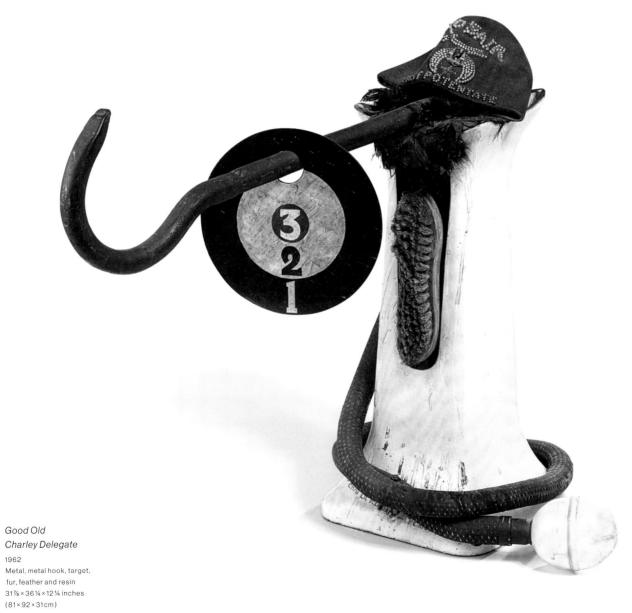

Good Old
Charley Delegate
1962
Metal, metal hook, target,
 fur, feather and resin
31⅞ × 36¼ × 12¼ inches
(81 × 92 × 31 cm)

165

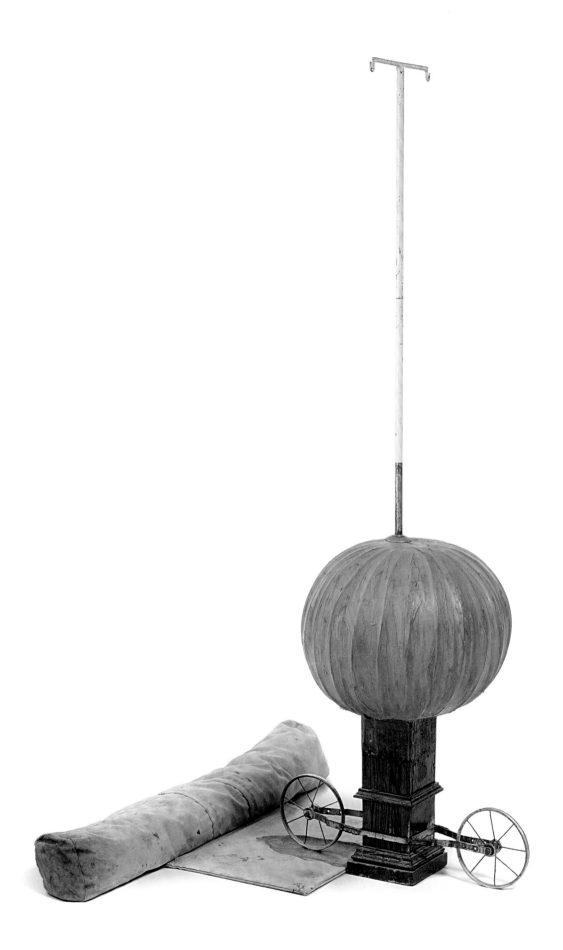

A Star Is Birthed

1963
Metal, adhesive tape,
and textiles
68½ × 48 × 50 inches
(174 × 122 × 127 cm)

— Franz Kline

1910 — 1962

Zinc Door
1961
Oil on canvas
92½ × 67¾ inches
(235 × 172.1 cm)

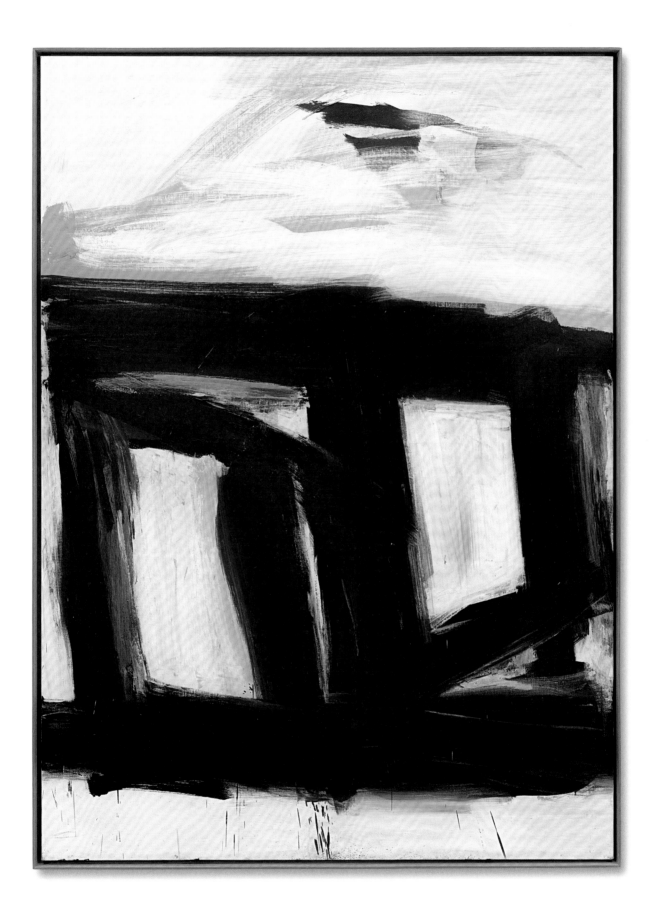

— ## Morris Louis

1912 — 1962

Gamma Iota

1960
Acrylic resin (Magna)
on canvas
102 × 156 ½ inches
(259 × 397.5 cm)

Gamma Tau
1960
Acrylic resin (Magna)
on canvas
102¾ × 166½ inches
(261 × 422.9 cm)

Dalet Vav

1958
Acrylic resin (Magna)
on canvas
89 × 158 inches
(226.1 × 401.3 cm)

Beth Zayin
1959
Acrylic resin (Magna)
on canvas
99½ × 141½ inches
(252.8 × 359.4 cm)

177

— Robert Motherwell

1915 — 1991

*Wall Painting
No. III*

1953
Oil on canvas
54 × 72⅞ inches
(137.1 × 184.5 cm)

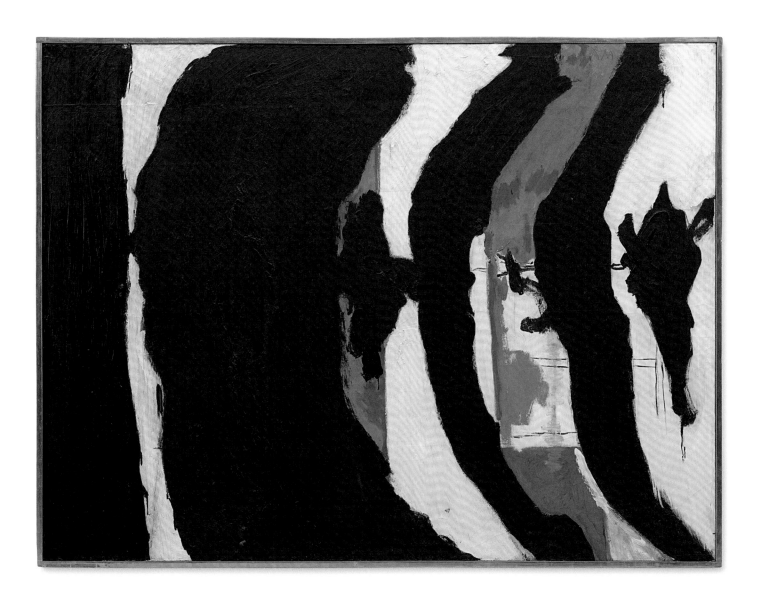

— Barnett Newman
1905 — 1970

Uriel

1955
Oil on canvas
96 × 216 inches
(243.8 × 548.6 cm)

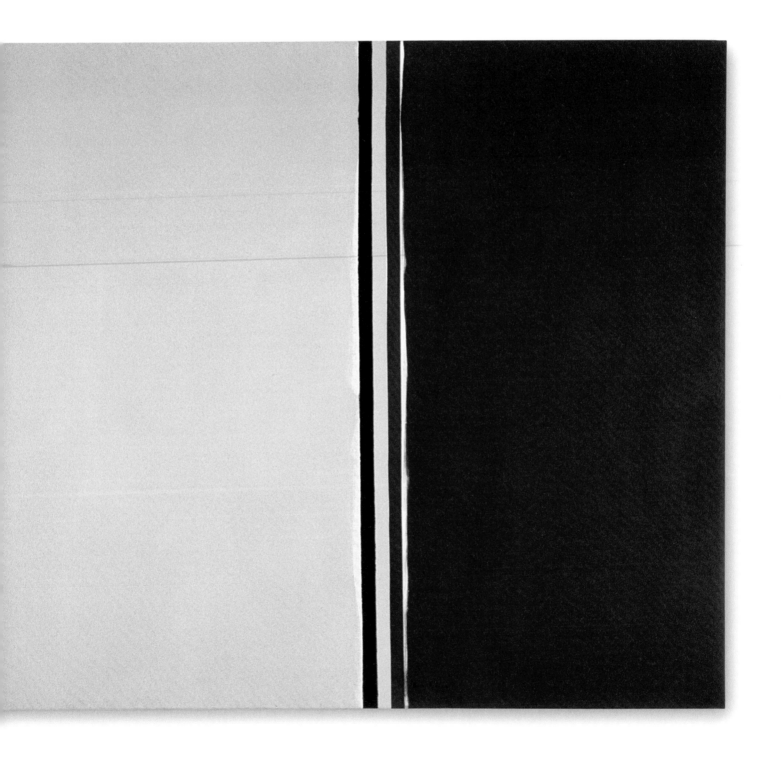

— Kenneth Noland

1924 — 2010

Wotan
1961
Acrylic on canvas
82⅝ × 82⅝ inches
(210 × 210 cm)

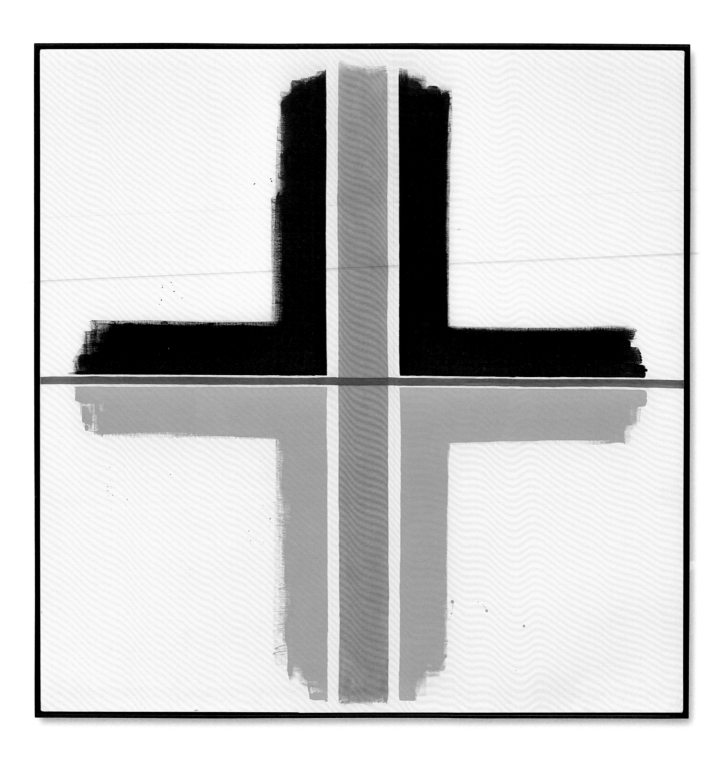

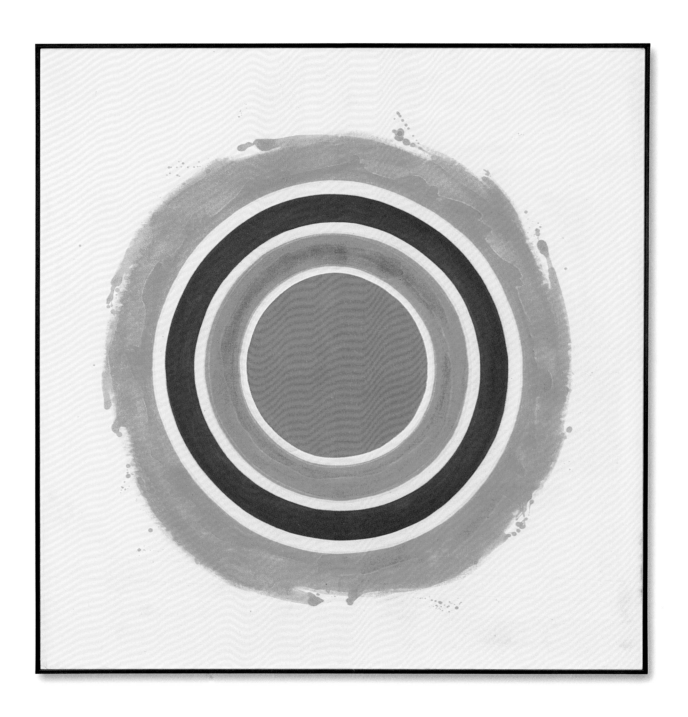

Sunwise

1960
Oil on canvas
76 × 76 inches
(193 × 193 cm)

— Claes Oldenburg

b. 1929

Model for a
Mahogany Plug,
Scale B

1969
Plywood and Masonite,
painted with latex
59 × 39 × 28 ½ inches
(149.9 × 99.1 × 72.4 cm)

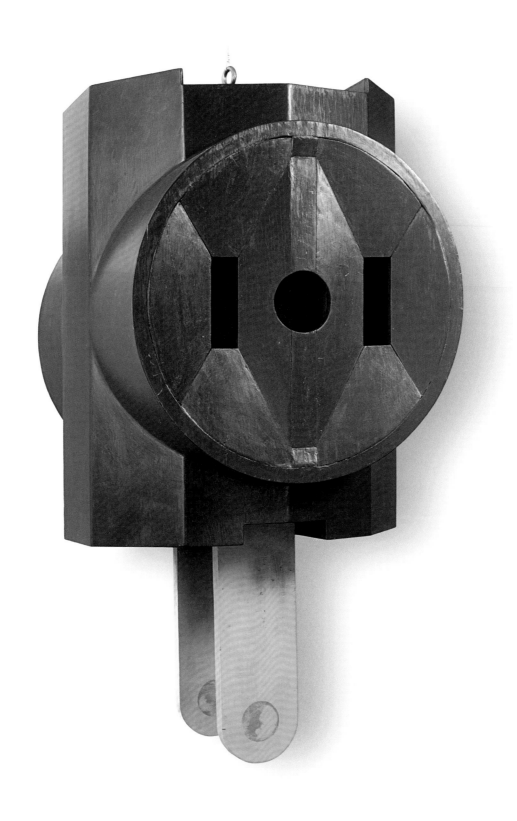

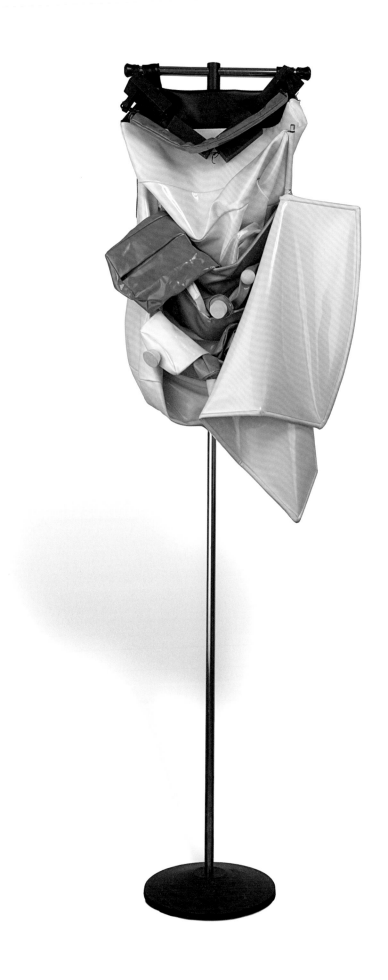

Soft Medicine
Cabinet
1966
Vinyl, kapok, wood,
metal, and acrylic
90⅛ × 24 × 6½ inches
(229 × 61 × 16.5 cm)

Toy Box

1962
Canvas primed and
painted with latex;
wood painted with latex
9 ⅞ × 36 × 24 inches
(25.1 × 91.4 × 61 cm)

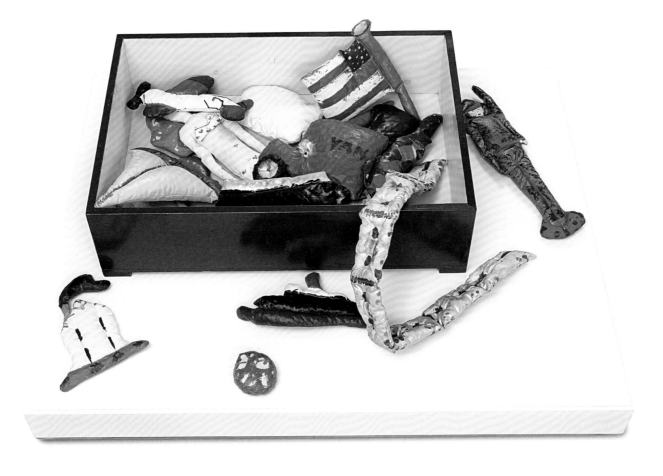

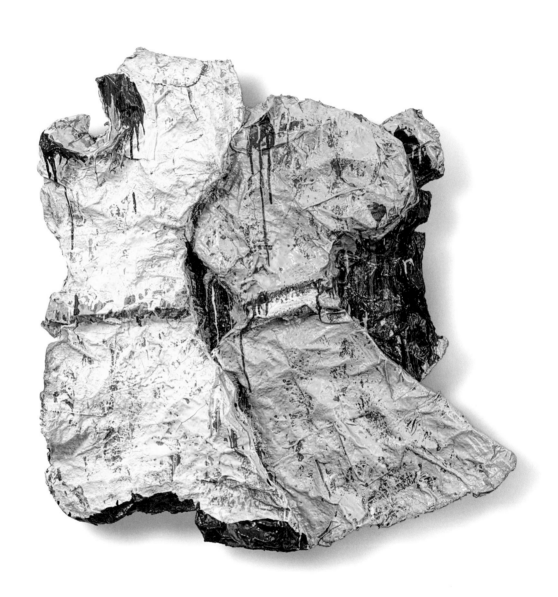

Two Girls' Dresses
1961
Muslin soaked in plaster
over wire frame,
painted with enamel
44 ¾ × 40 × 6 ½ inches
(113.7 × 101.6 × 16.5 cm)

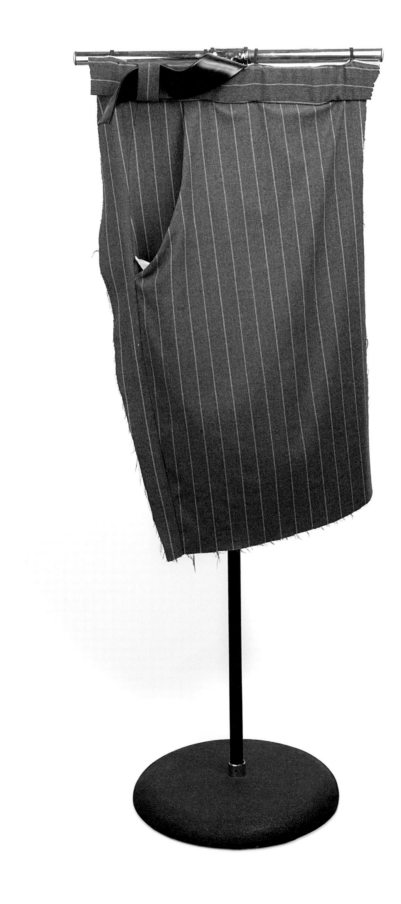

*Pants Pocket
with Pocket Objects*

1963
Fabric, vinyl, and metal
54 ½ × 27 × 16 inches
(138.4 × 68.6 × 40.6 cm)

Inverted Q
6ft. Prototype
1976
Rigid foam, coated with
resin and painted
with polyurethane enamel
72 × 64 × 71 inches
(182.9 × 162.6 × 180.3 cm)

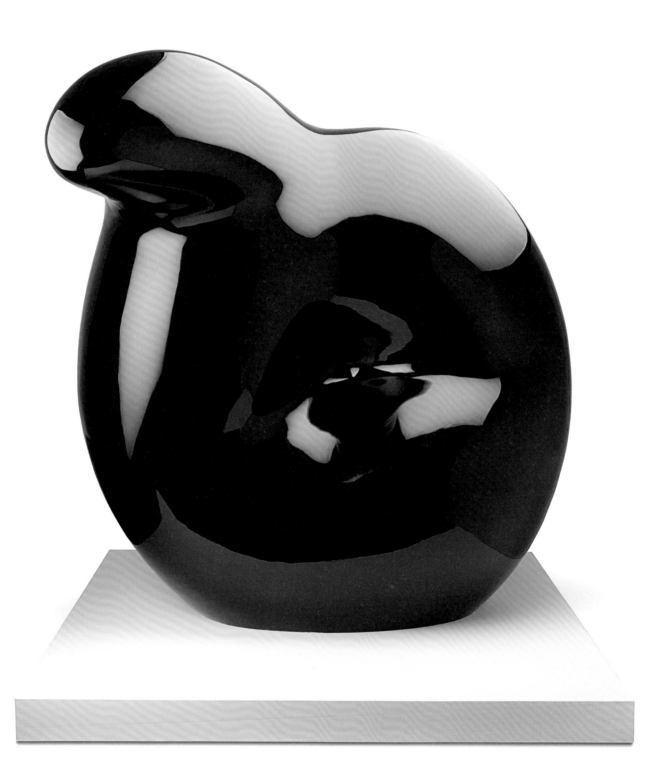

192

Torn Notebook,
Three

1992
Muslin, wire mesh,
clothes line, steel, and
aluminum; coated
with resin and painted
with latex
24×33×36 inches
(61×83.8×91.4 cm)

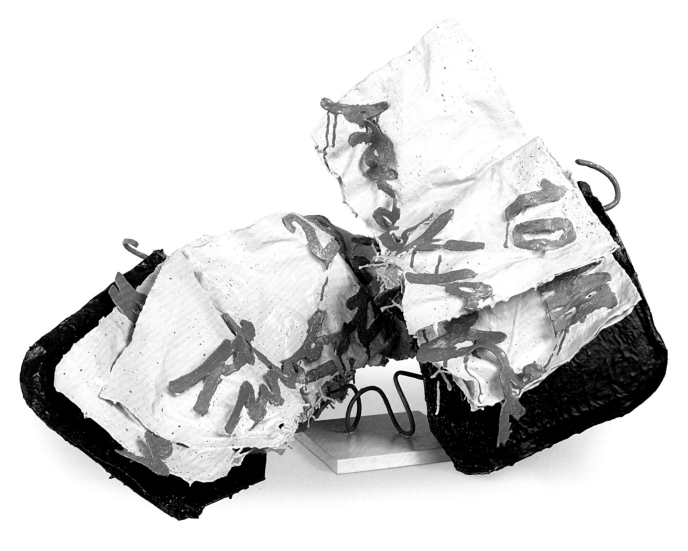

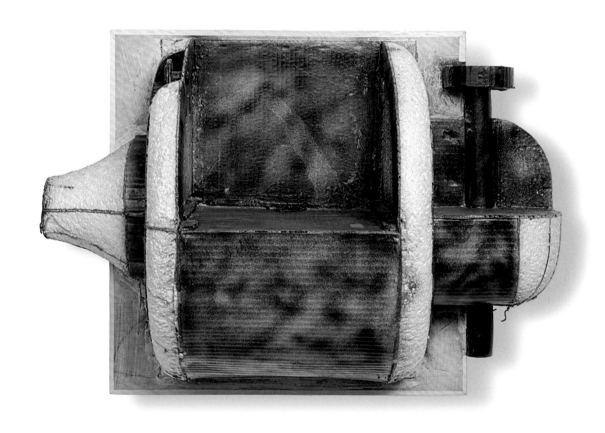

Model, Motor Section —
Giant Soft Fan
1967
Expanded polystyrene,
cardboard, wood, string, tape,
nails, t–pins, staples,
painted with spray enamel
and latex, crayon, pencil, coated
with shellac
24 × 34 × 12 inches
(61 × 86.4 × 30.5 cm)

194

— Robert Rauschenberg
1925 — 2008

Pilgrim
1960
Combine: oil, graphite, paper,
printed paper, and fabric on
canvas, with painted wood chair
79 ¼ × 53 ⅞ × 18 ⅝ inches
(201.3 × 136.8 × 47.3 cm)

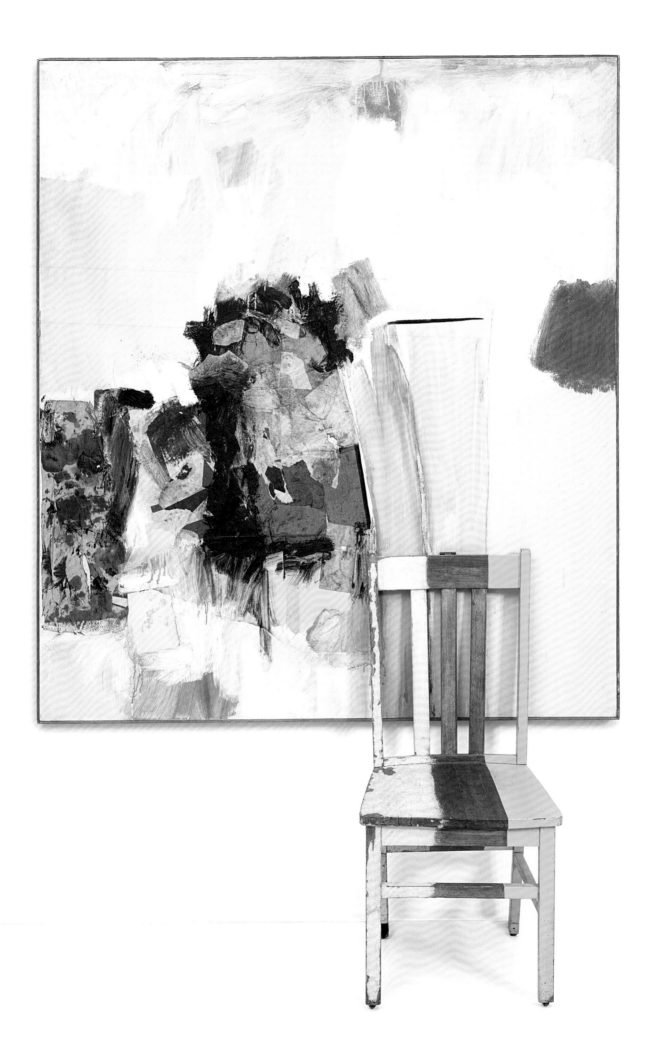

— Ad Reinhardt

1913 — 1967

Abstract Painting

1956
Oil on canvas
80 × 50 inches
(203.2 × 127 cm)

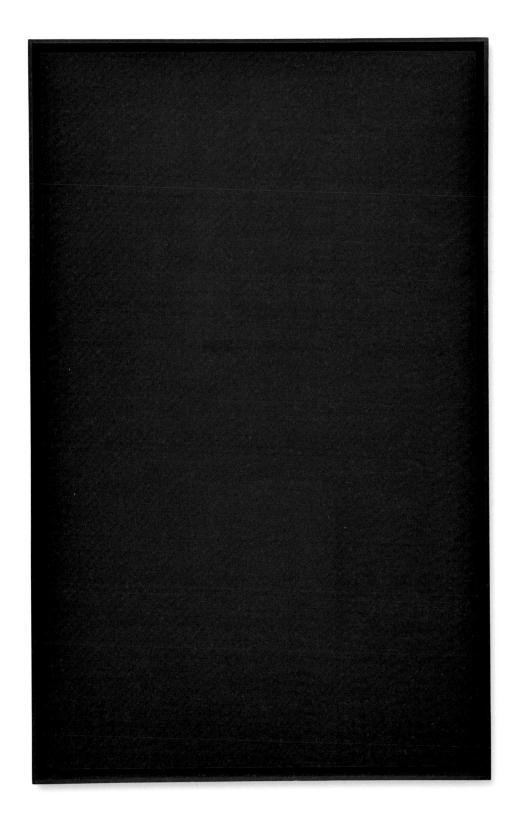

— Larry Rivers

1923 — 2002

The Journey

1956
Oil on canvas
104 × 115 inches
(264.2 × 292.1 cm)

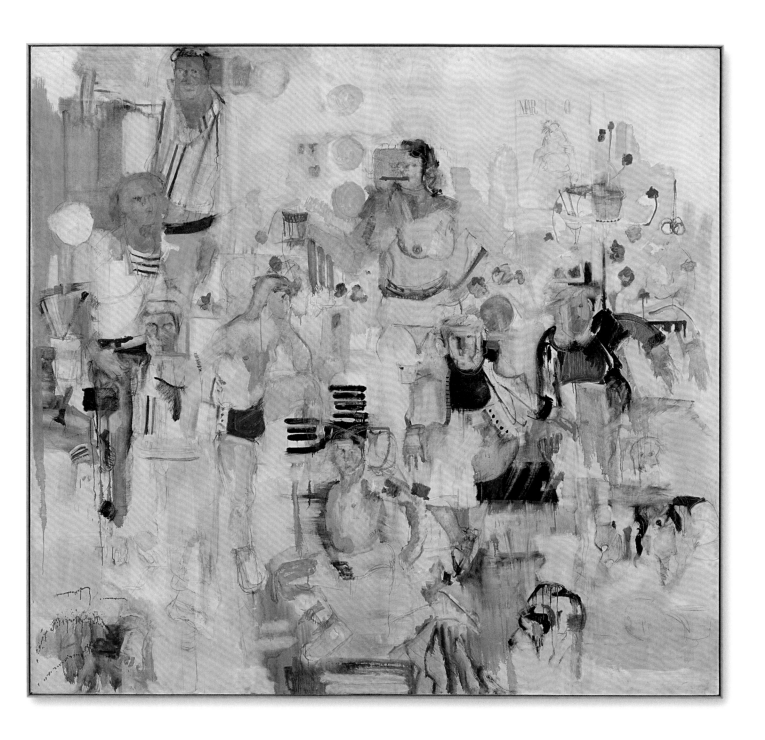

— Dieter Roth
1930 — 1998

Zwerge (Dwarves)
1970
Garden gnomes,
chocolate
22 × 41 3/8 × 18 1/8 inches
(56 × 105 × 46 cm)

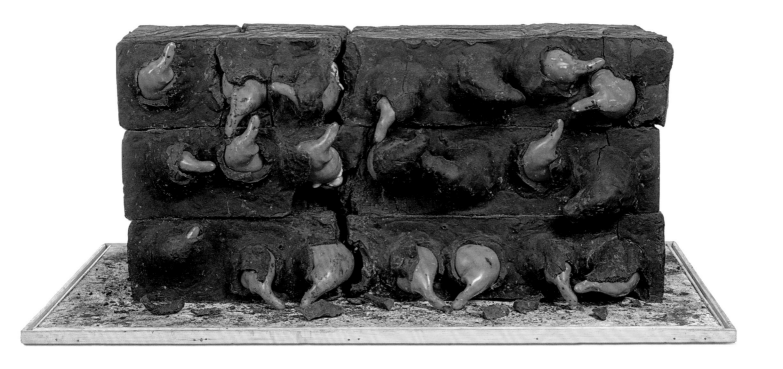

— George Segal
1924 — 2000

The Farm Worker
1963
Gypsum, simulated brick,
wood, and glass
95⅝ × 95⅝ × 42⅛ inches
(243 × 243 × 107 cm)

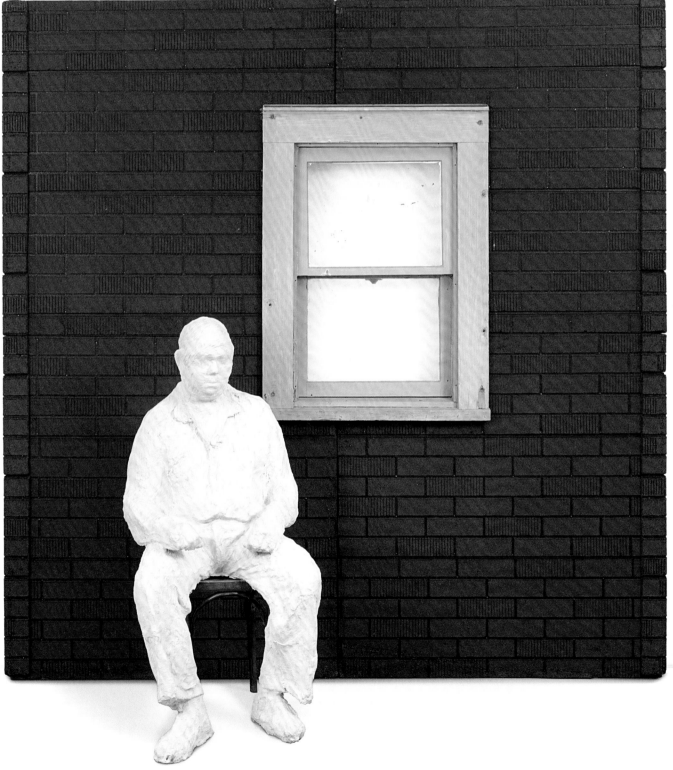

— Richard Serra

b. 1939

Do It
1983
Hot rolled steel
131 × 102 × 141 inches
(332.7 × 259 × 358.1 cm)

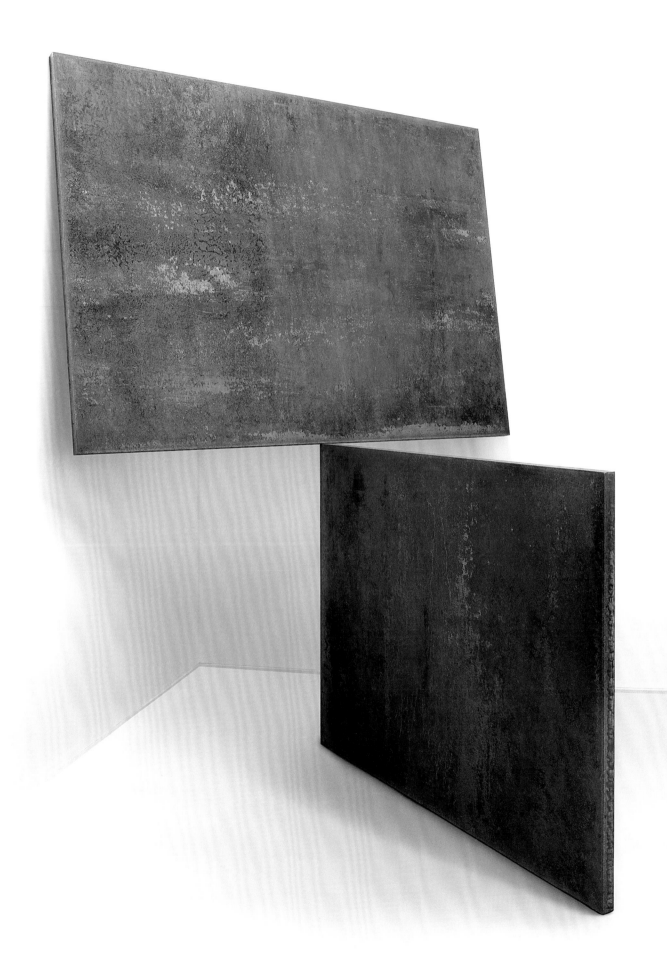

— David Smith

1906 — 1965

Seven Hours
1961
Pre-painted steel
84 ½ × 48 × 17 ⅞ inches
(214.5 × 122 × 45.5 cm)

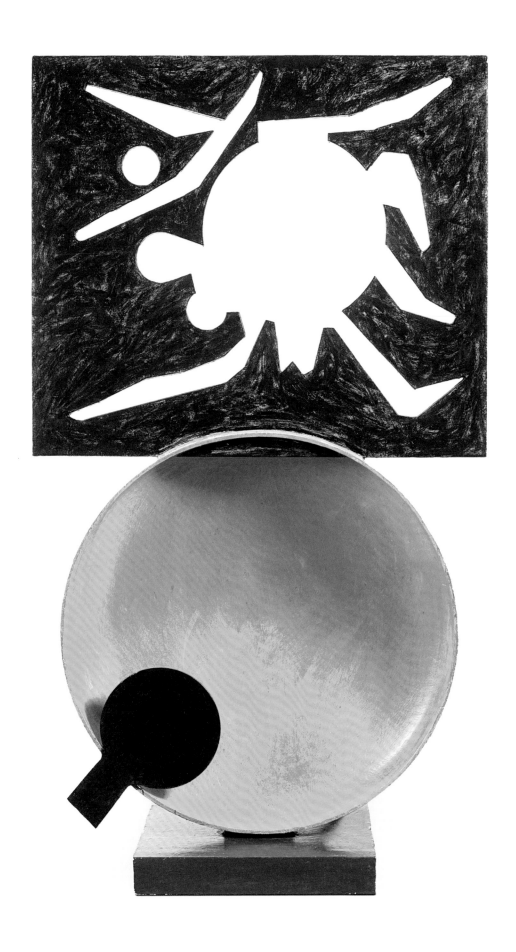

— Frank Stella

b. 1936

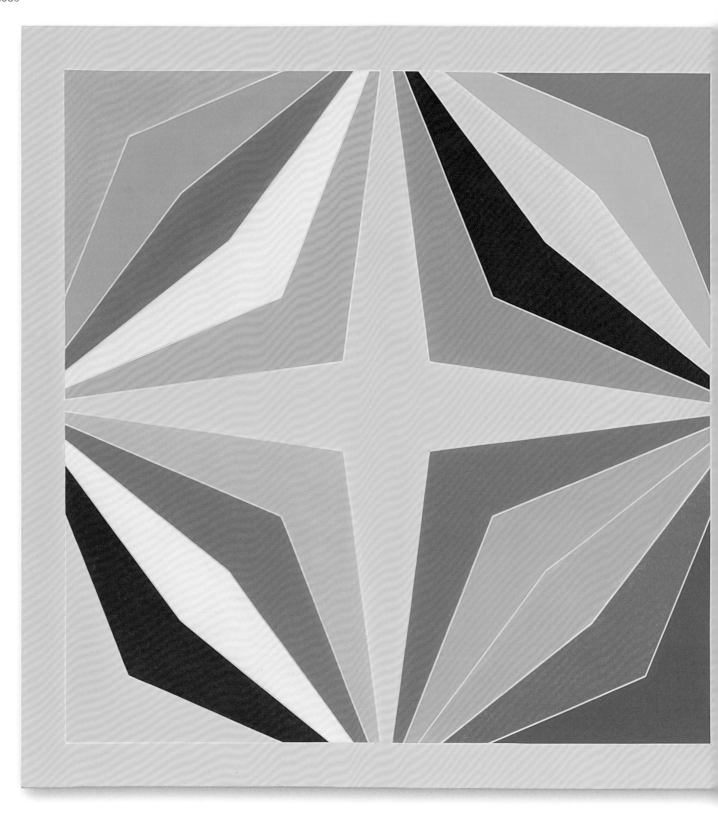

Protractor Variation

1969
Acrylic on canvas
120 × 240 inches
(304.8 × 609.6 cm)

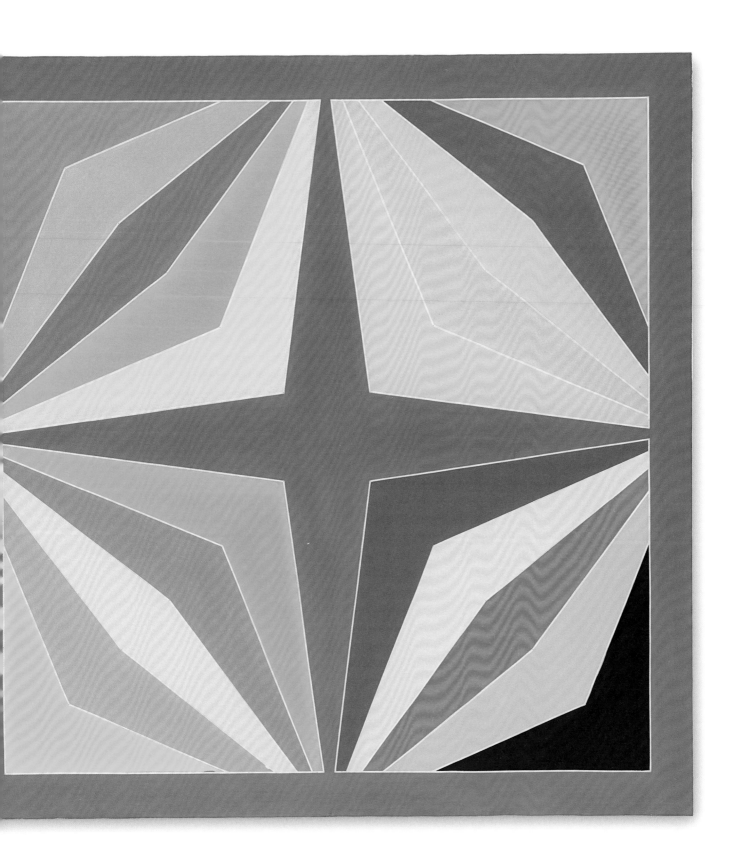

— Clyfford Still

1904 — 1980

PH–131
1951
Oil on canvas
117 × 105 inches
(297.2 × 266.7 cm)

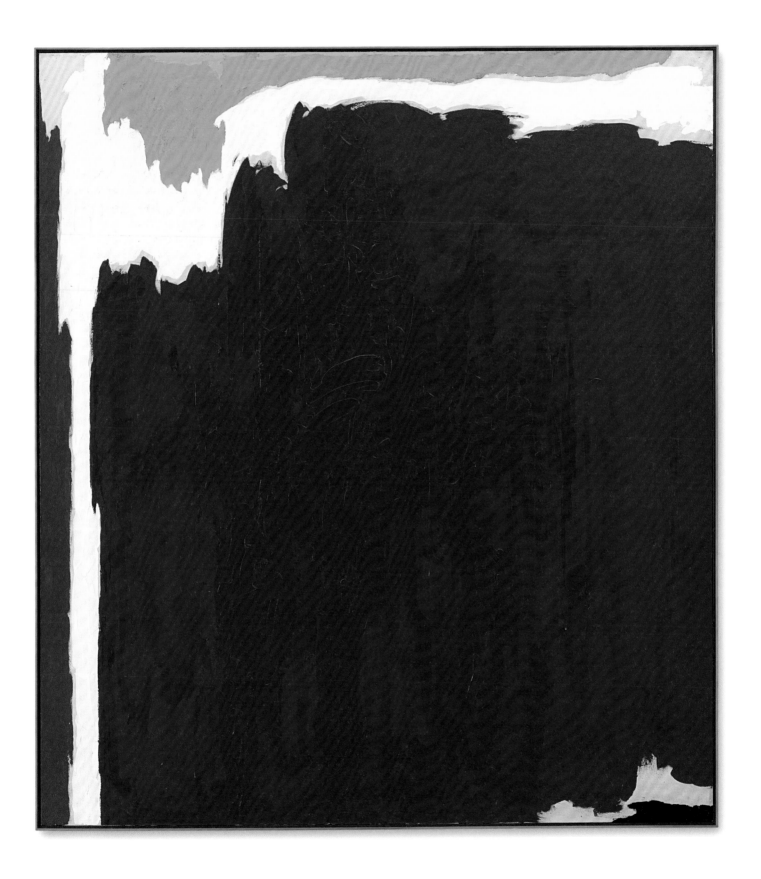

213

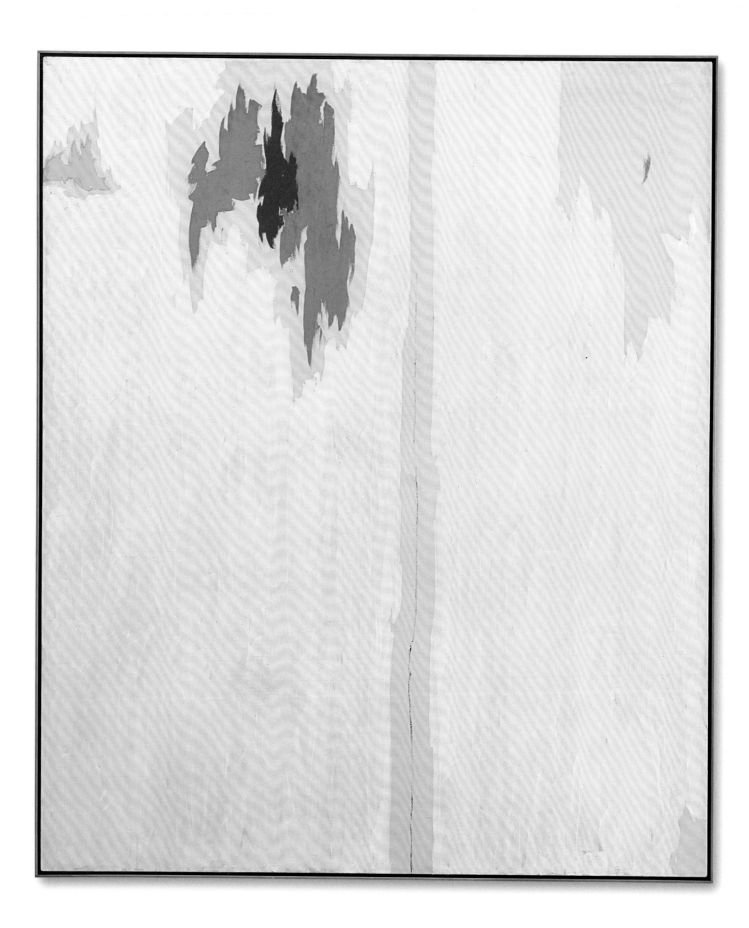

1953–No. 2
(PH–847)

1953
Oil on canvas
109 × 92 inches
(276.9 × 233.7 cm)

— Richard Tuttle

b. 1941

Two or More I
1984
Wire, plastic,
wood, cardboard,
and acrylic
6 ¼ × 24 ⅝ × 2 ¾ inches
(16 × 62.5 × 7 cm)

Two or More IV

1984
Fabric, aluminum can,
wire, wood, cardboard,
foam, and acrylic
14 × 10 ⅜ × 4 ½ inches
(35.5 × 25.5 × 11.4 cm)

Two or More IX
1984
Wire, plastic, paper,
canvas, wood, ink,
cardboard, and acrylic
50 × 32⅜ × 3½ inches
(127 × 82.1 × 8.9 cm)

Two or More XII

1984
Fabric, aluminum Pepsi can, wire,
feather, glass, wood, cardboard,
enamel, acrylic, spray enamel, and
dry pigment
41 × 24 ½ × 6 inches
(104.1 × 62.2 × 15.2 cm)

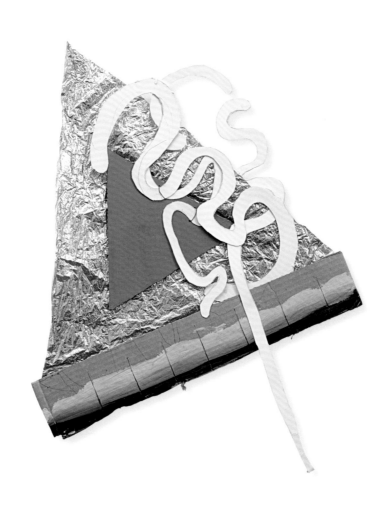

*Secret Ways to
remain happy, No. 1*

1986
Wire, cardboard, foil
and acrylic
19⅝ × 19⅝ × 1⅛ inches
(50 × 50 × 3 cm)

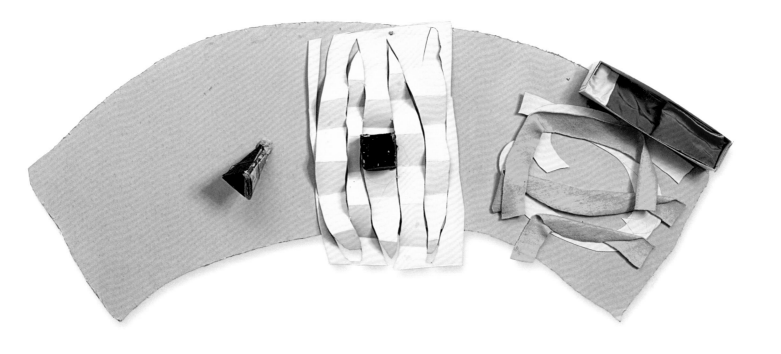

Secret Ways to
remain happy, No. 5
1986
Fabric, wire,
cardboard, newspaper,
glue, and acrylic
45 ¼ × 19 ⅝ × 4 ⅛ inches
(115 × 50 × 10.5 cm)

— Cy Twombly
1928 — 2011

Leda and the Swan

1960
Oil, chalk, and crayon
on canvas
76¼ × 80 inches
(193.7 × 203.2 cm)

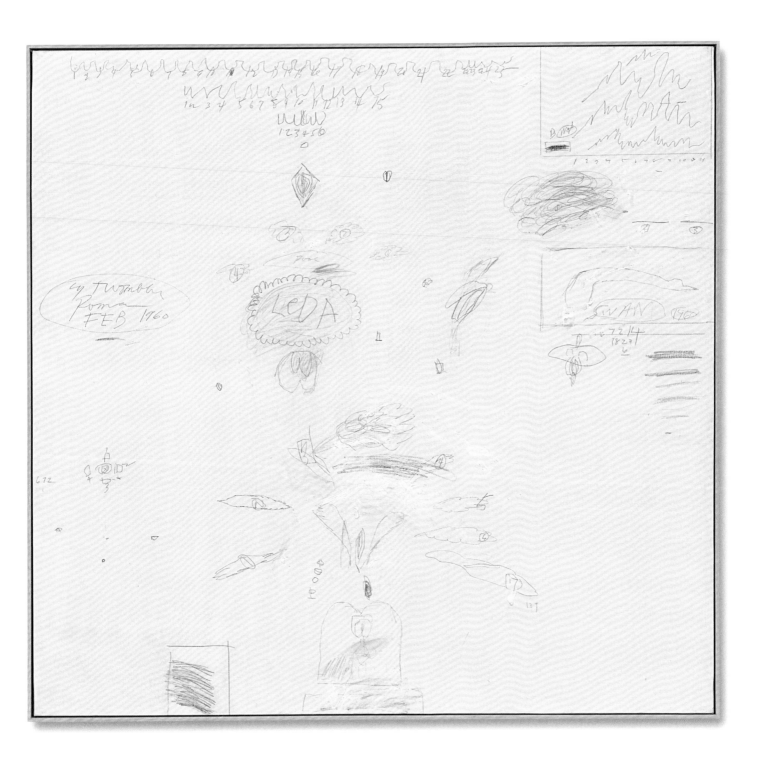

— Lawrence Weiner
b. 1942

Covered From the Rear
1970 / 2013
Language & the materials referred to
Dimensions variable

COVERED FROM THE REAR

— John Wesley

b. 1928

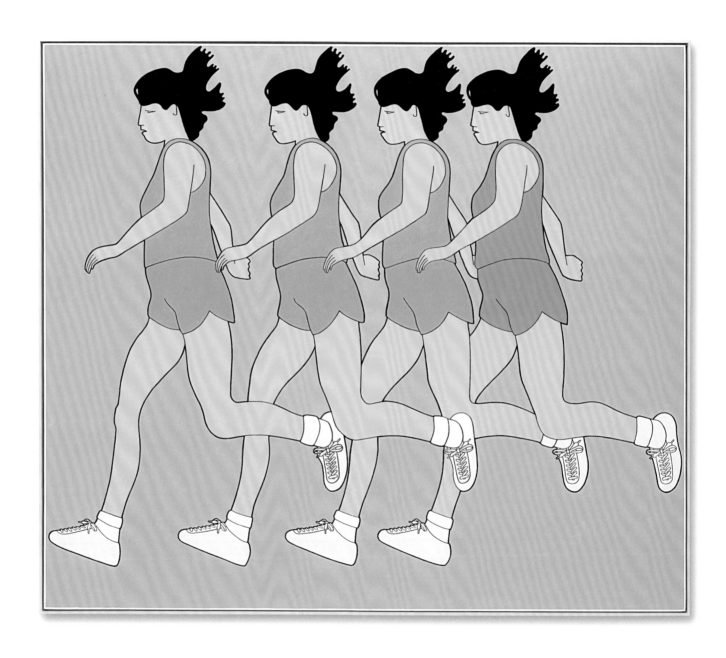

Heat
1986
Oil on canvas
72 × 83⅞ inches
(183 × 213 cm)

Cheep!
1962
Oil on canvas
72 × 72 inches
(183 × 183 cm)

227

Whale
Skippers' Wives
1986
Oil on canvas
60¼×72 inches
(153×183 cm)

Olympic Field
Hockey Officials

1962
Oil on canvas
72 × 72 inches
(183 × 183 cm)

— H.C. Westermann

1922 — 1981

Abandoned
Death Ship of No Port
with a List
1969
Basswood, walnut,
and brass plate
Ship: 5 × 22¼ × 4⅛ inches
(12.7 × 56.5 × 10.5 cm)
Box: 11 × 29½ × 8 inches
(27.8 × 75 × 20.4 cm)

Installation
Views

— Hauser & Wirth Savile Row

North

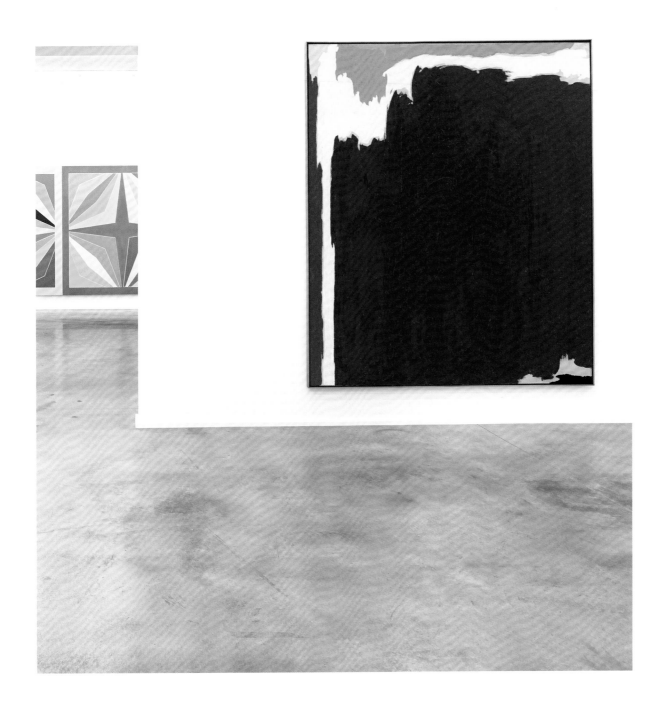

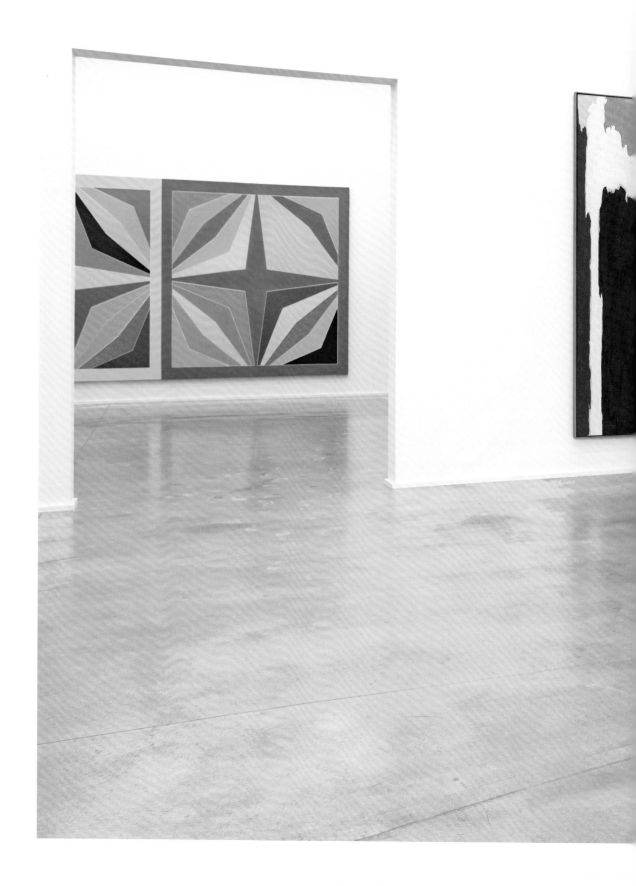

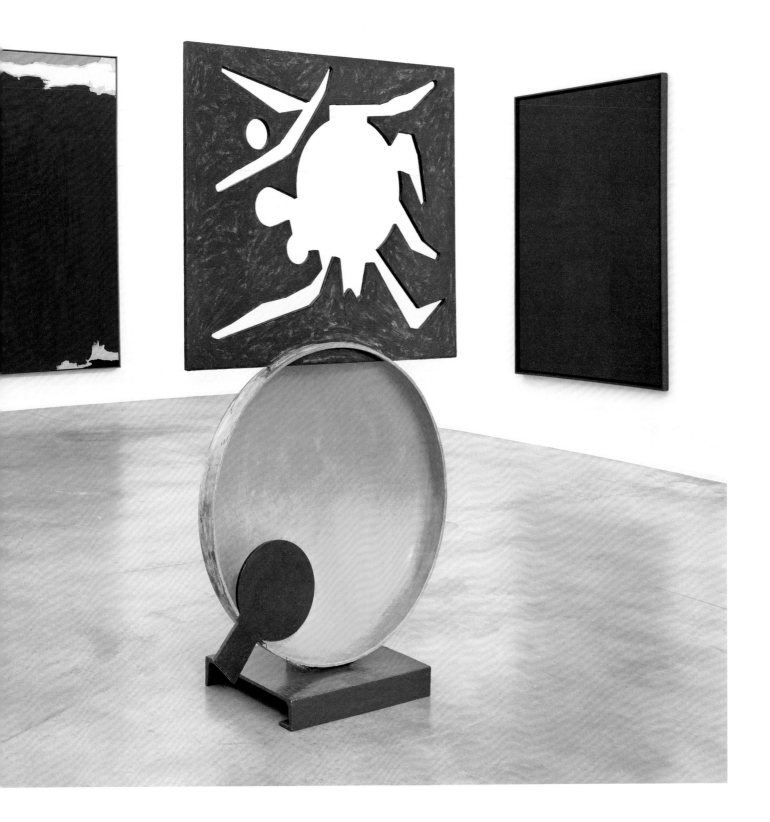

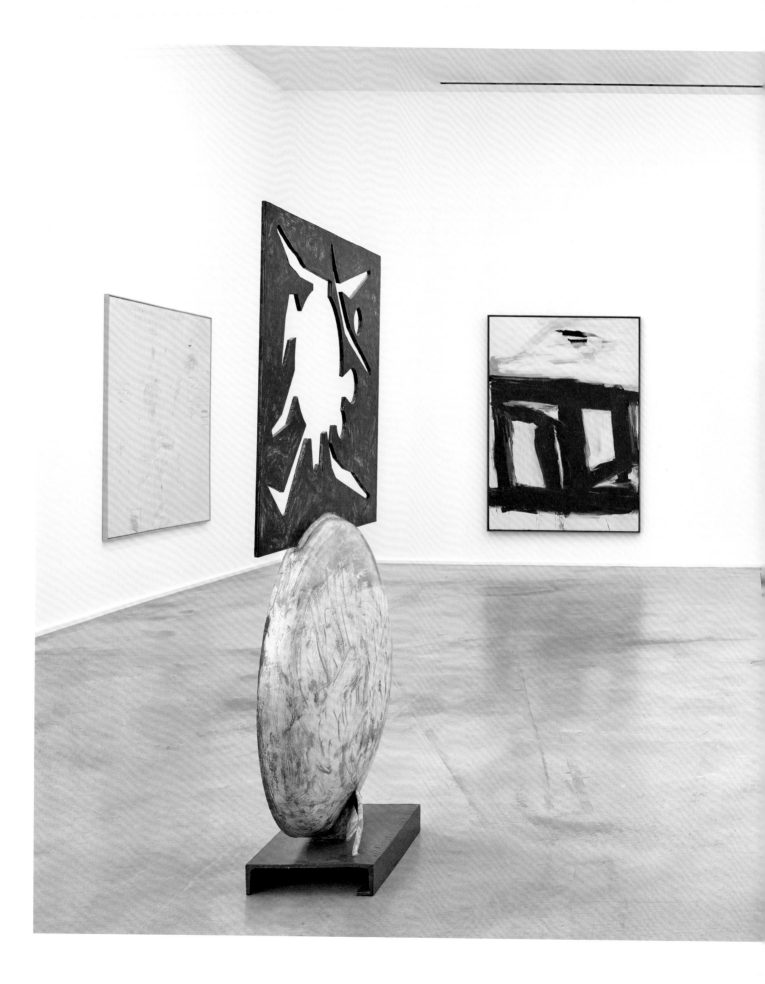

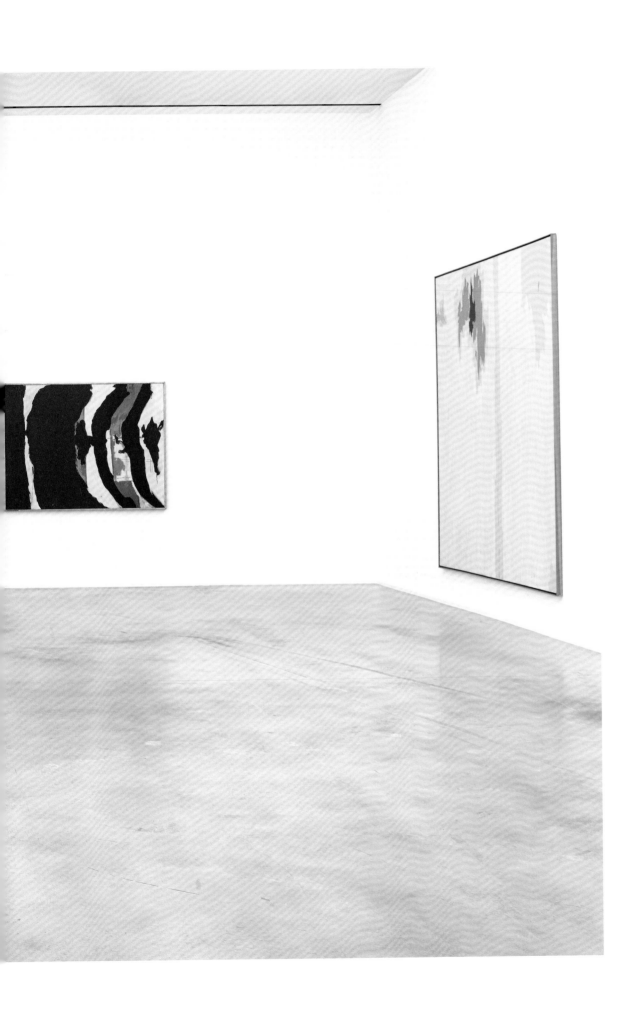

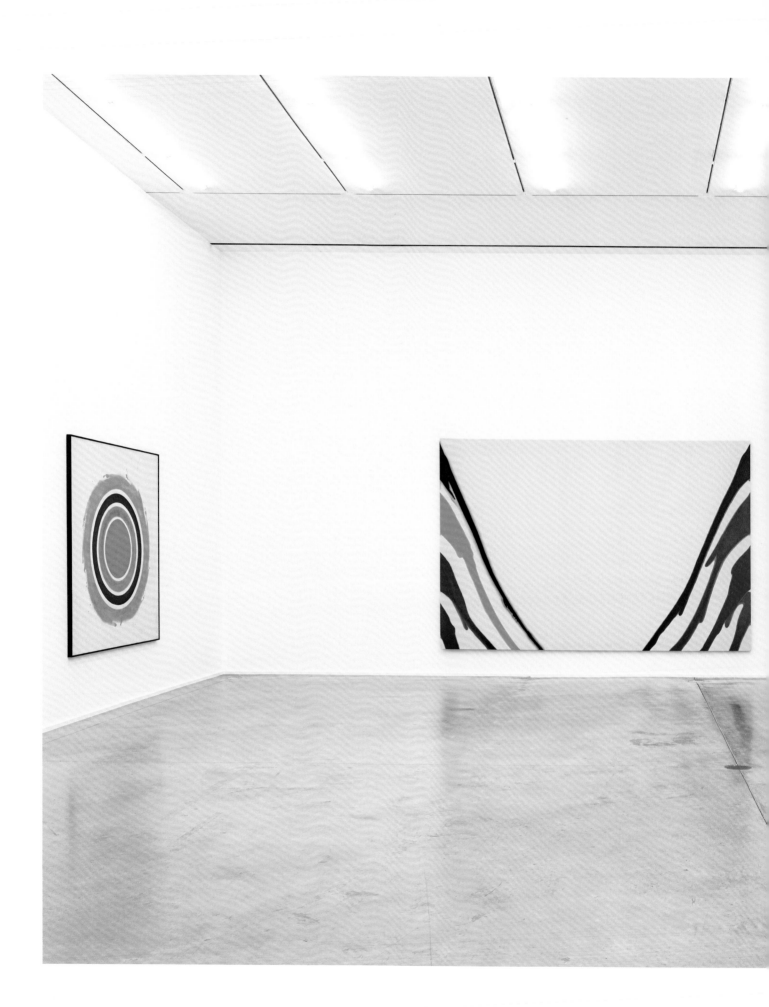

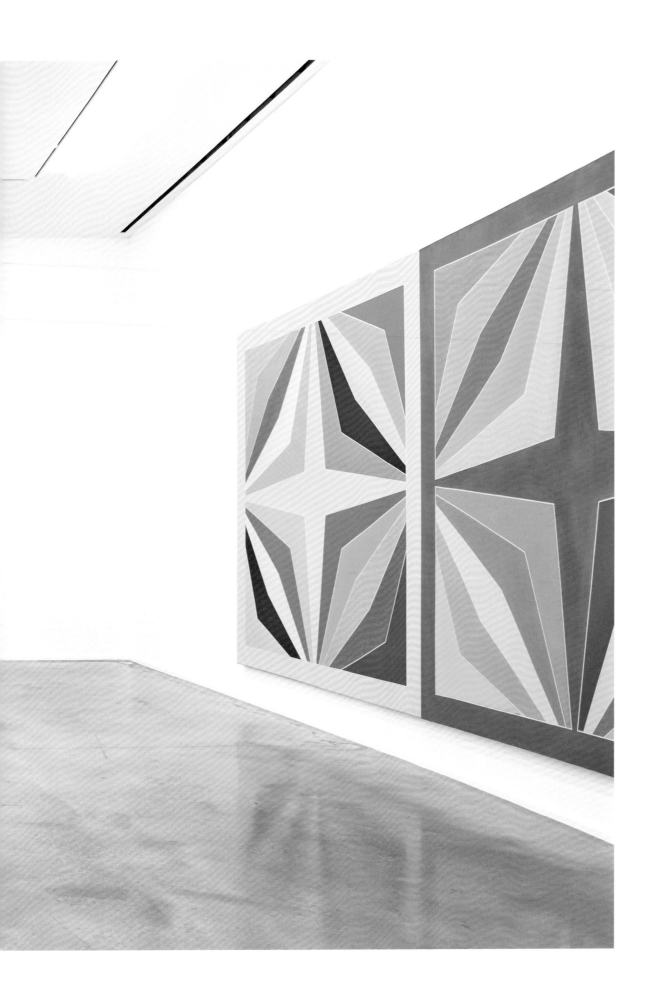

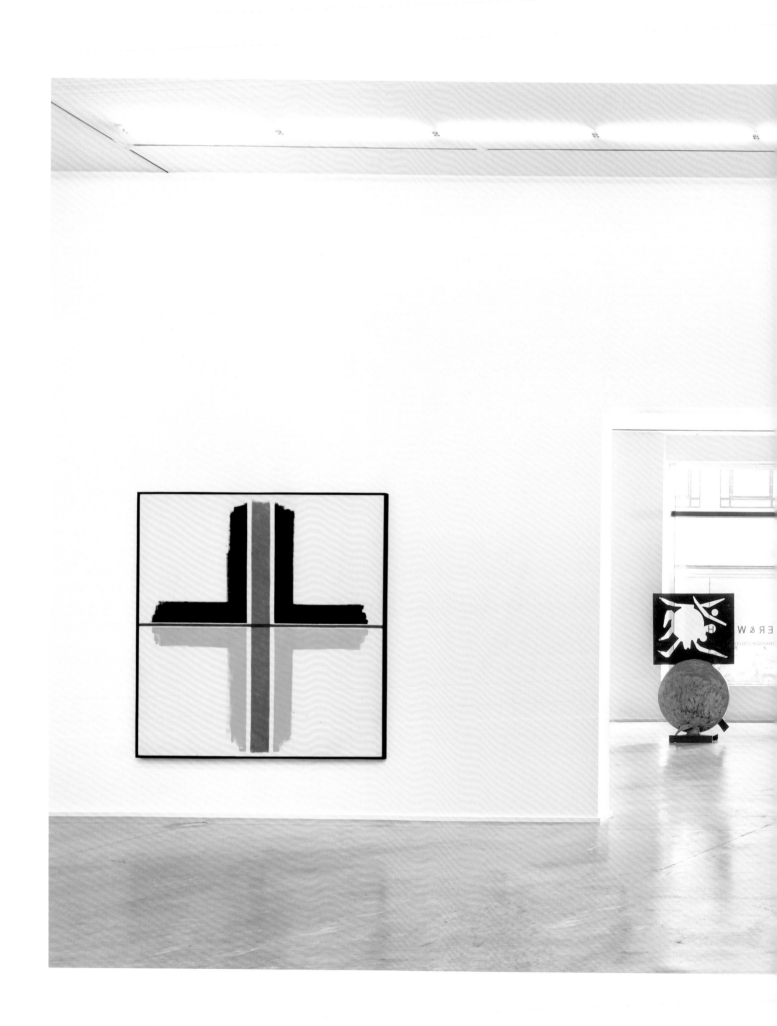

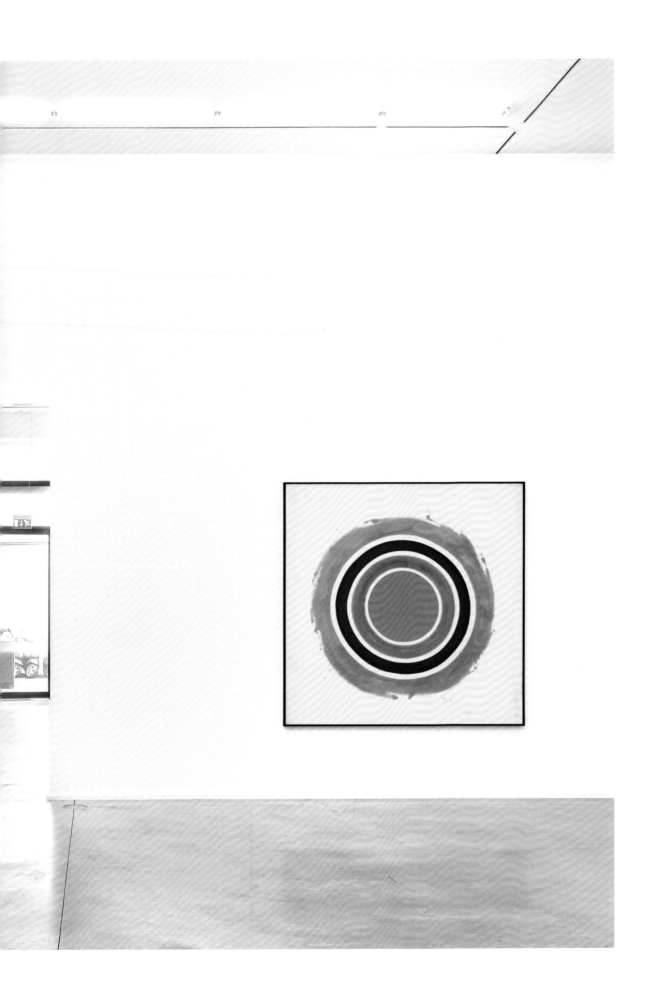

— Hauser & Wirth Savile Row

South

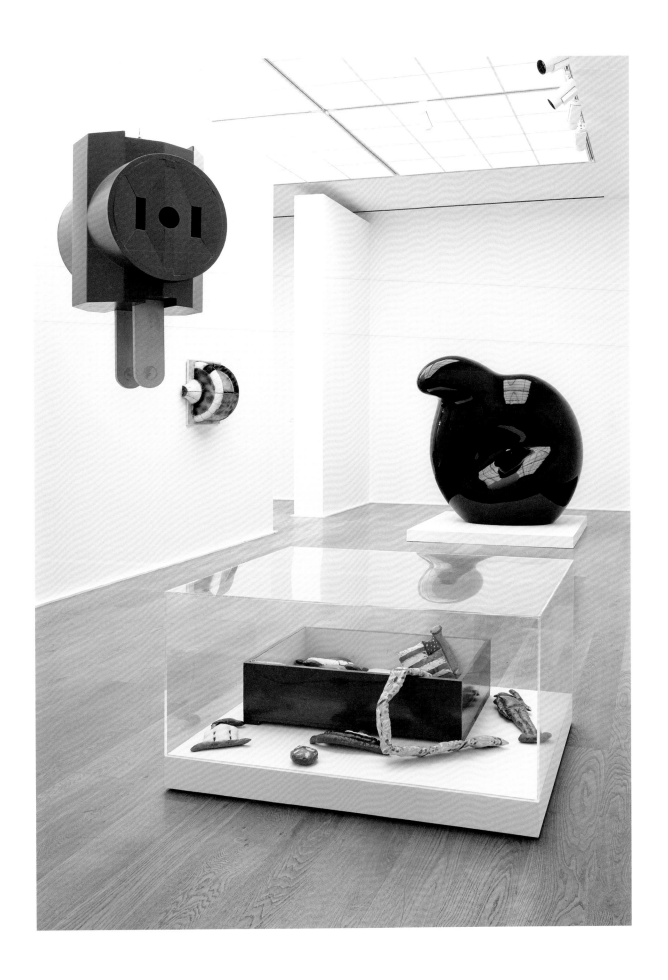

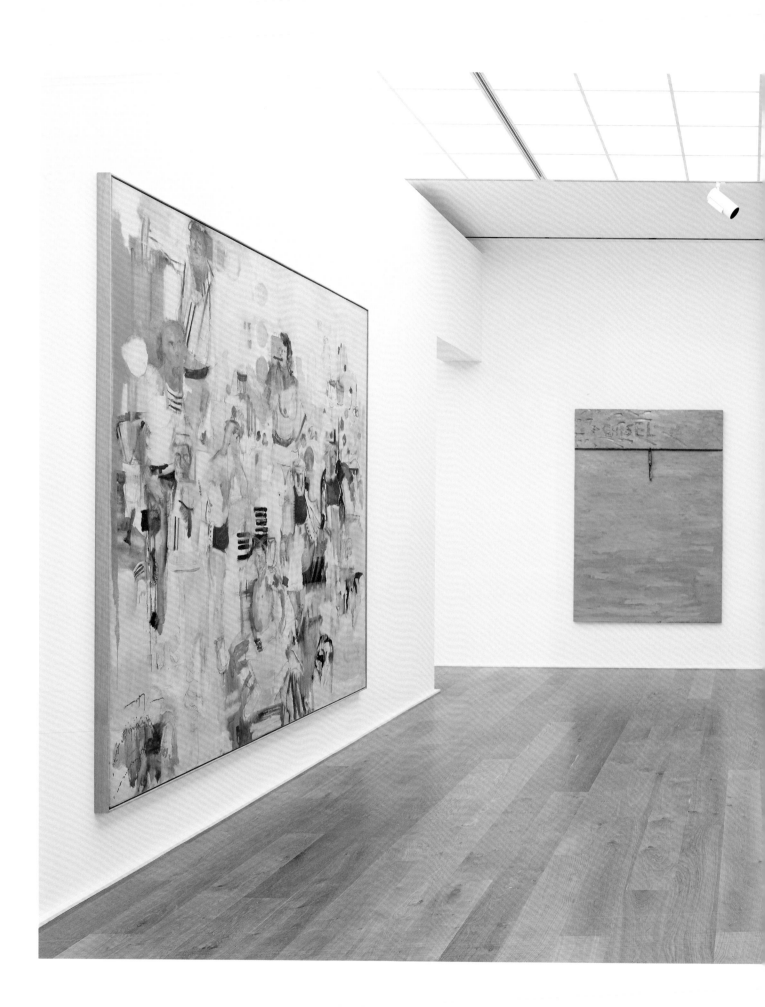

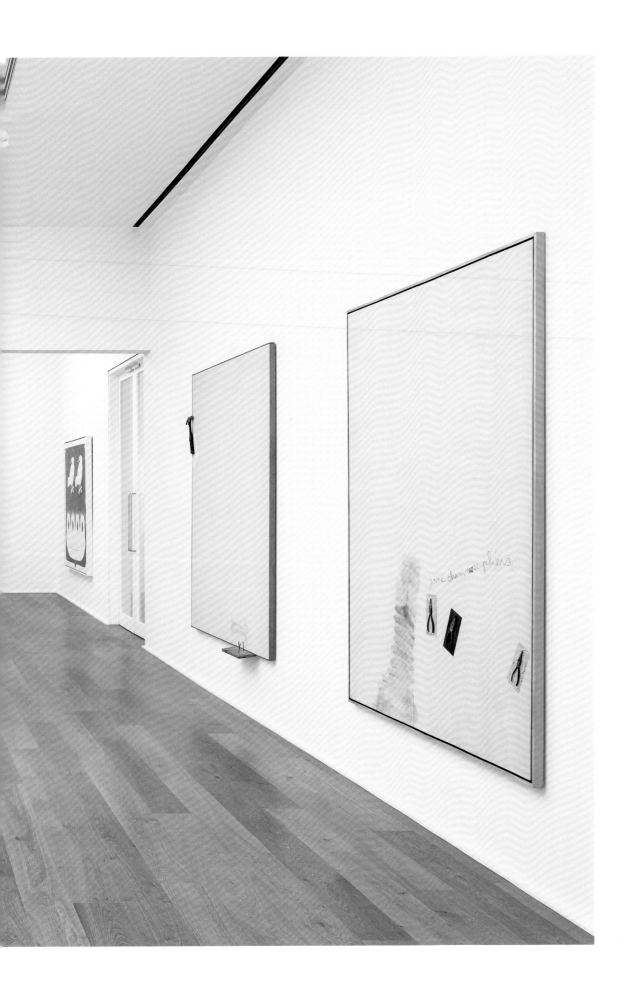

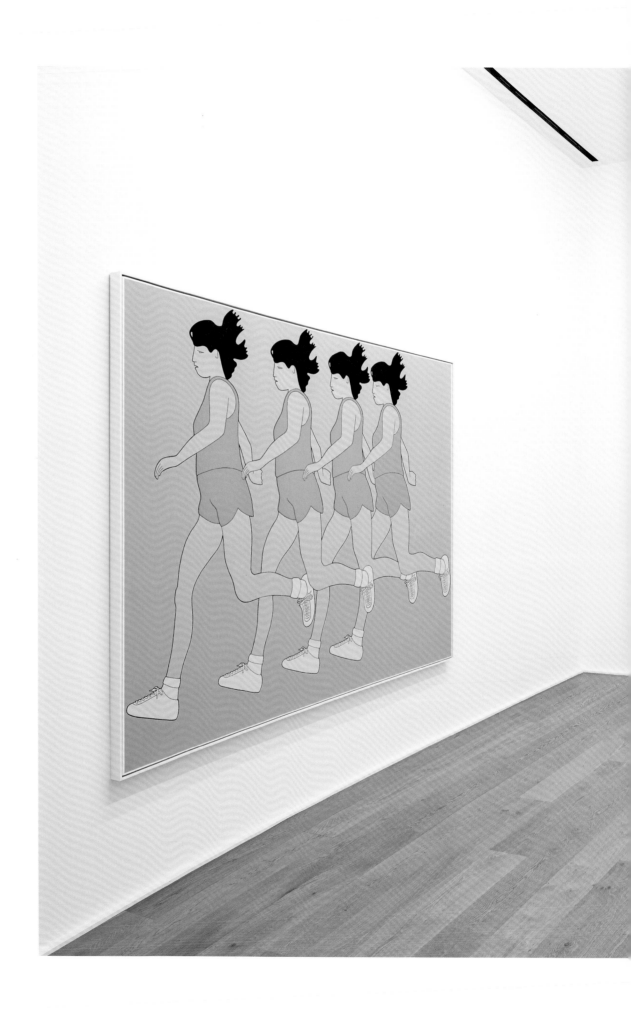

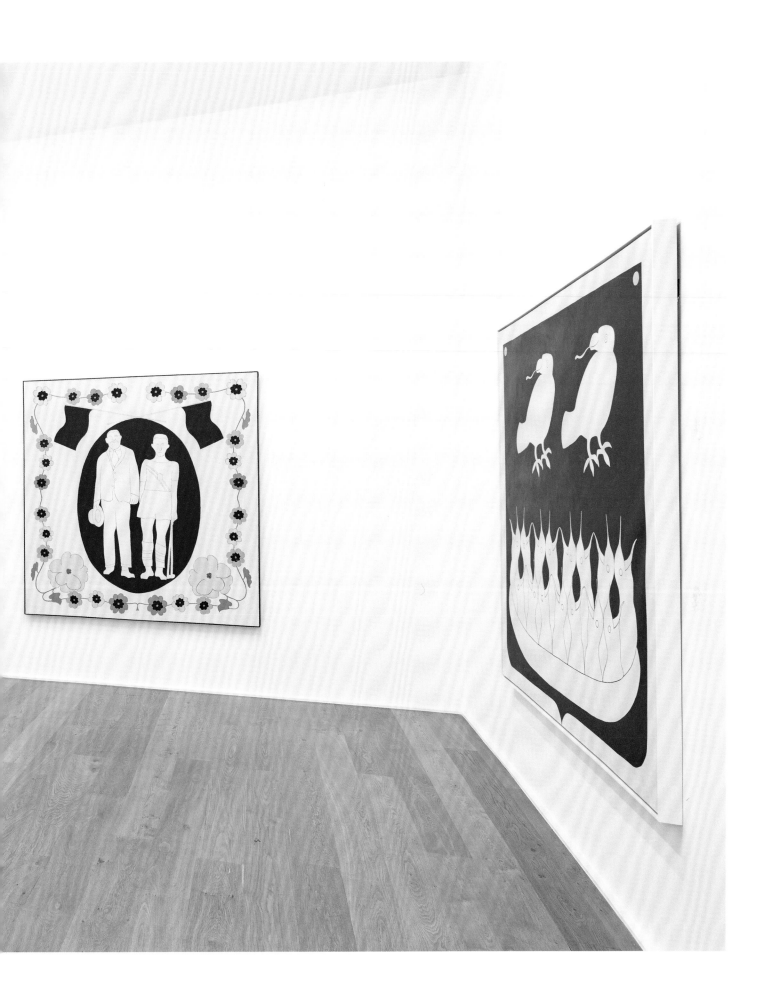

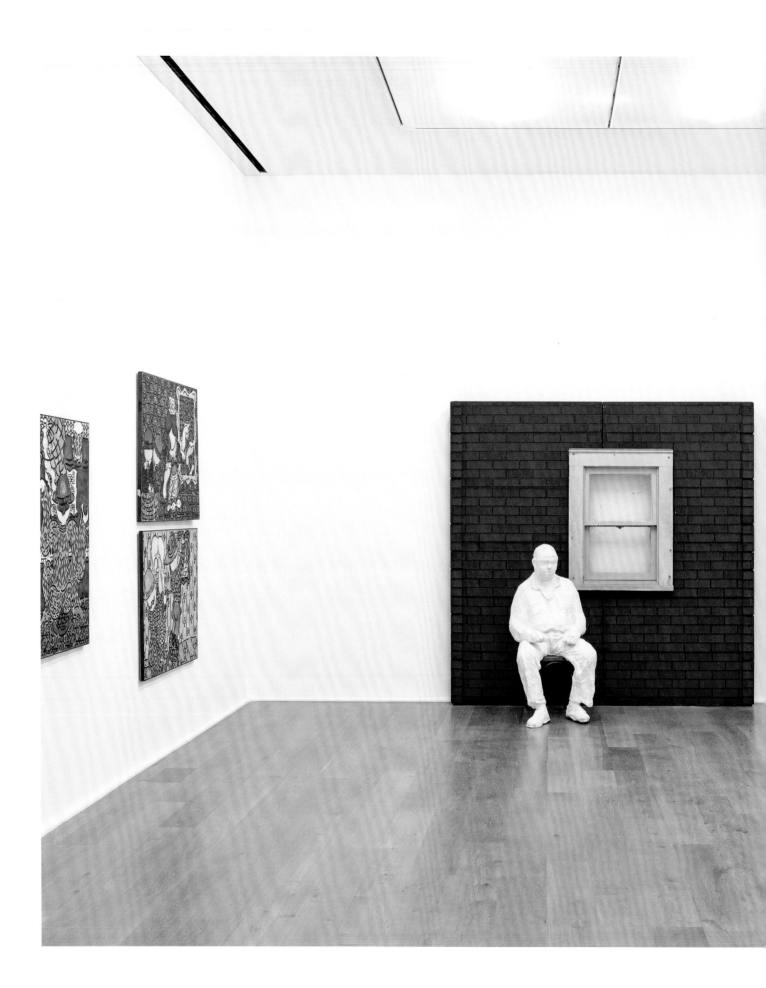

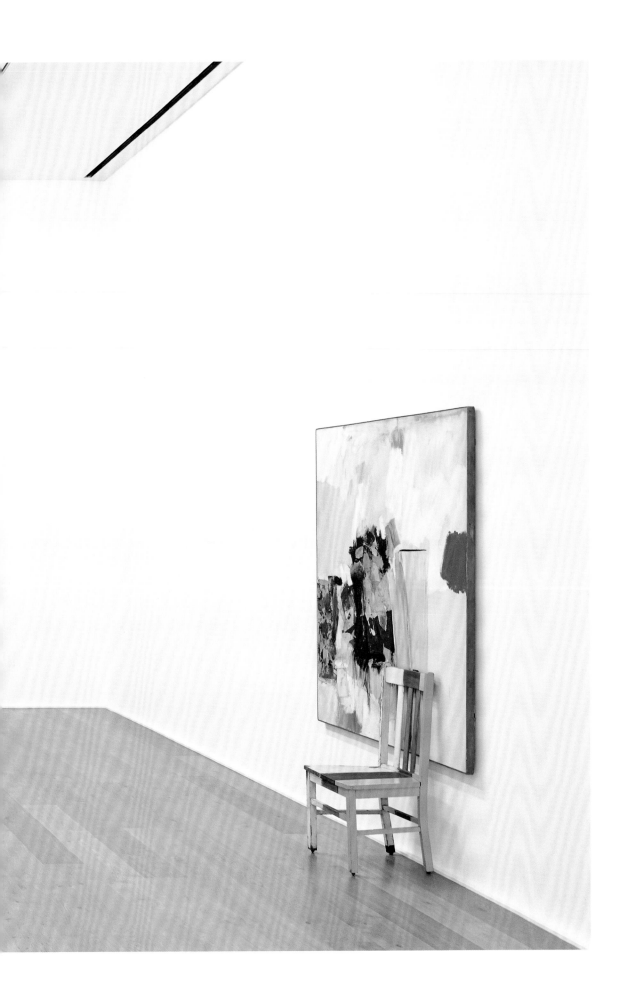

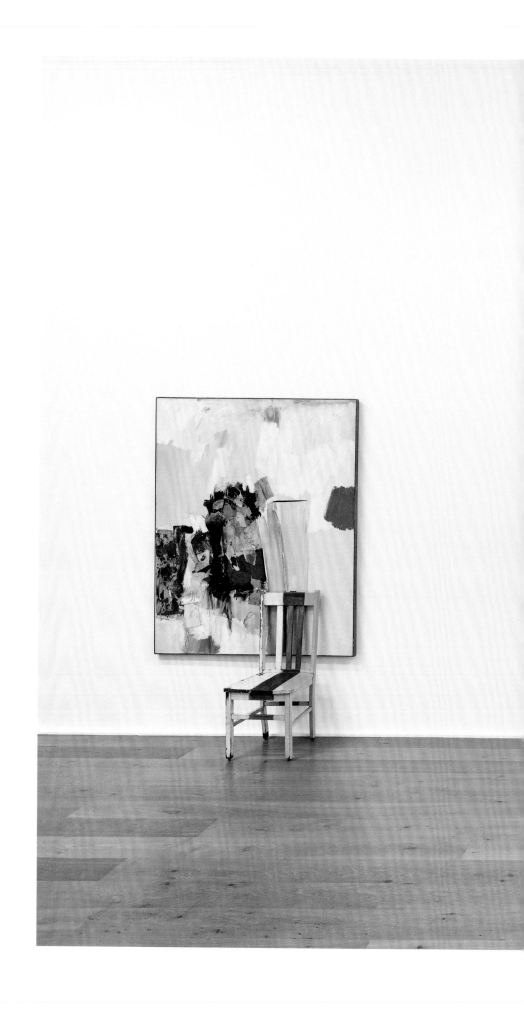

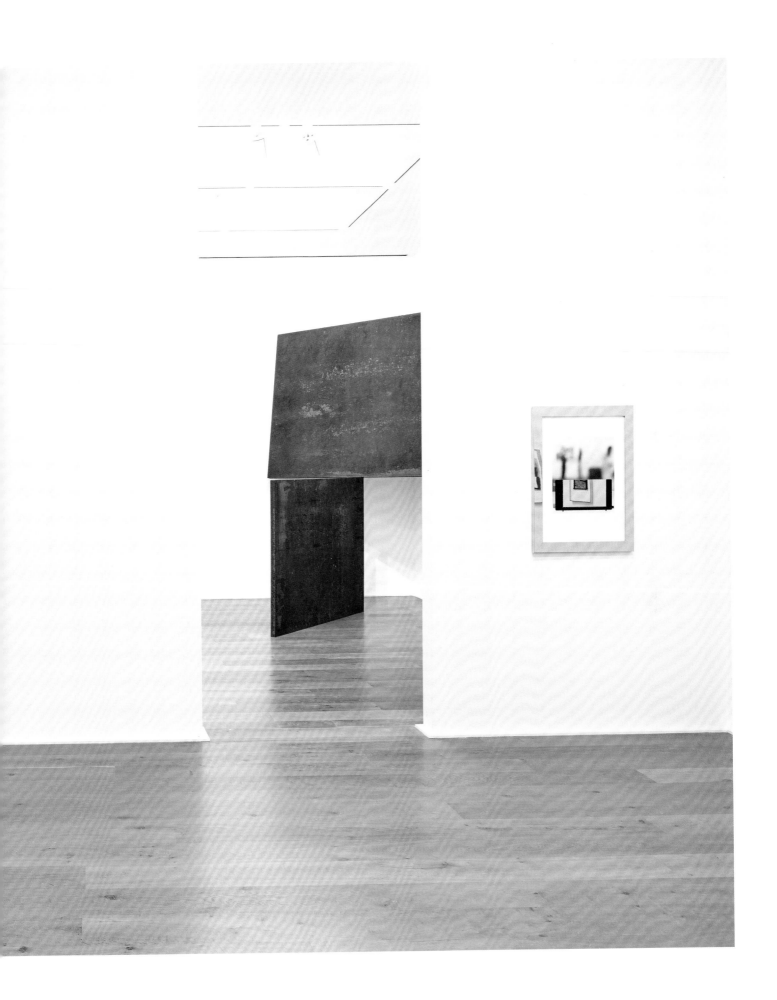

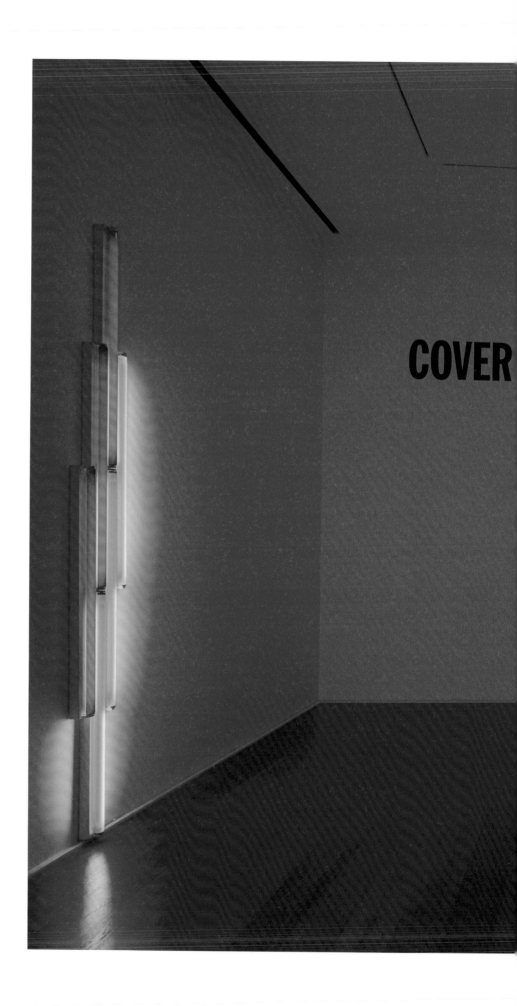

COVER

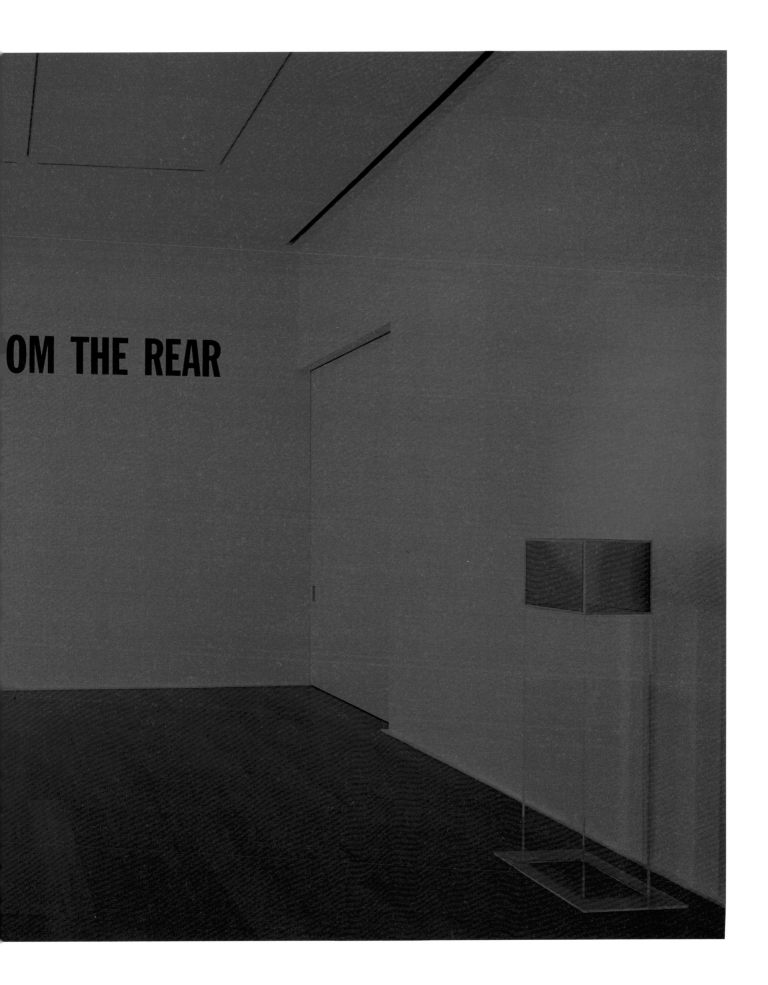

— Hauser & Wirth Piccadilly

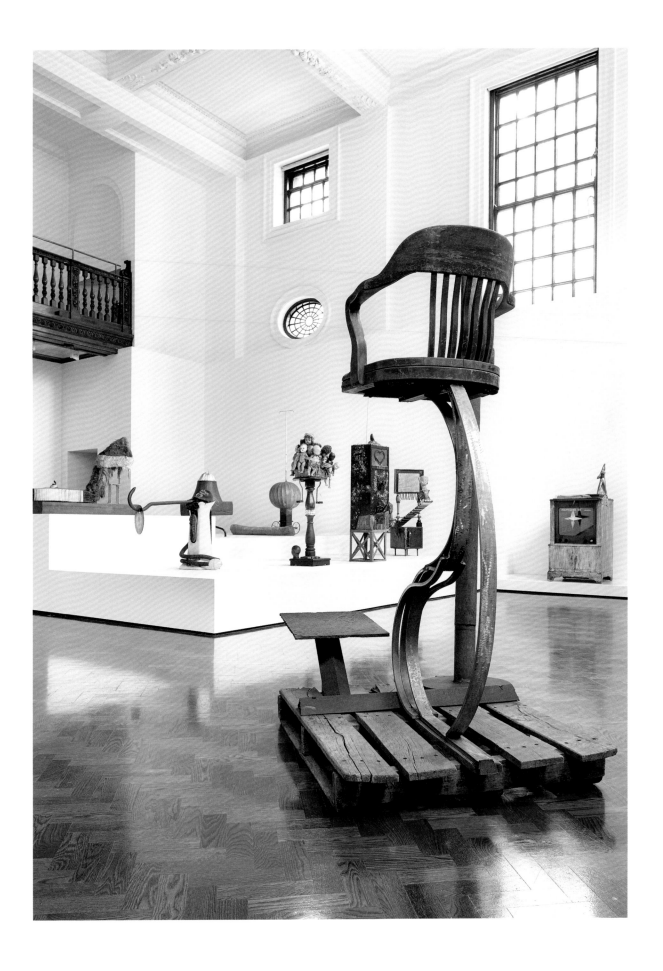

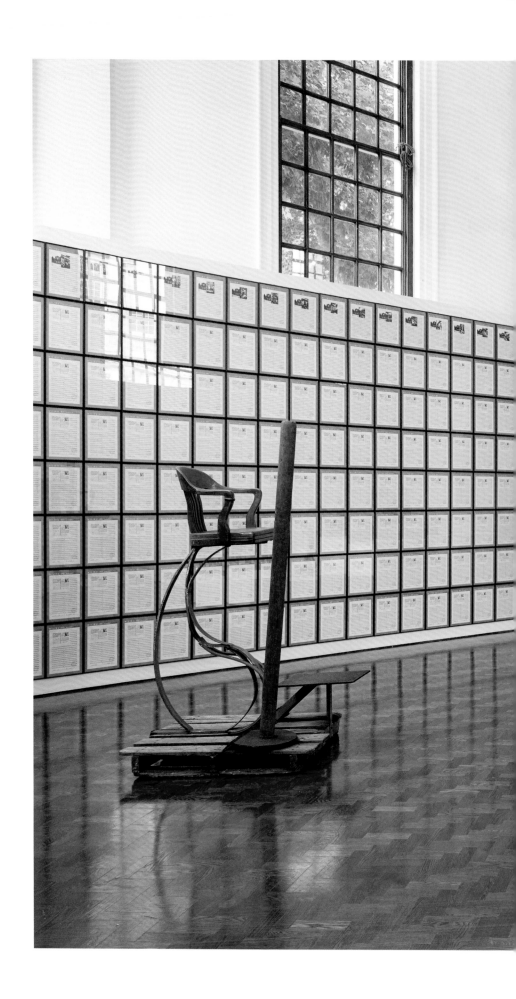

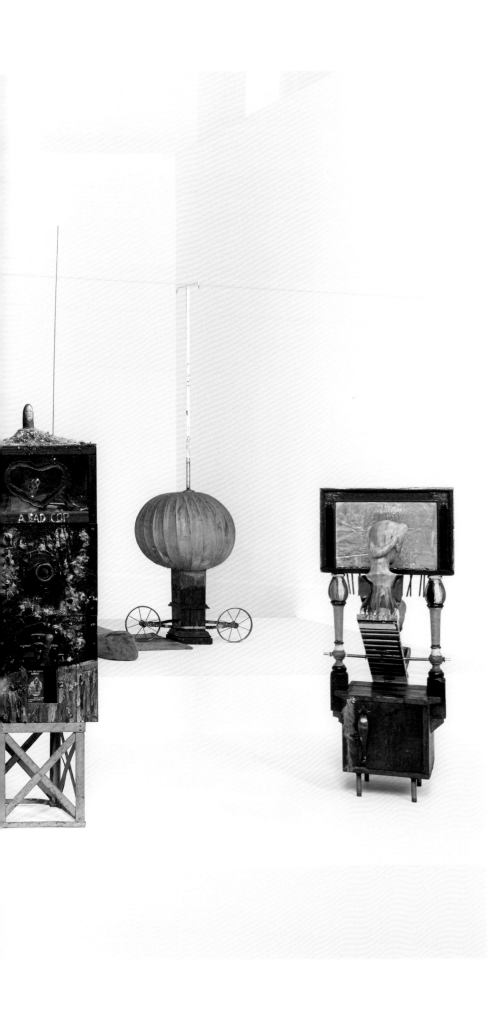

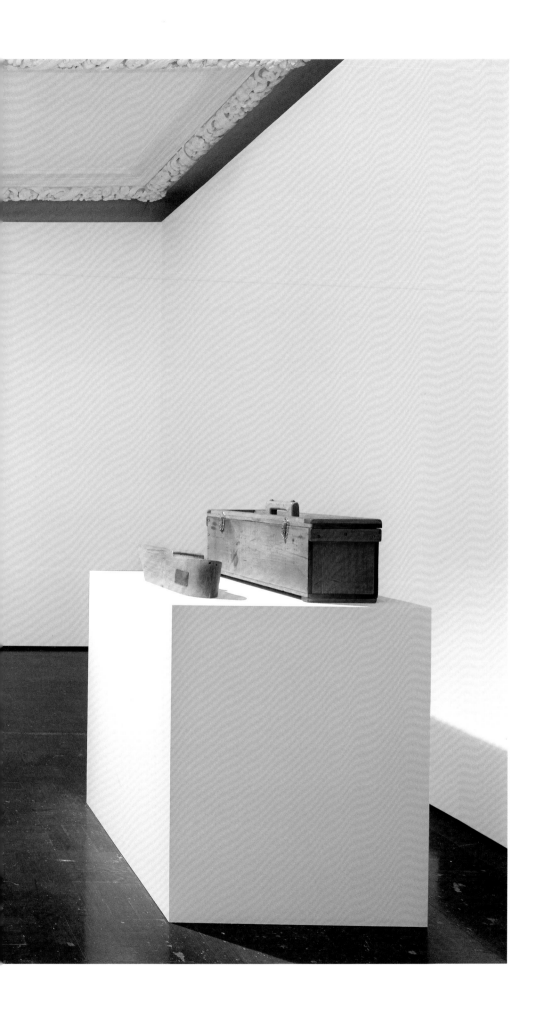

Published by SNOECK
www.snoeck.de

www.hauserwirth.com

ISBN
978–3–86442–075–7

Printed in Germany